Seven Degrees of Independence:

Shifting Currents in Alternative American Cinema

A Collection of Essays

Amir Ganjavie
Mahmood Khoshchehreh

H&S

2015

Seven Degrees of Independence:
Shifting Currents in Alternative American Cinema
© 2015 Amir Ganjavie & Mahmoud Khoshchehreh

Cover: H&S Media
Layout: H&S Media

ISBN: 978-1780835235

www.hadnsmedia.com
info@handsmedia.com

Contents

Introduction

Amir Ganjavie

Mahmood Khoshchereh

This book is dedicated to various aspects of contemporary alternative American cinema. While our hope is to investigate the works of those American filmmakers who propose an alternative vision for American cinema, our overarching goal is to highlight the traits and peculiarities that shape the cinemas of these filmmakers, including their codes of practice, formal approaches, political tendencies and thematic interests.

We have chosen the term "alternative" instead of "independent" for this book since we think it explains more productively our overall approach. In the United States, there are few limitations in terms of the representation of content, which means filmmakers are relatively at ease to tackle different topics in their films. Keeping this in mind, when we refer to independent cinema, it usually means the independence of a film production from the capitalist system of production, distribution, and exhibition. However, we believe that such an approach for investigating alternative voices in American cinema is inadequate.

Equating independence in art with the economic independence of film production provides little possibility to examine the complexities of the production, circulation interpretation and reception of movies. Such an approach resembles Theodor W. Adorno's hostile view of movies made for mass culture (Adorono 3). Adorno was extremely critical of mass-produced art, including Hollywood movies and certain kinds of music such as Jazz. To him, the joy produced by mass-produced artwork is a childish joy (33). He suggests that not only does this joy refuse to engage with reality it is also a regressive form that favours repetition and closure. According to Adorno, the essential trait of such "childish" thought is an internal compulsion to repeat ever the same. He contends that this childish repetitive pattern of mass-produced artwork happens because of the fetishistic quality of artwork within the capitalist system. Adorno refers to Marx in order to substantiate his claim, suggesting that "Marx defines the fetish character of the commodity as the veneration of the thing made by oneself which, as exchange-value, simultaneously alienates itself from producer to consumer" (38). Accordingly, Adorno argues that an artist who produces an artefact in the capitalist mode of production experiences a sense of alienation.

This sense of alienation occurs because the artist has no longer control over what he produces. He is being commissioned to produce a piece of art, but its result does not depend on his own thought and feeling. It is the exchange value of the commodity that brings fame for the artist rather than its use value. Not only is the artist unable

to fully relate to what he has produced, the consumer who buys it does not also comprehend its meaning. This happens because, on the one hand, there is an emphasis on success in the capitalist mode of production and, on the other hand, the system justifies the repetition of success stories. As Adorno points out, successful pieces of artwork are reproduced again and again, thus becoming even more familiar. This repetition means that "[t]he forms of hit songs are so strictly standardized, down to the number of beats and the exact duration, that no specific form appears in any particular piece" (49). Thus, here the consumer pays for repetitive works rather than genuine art and this, as the consumer embraces mass culture, only leads to his alienation. Furthermore, Adorno sees a tendency in mass-produced artwork to utilize segments of successful pieces in its structure, which means that the unity of the original pieces is subordinated to the demands of the market. From Adorno's perspective, this explains the reason why American movies produced in the studio system lost their unique quality and turned into a tool for making audiences feel happy while watching a movie. With these arguments in mind, Adorno sees scant possibility for alternative experiences in American mass products.

Although Adorno's critique of mass culture and its products helps us think more seriously about the relationship between culture and politics in the capitalist mode of production, one should not underestimate the human agency in grasping and analyzing the complexities of cultural products. Frederic Jameson has discussed this aspect quite extensively. Jameson, too, accuses capitalism

of emptying artworks of their content, but what is innovative about his thought is his refusal to consider this condition to be completely without resistance by the elements that contest its hegemony. To Jameson, "[w]orks of mass culture cannot be ideological without simultaneously being, implicitly or explicitly, Utopian; they cannot manipulate unless they offer some genuine shred of content as a fantasy bribe to the public about to be manipulated" ("Reification" 132). So, instead of the usual Adornian negation of low culture, Jameson tries to extract its Utopian elements. To him, mass-produced movies simultaneously address both the actual and coming-to-be modality of human social relations and, because of this, they are at the same time utopian and ideological, which means they can help humans create a better world. Jameson assumes that cultural and critical scholars must wake up and understand that current society, in fact, presents us with essential issues that go beyond the nostalgic elitist tendency to create dichotomy between the present and the past. "No society," Jameson states, "has ever been saturated with signs and messages like [our contemporary society]" (137). Additionally, he argues that "mass culture and modernism have as much content...as the older social realisms" (25).

In order to apply his framework, Jameson employs the strategy of the contradictory text, attempting to discover the repressed meanings that disrupt explicit or surface meaning in the text. Here the critic hopes to unmask ideology by showing all the flagrant distortions in the film, but he also tries to "save" the film by pointing

out how it either embodies progressive elements or contains, in its very incompatibilities, some illuminating indications of how firmly ideology must battle in order to keep its authority. In this process, Jameson's overall goal is to "restructure the problematic of ideology, of the unconscious and of desire, of representation, of history, and of cultural production, around the all-informing process of narrative" (143).

For example, concerning *The Godfather*, Jameson argues that its Utopian impulse lies in its representation of the family as the fantasy of a resolution, a fantasy to redefine the meaning of the other. As he argues, *The Godfather* emerged at a time when masculinity and its representation was a source of constant questioning in cinema. A significant number of movies during this time presented images of weak and flawed men, as can be seen in roles played by the likes of Robert Deniro, Al Pacino and Jack Nicholson. Furthermore, although the idea of family seemed to be an alien and outdated concept in this period, *The Godfather* placed family and strong men at the center of its universe. It represented the repressed desire of an American society which fantasized about a lost patriarchy.

As previous arguments have suggested, there are two schools of thought in relation to mass culture and its relationship with alternative, emancipatory cinema: while Jameson favors reading mass culture in order to exploit its alternative dimensions, Adorno pessimistically rejects mass culture as a whole. What is striking in this debate is that Adorno's rejection of alternative dimensions of mass culture minimizes the importance of human agency. In

fact, Adorno largely downgrades the agency of spectators, making only rare references to audiences and their choices and not seeming very optimistic about their role on the whole. To Adorono, consumers of movies and other art forms generally experience no political reflection. That is why they need to be helped since they themselves are not aware of this problem.

Although Adorono praised those movies that incite the spectators to think and reflect, consumers of movies in Adorno's model have practically no subjectivity and are the mere slaves of the mode of production, a suggestion which seems problematic to the editors of the present volume. Different perspectives in cultural studies show that consumers grab every opportunity to oppose the capitalist system and assert their individuality. A classic example in this respect is Dick Hebdige's *Subculture: the Meaning of Style* (1979), a study which looks at the process of the creation of identification by young, white, working-class males through music. This study suggests that, instead of being manipulated, individuals actually take these products and manipulate them, subverting them in order to create a new identity. In this sense, it is hard to relate to Adorno whose perspective seems in conflict with what Marx has argued. As Marx contends in *Capital*:

> The advance of capitalist production develops
> a working class, which by education, tradition,
> habit, looks upon the conditions of that mode
> of production as self-evident laws of Nature.
> The organization of the capitalist process of

production, once fully developed, breaks down all resistance. The constant generation of a relative surplus-population keeps the law of supply and demand of labour, and therefore keeps wages, in a rut that corresponds with the wants of capital. The dull compulsion of economic relations completes the subjection of the labourer to the capitalist. Direct force, outside economic conditions, is of course still used, but only exceptionally. In the ordinary run of things, the labourer can be left to the "natural laws of production," i.e., to his dependence on capital, a dependence springing from, and guaranteed in perpetuity by, the conditions of production themselves. (737)

In this passage, Marx argues that consumers follow the dictates of a system because they have no other choice. They want to survive, and that means they must submit to the economic control of the capitalists. Thus, Marx sees consumers as *conscious* people who can make decisions about their own lives, but fail to do so because they lack sufficient power to act on their intentions. This, however, does not necessarily negate the fact that they possess a potential agency that can be materialized in certain junctures. In contrast, Adorno views people as masses lacking any agency of their own. Adorno's emphasis on the audiences' passivity makes it difficult to fully embrace his position in our investigation of alternative American cinema.

Adorno's position on mass products provides an inadequate model for analyzing the complexity of mass-produced artwork. The question that arises here is if we reject innovations in mass production because they are introduced by the capitalist system, then are not we rejecting the very contradictions immanent in the capitalist system that can be utilized to subvert it? And must a low-budget movie financed by a modest company be considered Utopian and emancipatory in relation to a sophisticated and well-managed movie financed by a big company? If yes, does cinema have any essence or meaning at all regardless of who produces it? If one sides with Adorno on these questions, then it is necessary to reject mass-produced movies because they are only commodities produced purely for sale. Thus, this model does not allow for profound thinking about mass culture films.

Differing from Adorno, Jameson's way of conceptualizing the political impulse in mass culture is more complex; it is based neither on straightforward enthusiasm nor on total disdain for popular culture as mere commoditisation and manipulation. Jameson's model derives from historical materialism in the sense that he defines good and bad within the dialectical framework of history. In this way, Jameson proposes a methodological tool for research on alternative modes of practice with respect to all forms of cultural products within capitalism. Thus, cultural products of capitalism will be studied here in order to see if they contain a "political surplus," a dimension that can open them up to critical analysis.

Jameson reminds us that only a lazy thinking would dismiss popular culture by suggesting that it serves wholly the system of capitalism. But cultural products can be viewed as a locus in which meanings are contested as they also offer moments of resistance and fantasy. The analysis of mass-produced artwork is essential because most people receive their entertainment and information through these products. It is not just listening to Schoenberg's music that can trigger a critique of culture; listening to Lady Gaga's songs, precisely because of the dialectical character of all social and cultural phenomena, can also provide us with a critical perspective on culture. It is therefore essential to analyze popular forms and investigate their political dimensions. In this sense, the task of a cultural critic is to critically read cultural products and understand their surplus political content in order to find chinks and cracks in their pronounced ideological stance and discuss what in these products has been offered or suppressed, under what conditions, and why. This way, one can find out what is missing or deficient in our world and how such deficiency can be rectified.

On the basis of what was suggested above, we do not define alternative American cinema as independent from the Hollywood system of production and consumption. Furthermore, we do not equate alternative American cinema with only art-house productions. It may seem ironic that a cursory review of the status of cinema in countries that produce what we know as art movies, such as Japan, France and South Korea, reveals that in the majority of cases their main goal is not to propose an

alternative vision to the Hollywood mode of production. In fact, most of them seek to produce a commodity that can be sold in the global market. The tendency of contemporary filmmakers to use strategies of excess is easily understandable from this perspective. It has become quite common for contemporary global filmmakers to startle their audiences with excessively bizarre stories, introduction of highly unlikely characters, and use of unpredictable and shockingly violent endings.

This cinema of excess might better be labeled as the cinema of absence since lack of innovation is, in fact, the main reason for resorting to strategies of excess. In the absence of any clear idea for new experiments in the production of cinema, most art-house movies attempt to show their originality through such strategies of excess. Within this process, it is rare to find an innovative filmmaker experimenting with the language of cinema, and we suggest that such strategies of excess are employed only to ensure a high turnout at the box-office. As recent literature on the topic shows, the question of whether or not identity is authentic is relegated to a secondary consideration in these films. An example from another field of production may shed light on the point we are trying to make here. Rosemary J. Coombe and Nicole Aylwin argue that although Italian cheese produced in Turin was never regarded as a traditional product in the past, its commercial success has prevented people from questioning its authenticity (2032). Here, the central ideological assumption holds that producers must implement policies in order to remain competitive in the

global economy. The impact of this situation is obvious in the context of film, especially if it is perceived in relation to film festivals. As Jameson argues, film festivals have turned into places to show movies that can be described simply as Japanese, French, etc., with specific generic traits (*The Geopolitical*). Here we use history nostalgically in order to uncritically evoke memories and thereby reassure ourselves that our beliefs about other cultures and identities are true and non-problematic.

All these issues compel us not to equate alternative American cinema with terms such as "independent" and "art-house." We use the term "alternative" to refer to a cinema that is closely connected with the concept of Utopian thinking, encompassing both its normative and critical aspects. On the one hand, this term describes movies that make us think about the possibility of a better future, reminding audiences that hope and imagination for a better life are central aspects of human existence. On the other hand, it incites readers to be critical of the current world for the sake of a better future. Thus, this term designates movies that have a fundamentally critical and disruptive approach to the status quo in American cinema. It defines positively those movies that disrupt and criticize the ideas and frameworks which consider the current world and its realities to be the only possible option. Finally, similar to Utopia, in which the end state is always unclear, alternative cinema does not valorize one project over another. Actually, the term encompasses movies from different genres that voice varied thematic and political concerns. Given this, we do not wish to propose the terms

"independent" or "alternative" as referring to the inclusion of particular films in an auteurist canon. To us, alternative cinema is not a genre within American cinema because it reaches its end as soon as it becomes institutionalized. When alternative cinema is finalized as a fixed category, it is no longer an alternative vision. An authentic alternative cinema cannot be regarded as a blueprint for making films. In this sense, it is a qualitative term which resists being designated as belonging to a specific group.

Alternative cinema is a "qualitative" and "Utopian" denominator that does not conflate culture with ideology. This does not mean that alternative cinema is not political. In fact, alternative movies manifest a drive to explore forbidden areas (repressed desires) and bring them to the fore—this means that their projects are intensely political since it is the oppressive structure of state which has usually created such forbidden areas. In this sense, the endeavours of alternative filmmakers are political, even if they do not admit it. From this perspective, our approach is similar to Jeffery Sconce when he defines smart cinema. Sconce did not define smart cinema in relation to a particular genre within American cinema. As he argued, smart movies are mostly interested in the trope of irony, which is defined very broadly. Furthermore, Sconce notes that smart films are in harmony with the cultural tastes and consumption patterns of Generation X, a group that derives pleasure from irony and artistic sensibility (349–69). Thus, he defines the project of smart cinema as political. According to his analysis, these cycles encompass a diverse set of works, including those of Hal Hartley, Todd Haynes,

Todd Solondz, Wes Anderson, Paul Thomas Anderson, Kelly Reichardt, and the films of the screenwriter Charlie Kaufmann, as well as some individual works such as *Ghost World* (Terry Zwigoff) and *Donnie Darko* (Richard Kelly). In order to look for alternative voices, we have focused on seven contemporary American filmmakers. We limited ourselves to American filmmakers because little has been written about contemporary American movies critically.

Zorianna Zurba investigates how Woody Allen responds to sentimental love in his films. Situating her analysis inside the overall structure of romantic comedy, Zurba contends that while Allen's movies, such as *Play It Again, Sam*, *Annie Hall* and *Manhattan*, are good examples of dominant discourses during the 1970s, they also exhibit a form that one may describe as nervous romance. Where the space of romantic comedy is a place where love and marriage create a stable sense of identity, the space of nervous romance is riddled with hesitation and anxiety. That is why the sense of relief that the nervous romantic experiences at the end of Allen's films is ambivalent. Nevertheless, the failure of the nervous romantic to solidify his love relationship in Allen's films is compensated for by the creative space and excitement which a particular relationship generates.

In his article on Ramin Bahrani, Ben Dooley emphasizes the range of various tendencies that shape Bahrani's films, including traditional realism, art-cinema, neorealism and existentialism. Bahrani's films may be somewhat similar to conventional realist films since they present reality

in all its rawness. Nonetheless, Bahrani goes beyond a simple conception of reality by suggesting that while movies can depict reality, they can also question its very nature. In an interesting turn, Dooley also draws attention to Bahrani's enthusiasm for existentialist thought, especially that of Albert Camus. According to Dooley, the persistence of an existentialist outlook in *Man Push Cart* and, in particular, *Goodbye Solo* reveals how pervasive the characters' sense of powerlessness is. Nonetheless, this existentialist perspective enables Bahrani to locate a total, comprehensive "reality" inside an absurd universe while allowing the audience to discover their own significant individual "truth" within his movies.

Adam Bagatavicius shows how music plays the most vital role in the films of independent filmmaker Gregg Araki. According to Bagatavicious, Araki's soundtrack connoisseurship is the axis on which all his films revolve. To clarify his argument, Bagatavicius utilizes Claudia Gorbman's idea of the *mélomane* (a music-obsessed director) to demonstrate how Araki employs music as a pivotal element to shape both his plots and create a space in which subcultural voices can emerge. At the same time, Bagatavicius argues that musical cues are not just signifiers of authorial taste in Araki's films; they also enable the audience to perform two things: first, the audience can read the content of Araki's movies through the autobiographical lens of an alternative connoisseur; second, through music subcultures can infiltrate in his movies and build up dialogue with the film through a kind of direct cooperation.

Amir Ganjavie argues that contemporary filmmakers are becoming more interested in Utopian genres than ever before. Released in 2013 and 2014, *Divergent*, *Ender's Game*, *The Mortal Instruments: City of Bones*, *Maze Runner* and *Elysium* are all Utopian movies. This raises a couple of questions: how do these movies confront the shortcomings of capitalist society?; and what types of alternative societies do they present? In order to answer these questions, Ganjavie analyzes Spike Jonze's *Her* (2013) by drawing on Michel de Certeau's writings on Utopia and his conceptualization of this phenomenon. As Ganjavie argues, there are certainly some merits to Jonze's criticism of our current social system in *Her*, which exposes the limitations of a world centered on mobile technologies. However, Jonze does not tackle the reality of capitalism in a serious way. His film makes no mention of a collective struggle, a deficiency which creates a real danger of essentializing the individual struggle as the site of political resistance to the hegemony of globalization. This could be seen as an "individualist trap" that pays no real attention to collective energy as the site of social mobilization and protest. Jonze also remains silent about transition to a world without the technological contraptions that have besieged his protagonist. In fact, it seems as if he expected that this transition would just happen magically. The super-intelligent computer came unexpectedly into this world one day and Jonze seems to believe that it will vanish in a similarly sudden fashion some other day. Here, there is no description of a concrete project which is based on a deep understanding of existing society as *Her* does not take into account the concrete issues of the

existing world to propose improvements for the future; its strategies appear to be more wishful than wilful. Without a serious engagement with how the world actually works and a realistic attitude towards the production and use of technology, *Her*, according to Ganjavie, remains in the category of the interesting but trivial.

According to Richie Nonjang Khatami, the films of Steve McQueen are filled with irritating scenes rampant with images of violence, beatings, and brutality. These images compel us to ask why we subject ourselves to watching this kind of film. What connections do the images of defilement, disgust, suffering and perseverance, which are scattered throughout McQueen's work, have to our own lives? Khatami contends that McQueen is basically a present-day tragedian who evokes primordial emotions in the manner of ancient Greek dramatists. Taking Greek tragedy as his starting point, Khatami maps out the ancient Greeks' flirtation with defilement and purity while connecting them with the modern concept of sympathy. McQueen's work, he argues, speaks to the same spirit of empathic bonding that the Greeks aimed for in their tragedies. McQueen's movies incite strong reactions in viewers through repulsion and distress in order to broaden their emotional range and make them more sensitive to the tangible torment of others. These films prompt present-day spectators to identify with their protagonists in order to understand their sufferings more deeply. This is done for the sole purpose of comprehending those characters at a more profound level. Furthermore,

through the lenses of Paul Ricoeur, Martha Nussbaum, Michel Foucault and Giorgio Agamben, Khatami praises McQueen's striking endeavours to make space for dialogue and inclusion in the hope of bonding individuals from varying backgrounds together. Khatami concludes his paper by suggesting that *12 Years a Slave* is McQueen's most significant work as it combines a convincing story with empathic power and social critique. This film likewise makes McQueen an American director since here he is concerned with the American political ethos.

Ramin Alaei and Borna Hadighi argue that Paul Thomas Anderson always examines the same specific theme, sometimes repeating and at other times expanding its subtle variations while moving from one character to another. As Alaie and Hadighi point out, Anderson's films are battlegrounds in which a man is locked in a ceaseless struggle either against another man or against himself. Alaei and Hadighi also isolate both a theological strand and a severe dysfunction in family ties as the major themes in Anderson's films. As Anderson's characters transgress certain boundaries, they always face divine retribution and punishment. Although as an archetypal motif, divine retribution, as in *There Will Be Blood*, often assumes a covert form, it sometimes appears, as in *Magnolia*, in the form of a direct reference to the Old Testament. In the same way, Anderson's characters often suffer from dysfunctional family relationships. For this reason, they often try, as in *Boogie Nights*, to form alliances with other characters in order to create a symbolic family. According to Alaei and Hadighi, the disrupted structure

of family goes hand in hand with an overpowering sense of loneliness in Anderson's films.

In his examination of Wes Anderson's cinema, Mahmood Khoshchereh aims to show how Anderson employs particular formal strategies to reveal the hypercomplexity of the social space in his films. Khoshchereh argues that the ideological weight that charges the framing and physical position of characters in Anderson's mise-en-scenes turns the space in which they interact into a field of social contention. According to Khoshchereh, none of the characters in Anderson's films can be taken "in themselves" or as isolated from other characters since they essentially figure as the sides of a continuous exchange within a social context in the frame's visual makeup. Khoshchereh draws extensively on Henry Lefebvre's concept of "production of space" to show how Anderson transforms the abstract space, in which a particular character assumes centrality and, thereby, negates all social relations, into a space in which a continually shifting pattern of power relations is deployed. In Khoshchereh's words, Anderson rejects the treatment of space in terms of "spatiality," that is to say, fetishizing space in a "way reminiscent of commodities" by viewing it in abstraction and as a "thing in itself" (90). Instead, through the production of space, Anderson succeeds in unmasking the social relations that in his films always assume an unstable character. Khoshchereh also advances his argument from a Hegelian position by suggesting that Anderson renounces the perception of space as a passive receptacle and, instead, employs space in an active way to uncover the dialectics of mastery and

oppression.

Various aspects of alternative American cinema are still evolving and, as the contributors to this volume will show, it is difficult to find consensus on its future. That is why additional volumes are needed to both examine the status of alternative American cinema thoroughly and outline its future in a more comprehensive way, especially because no single book can do justice to it and shed light on its complexity fully. The present book is limited to the knowledge of its contributors as regards the topic they have written about. Therefore, we hope to investigate these areas more extensively in the future collections that we are planning to publish. Having said this, we are truly honoured to have prepared the first book in this series. We firmly believe that the present work examines some of the complexities surrounding the future of alternative American cinema while opening up new horizons for reflection. The result was not possible without the support that we received from different individuals and institutions. We especially wish to thank Constance Dilley for her generous help with the book and the time that she dedicated to read the first manuscript.

Works Cited

Adorno, T. W. "On the Fetish Character in Music and the Regression of Listening." *The essential Frankfurt school reader.* Eds. Andrew Arato & Eike Gebhardt. New York: Continuum, 1991.

Coombe, Rosemary J., and Nicole Aylwin. "Bordering Diversity and Desire: Using Intellectual Property to Mark Place-Based Products." *Environment and Planning A: Society and Space, New Borders of Consumption* 3. 9 (2011): 2027-2042. Print.

Hebdige, Dick. *Subculture: The Meaning of Style.* London: Methuen, 1979.

Adorno, T. W., and Max Horkheimer. *Dialectic of Enlightenment.* London: Verso, 1986.

Jameson, Fredric. "Reification and Utopia in Mass Culture." *Social text.* (1979): 130-148. Print.

Jameson, Fredric. *The Geopolitical Aesthetic: Cinema and Space in the World System.* Indianapolis: Indiana University Press, 1995.

Marx, Karl. *Capital: a Critique of Political Economy, vol. 1.* New York: International Publishers, 1967.

Transforming the Cold Feet of the Nervous Romantic: Woody Allen and the Space of the Romantic Comedy

Zorianna Zurba

As Frank Krutnik suggests, the term romantic comedy results from the intersection of laughter and interpersonal narratives and "can designate a bewildering array of possible combinations of sex and comedy" ("Conforming Passions"133). Woody Allen's work may not qualify for all the formal criteria of the genre of romantic comedy, but it obsessively returns to inquire into what Celestino Deleyto deems to be the "main discursive space" of romantic comedy: "the exploration of love and human sexuality and its complex and fluid relationships with the social context" ("Secret Life" 28-29). Allen's oeuvre is marked by its recurrent thematic concerns: self-inquiry, the meaning of life, and love and sex, which are aligned with the generic concerns of the romantic comedy in the seventies. The theorists of the genre of romantic comedy (Krutnik, Mortimer, Deleyto, Jeffers, McDonald) acknowledge Allen's contribution to the genre in the seventies and credit him with inaugurating a genre cycle of nervous romance, but then Allen's "name disappeared

from the conversation" (51).[1]

My intention is to momentarily bracket generic questions in order to analyze more deeply Allen's own approach to romantic love through an analysis of the types of relationships appearing in his films. I will then position these findings within the dominant discourses of romantic comedy. In doing so, I will argue that not only Allen's films, including *Play it Again, Sam* (1972), *Annie Hall* (1977) and *Manhattan* (1979), are indicative of the dominant discourses of the seventies, they are also representative of themes dear to Allen. The nervous romantic period was an evolution in the romantic comedy genre cycle that adopted a revisionary approach to "happy ending" and made use of the space of romantic comedy to transform the protagonist. Like the space of romantic comedy, the space which characterizes nervous romance affords its protagonist a pause. But unlike the situation in the pastoral space, which is typical of the comedy that grants space from prevailing social discourses, the nervous romantic is transformed in an urban creative space that is marked by a hiatus generated by nervousness. The ambivalent ending in nervous romance is the result of transformation through the experience of a creative space which permits the character a moment of reprieve from nervousness and enlightens his/her understanding of love.

Making distinctions and parsing items into categories is a game several of Allen's characters play. For instance, Mary (Diane Keaton) and Yale (Michael Murphy) in

1 Tamar Jeffers McDonald has described this cycle of films as the radical romance.

Manhattan create the academy of the overrated, which lists Gustav Mahler, Vincent van Gogh and Ingmar Bergman amongst its greats; and *Annie Hall's* Alvy Singer (Woody Allen) divides up life into the horrible and the miserable.

If, for characters in Allen's films life can be divided into the horrible and the miserable, then within the world of Allen's cinema, romantic relationships can be divided into the sweet, the heat, the cheat, the beat, and the cold feet. The sweet is optimistic about the power of love.; the beat characterizes a couple that no longer enjoys intimacy and is represented as in a malaise; the cheat refers to the union of a couple in which one partner is cheating, either secretly or openly, and may experience heat in his/her cheating; the heat is descriptive of a passionate couple whose intense relationship is doomed to extinguishment; the cold feet belong to the nervous romantic who is hesitant about love after divorce and questions the possibility of a happily ever after denouement.

These tropes are certainly not isolated instances. The sweet finds its expression in characters such as Cecilia (Mia Farrow) in *The Purple Rose of Cairo* (1985) who exhibit an uninhibited optimism about love, even if the relationship in which they are involved is not working. As sweet characters, Cecilia and Sally (Greta Gerwig) from *To Rome with Love* (2012), just as their cold feet counterparts, are shy and mildly nervous types. The spark of the heat, or wanting the spark of the heat, is what inevitably leads to the cheat, sometimes from the beat.

In Allen's films, there are individual characters that can

be classified as typically sweet: they are optimistic, naive, well-intentioned, supportive, kind, and loving in nature. Emily (Anne Byrne Hoffman) in *Manhattan*, Sally in *To Rome with Love*, Adrian (Mary Steenburgen) in *A Midsummer Night's Sex Comedy* (1982), and Cecilia in *The Purple Rose of Cairo* all demonstrate these attributes. Allen uses these characters to show how unfailingly boring are everyday committed relationships in comparison with trysts with the neurotic kamikaze woman who dives in and shakes up life tumultuously. *Husbands and Wives* (1992), *Anything Else* (2003), *Manhattan*, and *Stardust Memories* (1980), all portray this female Kamikaze type. In any case, sweet relationships are depicted as having positive effects on people's lives. The transformative power of love, as in *Zelig* (1983), *The Purple Rose of Cairo*, *Hollywood Ending* (2006) and *Whatever Works* (2009), cures and brings to the surface aspects of ourselves that have been kept hidden.

The beat, as in *Interiors* (1978), is the tired relationship that has turned into drudgery for the parties involved and is characterized by a stalemate or lack of progression. Long-term relationships are often under scrutiny in Allen's films and even equated with death. In *Annie Hall*, Alvy hesitates when Annie wants to move in, still wanting a life raft. After seeing death—metaphorically and not literally as in some other Allen's films in which the Grim Reaper makes a brief appearance—Alfie (Anthony Hopkins) in *You Will Meet A Tall Dark Stranger* (2010) becomes obsessed with youth. Being beat characterizes several couples in Allen's films: Marion (Gena Rowlands) in *Another Woman* (1988) has not had a night in with her

husband for quite some time; Alvy avoids intimacy with his wives before inevitably leaving them; Chloe (Emily Mortimer) in *Match Point* (2005) is the upward mobile choice for Chris, but he does not hone in on her; and Judy (Patricia Clarkson) in *Vicky Christina Barcelona* (2008) secretly longs to relinquish her relationship with Mark (Kevin Dunn) in Barcelona, but loves her lifestyle too much to make such a move.

The cheat includes love triangles featuring close relationships: a friend's mistress (*Manhattan*); the partner of a friend (*Play It Again, Sam, A Midsummer's Night Sex Comedy, Manhattan Murder Mystery* (1993); the friend of a partner (*Another Woman, Anything Else, To Rome with Love, Melinda and Melinda* (2004)); the sister of a wife (*Hannah and her Sisters* (1986), *Interiors*; and the partner of a spouse's sibling (*Match Point*). The cold feet characters brag about breaking records (*Manhattan*) and becoming strong virile types (*Annie Hall*), but, as in *Love and Death* (1975), they are typically confused in bed. That is why they replay baseball games (*Play It Again, Sam*), discuss the JFK assassination (*Annie Hall*), or complain about the rats playing bongos (*Manhattan*) to distract themselves and avoid sex altogether. As Vittorio Hösle rightly observes, Allen's comedies are an act of sexual deflation. An exception to this is the cheating duo to whom the majority of passionate sex scenes or discussions of passionate sex refer. For example, in *Hannah and Her Sisters*, Elliot and Lee lie in a hotel bed enjoying the afterglow of "perfect" sex. Love and passion become particularly intertwined in *Match Point* as Chris Wilton (Jonathan Rhys Meyer) and

Nola Rice (Scarlet Johansson) are frequently depicted massaging each other with baby oil and having afternoon sex.

In *Husbands and Wives* (1992), Gabe (Woody Allen) describes to Rain (Juliet Lewis), his young protégé, his longing for kamikaze women who are self-destructive and crash into you. The kamikaze woman is a dangerous combination of attractive, sexually adventurous, manipulative, and unstable. Gabe is not alone in his desire. In *Manhattan*, Isaac (Woody Allen) is warned by his analyst about his ex-wife Jill (Meryl Streep), but since she is too beautiful, Isaac prefers to get another analyst. In *Stardust Memories* (1980), Sandy Bates (Woody Allen) engages in a prolonged relationship with the tormented and beautiful Dory (Charlotte Rampling). Jerry Falk (Jason Biggs) in *Anything Else*, Jack (Jessie Eisenberg) in *To Rome with Love*, and Hobie (Will Ferrell) in *Melinda and Melinda*, all cheat on their wives with a kamikaze woman who happens to be their wives' best friend. In *Vicky Cristina Barcelona*, Juan Antonio (Javier Bardem) is unable to give up on Maria Elena (Penelope Cruz), his kamikaze ex-wife, so they negotiate their heat by sharing Cristina (Scarlett Johansson).

Left timid and lacking self-confidence after a divorce (or two), the cold feet are, if not totally anxious, hesitant and apprehensive about romantic relationships. "Get a woman into bed! I couldn't get a woman into a chair," the bumbling Allan Felix (Woody Allen) complains shyly in *Play It Again, Sam*. Allan's comedic ways resemble that of Alvy Singer in *Annie Hall*, Isaac in *Manhattan*, and

Mickey Sachs (Woody Allen) in *Hannah and Her Sisters*. The cold feet employ the strategy of using humor to hide their anxiety about their shortcomings or what Geoff King has described as Jewish humor, a self-deprecating form of humor that serves as a defense strategy (153). A standout moment is Alvy borrowing a joke from Freud and Groucho Marks: he would not want to belong to any club that would have someone like him as member. Indeed, the cold feet bear a resemblance in their use of humor and conversation strategy to Woody Allen's schlemiels (Wernblad), the little-man character (Pogel), or the Woodman (Spignesi), whose humor is based on a kind of childishness in terms of their powerlessness and lack of co-ordination and control (Neale and Krutnik 78). The Allenesque type is perhaps the most recognizable of all Allen's characters, chiefly because he is typically played by Woody Allen himself.[1]

If quips, sarcasm, snide remarks and the use of Jewish humor serve to protect the ego of the sensitive cold feet, then analysis and medication is used to strengthen and heal the ego. When his analyst is on vacation, Allan is stranded in San Francisco, relying on darvon and apple juice to bolster himself; Alvy has also been in analysis for 15 years and hopes to have no longer any need for the

1 2 Lee Simon (Kenneth Branagh) in Celebrity (1998), Hobie (Will Ferrell) in Melinda and Melinda (2004), Jessie Eisenberg in To Rome with Love (2010) and Sondra Pransky (Scarlett Johanson) in Scoop (2006) perform their characters with a slight Allenesque nervousness similar to that of the cold feet. Also, it has often been noted how difficult it is to tell apart the "real" Woody Allen from the characters he plays (Bjorkman and Allen).

lobster bib; and Isaac refers to his analyst as Dr. Chomsky lest he be hit with a ruler.

For the cold feet, loving is also a hopeless task, so they shy away from women. When darvon and apple juice are not strong enough, Allan Felix relies on Bogart's step-by-step instructions through life. Wanting the security of certainty that the other person is as vulnerable in love as they are, the cold feet delay expressions or confirmations of love until the final possible moment. Alvy wordplays "loff" and "luff" and, before pushing the responsibility onto Annie, asks: "Didn't you think I loved you?"[1]

While the general nervousness expressed by Allenesque characters was not a new trait among the characters of romantic comedy, the particular nervousness inflected in Allen's films were "less superficial character traits and more thematic tropes" (Stillwell 29). Nervousness—particularly nervousness about love and romantic relationships and their connection to the meaning of life—is the theme in Allen's films that takes the emotional balance of the narrative. *Annie Hall* and *Manhattan* are typically singled out as the films signaling a shift in the romantic comedy genre and, thereby, inaugurating the sub-genre of nervous romance (Krutnik, Mortimer, Deleyto).

Written as a play and later made into a film, *Play It Again,*

1 For Frank Krutnik ("Love Lies"), Alvy "compulsively subjects [the word love] to a string of punning disavowals and deformations that translate it into the pregnant signifiers "loathe" and "laugh'" (21). This malapropism renders Alvy's anxiety about love as antagonistic and aggressive. I read this scene as more gently expressing Alvy's anxiety as an inability to mouth or simply pay lip service to Annie by saying I love you.

Sam is often overlooked as a nervous romance. Although Woody Allen wrote and starred in *Play it Again, Sam*, it was directed by Herbert Ross. As Peter Cowie points out, "so faithful was Ross to the spirit and letter of the play, and so forceful was Allen's performance as the would-be Bogart, that for most audiences it *was* a film by Woody Allen" (12-13). With its discussion of psychoanalysis and anti-anxiety cocktails, use of stuttering awkward banter which delays intimacy, the support that Humphrey Bogart (Jerry Lacy) as an imaginary friend and romantic coach lends to the film's (anti) hero, and an ambivalent ending that finds this (anti) hero single and at a loss for love, *Play it Again, Sam* presents the symptoms of a classic Woody Allen romance, and a nervous romance at that.

Typically, romantic comedies are understood to be light and amusing tales dealing with everyday life (Neale and Krutnik). For Claire Mortimer, the elements that compose a narrative typical of the genre include: boy meets girl; obstacles prevent them from being together; they endure coincidences and complications; they realize they were meant to be together; and finally, the narrative concludes with the union of the couple, the happy ending. The key feature of a romantic comedy is the "central quest—the pursuit of love [which] almost always leads to a successful resolution" (Mortimer 4). The happy ending is the most persistent feature of romantic comedy. Predicated on the fantasy maintained by the happy ending, Kathleen Rowe has argued that the genre of romantic comedy has persisted because "it speaks to powerful needs to believe in the utopian possibilities condensed on the image of

the couple" (212). Romantic comedy, as Stacy Abbot and Deborah Jermyn assert, is a living genre that "continues to negotiate and respond dynamically to the issues and preoccupations of its time" (3). The image of the couple and the path to coupledom has undergone changes from the screwball comedies of the thirties and forties to the sex comedies of the sixties to the nervous romances of the seventies and early eighties, evolving again with the new romance in the eighties. There is little in the world of Woody Allen that is light and unserious; the gravity of relationships and self-inquiry is a recurrent topic for Allen, and one that captures the *zeitgeist* of the seventies.

Brian Henderson points out that the beginning of the sixties initiated an interest in self-discovery and deepened the relationship with the self. Sex had become a path to self-discovery and self-liberation. Henderson predicted that the appearance of this new form of self would lead to the death of romantic comedy. What Henderson could not predict was the emergence of Allen's nervous romances that treated the discovery of the self and the endless inquest into the meaning of life as part and parcel of the journey to finding romance. Indeed, as Deleyto wryly jokes, these films are "romances of self-analysis" (164). *Annie Hall*, in particular, takes the form of an analytic session as Alvy sits on a stool, stares straight into the camera, and asks: "Where did the screw-up come?" The screw-up he is referring to does not just undermine his relationship with Annie, but unsettles his whole life as well. The narrative conceit of *Manhattan* revolves around Isaac's attempt to write a novel by narrating it to his tape

recorder, an act through which he simultaneously shares with us concise summaries of the film. His book is about the people who "take the easy way out" and who "create unnecessary neurotic problems for themselves because it keeps them from dealing with more unsolvable terrifying problems about the universe…uh okay, why is life worth living?" In this way, "the romantic comedy is recast as an existential mystery" (Grindon 152).

The nervous romance cycle of films takes their name from the tagline of *Annie Hall*: a nervous romance. In Krutnik's words, the genre of nervous romance at its heart is characterized by "a nostalgic yearning for the lost possibility of romance and a more cynical awareness of the difficulty of maintaining an overriding faith in *the couple* in the face of the divisions which beset modern life" ("The Faint Aroma" 62). Geoff King goes so far as to suggest that the nervous romance signals the impossibility of romance (57). The films which unfold as nervous romance are filled with uncertainty about relationships and depict the attempts of the individual to make sense and find meaning in romance and existence (a boiled-down summary of most Woody Allen's films, if there ever was one). Claire Mortimer describes the attitudes expressed by a nervous romance as "in favor of greater realism" as they reject the happy ending, even if Allen's "films do not offer easy pleasure for a mass audience, with their references to other art works, criticism and psychoanalysis" (17). In neither *Annie Hall* nor *Manhatta*n does either Alvy or Isaac find love. Nevertheless, they do arrive at a key insight bridging love and the meaning of life, and this

leaves them ever more sweetly attuned to the possibility of love.

If the romantic comedy of the preceding years was typically understood to be a feminine film form aimed at primarily female audiences, the nervous romance, which matured in Allen's films, chronicles the experience of a male during the rise of feminism in "male-centered films in which romance is presented as complex, frustrating and elusive" (King 57). As evidenced by the recurring protagonist of the cold feet films, at the center of nervous romance there is an "unlikely neurotic and narcissistic male in the lead (anti) hero role, a figure far removed from the dashing romantic norm" (Abbot and Jermyn 2). According to Krutnik, where screwball comedies focused on the economic security that marriage granted to women, nervous romance focuses on the emotional security, or struggle toward the emotional security, of the male in committed relationships ("The Faint Aroma" 63). Allan is facing divorce; Alvy has been divorced twice; and Isaac, who is divorcing his second wife, is terrified by the release of the latter's tell-all book, *Marriage, Divorce, and Selfhood*. While their history of failed relationships has left these protagonists more apprehensive, it has also made the happy ending seem more like a myth. Krutnik describes Isaac as "emotionally embattled" and reads *Manhattan*'s narrative as fingering Jill (Meryl Streep), as Isaac's self-asserting, self-seeking exposé of his ex-wife-cum-writer in retaliation for his "loss of psychic and sexual security" (62). Like Alan J. Pakula's *Starting Over* (1979), in which Jessie (Candice Bergen) leaves her marriage to

find herself, Krutnik understands *Manhattan* as laying the blame on the late 1970's feminism, which ends up being portrayed as a kind of "corruptive narcissism" (63). The nervous protagonist wears his broken heart on his sleeve as he negotiates the shifting emotional and cultural terrain of relationships.

Allen examines sex in more "frank detail than is typical of the genre" (Mortimer 91). In a nervous romance, the bedroom is depicted as the site of panic and anxiety. Drugs, medicated or otherwise, help seal the deal in *Annie Hall*: when Robin (Janet Margolin), Alvy's second wife, is distracted by the siren of an ambulance which prevents her from reaching orgasm, she demands a valium; and Annie needs to make love high lest she feel disembodied. Unlike the sex comedies of the 1950's and 1960's, in which men attempted to win over women who might or might not be willing to go to bed with them, conversation becomes a way to delay intimacy; "verbal conflict is no longer primarily foreplay, but an articulation of real anxiety" (Stillwell 29). Alvy obsessively discusses the JFK assassination to avoid sex with Alison (Carol Kane). And while seeking shelter from the rain, Mary lists Saturn's moons to delay Isaac's advances to commit interstellar perversions. In order to appease the butterflies in his stomach, Alvy asks Annie if they can kiss before dinner so they can "digest better." Anxiety arousal, and not sexual arousal, is a symptom of romantic and sexual interest in nervous romance.

By the late 1960's, audiences had become literate about film and film history, which resulted in the use of parody and revisionism prominent in the works of Woody Allen

and his contemporaries, such as Mel Brooks (King 120-121). While *Play it Again, Sam* parodies *Casablanca* (1942), *Annie Hall* makes references to Bergman›s *Face to Face* (1976), Disney's *Snow White* (1937) and Marcel Ophuls' *The Sorrow and The Pity* (1969). Allen engages in "*reinventing* a tired and predictable genre" (Abbott and Jermyn 2), specifically by questioning the most conventional criteria of romantic comedy: the happy ending. The happy ending is a metonymy for the unification of a couple whose happiness is assumed to be guaranteed by their union or, even better, marriage, which is presumed to last ever after.[1] Nonetheless, as in the plot of a romantic comedy, the protagonist in Allen›s nervous romances undergoes a last minute resolution. The ultimate scene in Allen's nervous romances rewrites the happy ending as the terminus of a personal journey through anxiety and fear, where the protagonist reaches the clearing of hope through finding meaning in romantic relationships. The narratives end by leaving the nervous romantics single but hopeful: Isaac's eyes are widened by the mature knowledge of Tracy (Mariel Hemingway) who encourages him to find faith in people; Alvy realizes that relationships are a messy, but necessary part of life and is happy to just have spent time with Annie; and, Allan finds the courage to

1 James MacDowell argues that "the happy ending" is a Platonic type or prototype that does not actually exist in Hollywood films and the existing view of the happy ending assumes that the entire romantic comedy is conservative, a hangover of the Althusserian ideological critique that Deleyto also acknowledges. Thus, the happy ending remains a discursive shorthand for an up-beat, optimistic narrative closure.

articulate his feelings and move on. The development of the nervous romantic is made possible within the space of romantic comedy, which is re-located to the urban setting for the nervous romantic.

Central to the romantic comedy is the creation of the space of romantic comedy: "Through its comic perspective on cultural discourses on love and desire, romantic comedy proposes an artistic transformation of the everyday reality of human relationships by constructing a special space outside of history (but very close to it) (Deleyto 30). Deleyto utilizes the genre theorizations of Northrop Frye, Leo Salingar and Barbara Thomas that define the structure of romantic comedy as a framework in which the protagonist leaves his society to discover himself in order to be integrated back into that society with his new found self-knowledge. The nervous romantics likewise undergo transformation, but their journey does not take the form of a physical or external travel. Instead, they experience an inner journey during which they stand on the brink of isolation, only to traverse their romantic anxiety to locate new potential in love.

The comedy that transpires within the space of romantic comedy is essential to the transformation of the protagonist as the comedic triggers the transformational process that the protagonist undergoes. While the comic describes something that provokes laughter, the comedic is a quality of space (cited in Deleyto 33). This quality of humour permits a transformation, which differs from the one associated with romance and melodrama. Deleyto emphasizes that this space is humorous and benevolent

(34), permitting the character to momentarily envision "a "better world," a world which is not governed by inhibitions and repressions but is instead characterized by a freer, more optimistic expression of love and desire" (36). Where the space of romantic comedy momentarily brackets cultural discourses on love and sex in order to see them differently, the space of nervous romance must quiet down and soothe hesitation and anxiety in order to access a different set of affects which would allow a change of attitude on love and sex, a change that would quell the quivers of the nervous romantic.

As in the comedies of Shakespeare, the pastoral space or the countryside is a typical site of transformation. The countryside, with the moths in the windows and the Manson family living next door, as Alvy puts it, is not the preferred site of the cold feet or any romantic types Woody Allen plays. Although the cold feet do venture beyond the urban jungle (Allan goes away with Linda and Dick for a working weekend at a resort; Alvy and Annie rent a cottage in the Hamptons twice; and Isaac and Mary make love—successfully (!)—in a cabin), they prefer to pound the pavement while seeking cultural sites of creativity.

Woody Allen does not distinguish between high and low cultural forms. Indeed, Alvy would rather watch the Knicks game than chat with the chairs of philosophy departments who are missing a table to complete their dining set. In the same vein, Larry (Woody Allen) in *Manhattan Murder Mystery* demands to go home early to catch the Islanders game. Magic shows are featured

in *Oedipus Wrecks* (1989), *The Curse of the Jade Scorpion* (2001), *Scoop* and *Magic in the Moonlight* (2014). The symphony and music halls, as well as a nightclub, are featured in *Manhattan Murder Mystery*, *Take the Money and Run* (1969) and *Annie Hall*. The art gallery and museum are featured in *Play it Again, Sam*, *Manhattan* and *Match Point*. The cinema is the ultimate place and holds the space in *Play it Again, Sam*, *Annie Hall*, *The Purple Rose of Cairo*, *Manhattan*, *Hannah and Her Sisters*, *Crimes and Misdemeanors* (1989) and *Hollywood Ending* (2002). As Yale succinctly states, "the essence of art is working through a situation to get in touch with feelings you didn't think you had."

For the cold feet of the nervous romantic, the magic of the movies provides the site of transformation. Allan Felix is awestruck when watching *Casablanca*. *Play It Again, Sam* begins with Allan watching the final scene of *Casablanca* in which Rick (Humphrey Bogart) changes the travel arrangements on a tarmac. It then cuts to a close up of Allan's face, cheeks relaxed, mouth open, eyes wide, and glasses reflecting the flickers and figures from the screen. Peter J. Bailey's comment in connection with this scene is illuminating: "There may be no better emblem anywhere in Allen's canon for the power of film to overwhelm and overpower competing realities" (19). Seated in the darkness of the movie theatre, nervousness is suspended. Later, Allan bravely pushes himself out of his friend's zone and gains the confidence to woo Linda, a girl who is "something special," even if she is the wife of his best friend. In doing so, Allan realizes that

despite mutual bedroom chemistry with Linda, he would never hurt Dick. Even without Bogart's encouraging instructions, the confidence in love was available to Allan; he did not even have to whistle. Not only does *Casablanca* become a playbook for Allan—nor is its impact reducible to the imagined confidante he creates in Bogart—it also turns into a shorthand for Allan who is experiencing love without fear. In the space of cinema, Allan can simply be open to love.

This experience is echoed by André Bazin, the founder of *Cahier de Cinéma*: "In my opinion, the cinema more than any other art is particularly *bound up with love*" ("De Sica" 72). For it is "[o]nly the impassive lens, [which,] in stripping the object of habits and preconceived notions, of all the spiritual detritus that my perception has wrapped it in, can offer it up unsullied to my attention and thus to my love" ("Ontology" 9). Not only is our vision but also our full-embodied attention and love are accessed in the cinema. As Vivian Sobchack writes, filmgoers "have always made sense of the cinema (and everything else) not only with their eyes, but with their entire bodies" ("Embodying Transcendence" 194). Not only does the captivating space of the cinema prompt seeing the world anew through bodily experience, it also awakens a loving approach to the world in the nervous romantic.

Art and creativity have a privileged relationship to emotion in the films of Woody Allen. Isaac echoes the same point by saying that "nothing worth knowing can be understood through the mind." The space of nervous romance is a creative space that allows access to bodily

experience without an immediate grappling for security or the comfort of a pill. For the transformation to occur, the character must go through the saturation of experience. The question is not which medium can arouse this transformation, but if the medium arouses the relation necessary for its emergence. This relation takes on a meditative form in that it registers bodily affect at the fore of the experience. Meditation as a form of relation both inside our own bodies and to something outside ourselves—and not the mediation of the feelings that we have toward the thing outside ourselves—is what matters. Each of these sites permits a momentary transcendence of the persona of nervousness in that they orient attention simultaneously inward and toward something outside of the self. The experience in the space of nervous romance, to paraphrase Vivian Sobchack, makes sense because it has sense.

The sense of relief the nervous romantic experiences in the final moments of Allen's films is an ambivalent, if not a happy, ending. Rather than a grandiose gesture of love, like the one in *Casablanca*, or the attainment of marriage and unification of "the final couple," the nervous romantic experiences a change in his thumping heart from anxiety to excitement. Skipping a beat is no longer a sign of stressful palpitation, but once more a metaphor.

Works Cited

Abbot, Stacy, and Deborah Jermyn. "A Lot Like Love: The Romantic Comedy in Contemporary Cinema." *Falling in Love*

Again: Romantic Comedy in Contemporary Cinema. Eds. Stacey Abbott and Deborah Jermyn. New York: I.B. Tauris, 2009.

Bailey, Peter, J. *The Reluctant Film Art of Woody Allen*. Lexington: The University of Kentucky Press. 2001.

Bazin, André. "De Sica: Metteur on Scène." *What is Cinema? Vol II*. Trans. Hugh Gray. Berkley: University of California Press, 1971.

"Ontology of the Photographic Image." *What is Cinema? Vol II*. Trans. Hugh Gray. Berkley: University of California Press. 1971.

Bjorkmann, S., ed. *Woody Allen on Woody Allen*. London: Faber &Faber, 1993.

Cowie, Peter. *Annie Hall*. London: British Film Institute, 1996.

Deleyto, Celestino. *The Secret Life of the Romantic Comedy*. Manchester: Manchester University Press, 2009.

"Love and Other Triangles: Alice and the Conventions of Romantic Comedy." *Terms of Endearment: Hollywood Romantic Comedy of the 1980's and 1990's*. Eds. Celestino

Deleyto and Peter William Evans. Edinburgh: Edinburgh University Press, 1998.

Grindon, Leger. *The Hollywood Romantic Comedy: Conventions, History, Controversies*. Malden: Wiley-Blackwell, 2011.

Henderson, Brian. "Romantic Comedy Today: Semi-Tough or Impossible?" *Film Quarterly*, 31(4), 1978.

Hösle, Vittorio. *Woody Allen: An Essay on the Nature of the Comical*. Notre Dame: University of Notre Dame Press. 2007.

Jeffers McDonald, Tamar. *Romantic Comedy: Boy Meets Girl Meets Genre*. London: Wallflower Press, 2007.

King, Geoff. *Film Comedy*. London: Wallflower Press, 2002.

Krutnik, Frank. "Conforming Passions: Contemporary Romantic Comedy." *Genre and Contemporary Hollywood*. Ed. Steve Neale. London: British Film Institute, 2002.

"Love Lies: Romantic Fabrication in Contemporary Romantic Comedy." *Falling in Love Again: Romantic Comedy in Contemporary Cinema*. Eds. Stacey Abbott and Deborah Jermyn. New York: I.B. Tauris, 2009.

"The Faint Aroma of Performing Seals: the "Nervous" Romance and the Comedy of the Sexes." *Velvet Light Trap:* 26, 1990.

MacDowell, James. *Happy Endings in Hollywood Cinema: Cliché, Convention and the Final Couple*. Edinburgh: Edinburgh University Press, 2013.

Mortimer, Claire. *Romantic Comedy*. New York: Routledge, 2010.

Neale, Steve, and Frank Krutnik. *Popular Film and Television Comedy*. New York: Routledge, 1990.

Pogel, Nancy. *Woody Allen*. Boston: Twayne, 1987.

Rowe, Kathleen. *The Unruly Woman: Gender and the Genres of Laughter*. Austin: University of Texas Press, 1999.

Sobchack, Vivian. *Carnal Thoughts: Embodiment and Moving Image Culture*. Berkeley: University of California Press, 2004.

"Embodying Transcendence: On the Literal, the Material, and the Cinematic Sublime." *Material Religion*, 4.2, 2008.

Stillwell, Robyn. J. "Music, Ritual and Genre in Edward Burns' Indie Romantic Comedies." *Falling in Love Again. Romantic Comedy in Contemporary Cinema*. Eds. Stacey Abbott and Deborah Jermyn. New York: I.B. Tauris, 2009.

Spignesi, Stephen J. *The Woody Allen Companion*. Kansas City: Andrews and McMeel, 1992.

Todd, Erica. *Passionate Love and Popular Cinema: Romance and Film Genre.* London: Palgrave, 2014.

Wernblad, Annette. *Brooklyn Is Not Expanding: Woody Allen's Comic Universe.* Rutherford: Farleigh Dickinson University Press, 1992.

Realism, Neorealism and Existentialism in the Cinema of Ramin Bahrani

Dr. Ben Dooley

This essay draws attention to the diverse range of influences in the cinema of Iranian-American writer-director Ramin Bahrani and some of the different ways in which these influences interrelate within his films. On the release of his breakthrough film *Man Push Cart* (2005), many critics recognized in this work the influence of neorealist filmmakers' combination of fiction and documentary to advance social criticism, a view that continued in critical discussion of his next film *Chop Shop* (2007). This view of Bahrani's cinema was solidified in an influential 2009 article by New York Times critic A. O. Scott after the release of Bahrani's next film, *Goodbye Solo* (2008), which presented him as emblematic of a new wave of filmmakers in the US that Scott termed "neo-neo realist." The contested nature of the term "neorealism" has become such that it can be used to mean just about anything (as will be discussed here in more detail). Nevertheless, it is arguable that the popular conception of this term and its use within critical discussion of Bahrani's films is limiting, a view that Bahrani himself has

expressed on a number of occasions. It will be noted that a return to elements of neorealism not properly understood within current popular film culture but recognized by French philosopher Gilles Deleuze in his book *Cinema 2* can be informative to a discussion of Bahrani's cinema. However, this essay also draws attention to Bahrani's interest in existentialist philosophy, particularly that of Albert Camus. It is ultimately the aim of this essay to draw attention to a range of pre-occupations within Bahrani's cinema, emphasizing neorealism, as well as other different elements that set his films apart from the neorealist framework.

<p style="text-align:center">***</p>

In a 2009 article for New York Times, A. O. Scott offered the convincing argument that there has been a turn in a handful of independent films by young directors in the United States in the first decade of the twentieth century, a shift which, especially in the work of Ramin Bahrani, has exhibited an unmistakable realist style that Scott calls "Neo-Neo Realism" ("Neo-Neo Realism."). To Scott, this movement in cinema can be regarded as a response to the darker social and political atmosphere in the US and around the world following the events of September 11, 2001. During the Bush Years, this movement gained further momentum after the Financial Crisis of 2008, which led to homelessness, unemployment, poverty and disillusionment. In Scott's view, the roots of this new realism go back to the films of the Italian Neorealist movement, which developed during and after the Second World War and can be seen

especially in Roberto Rossellini's War Trilogy, Vittorio de Sica's *Shoeshine* (1946) and *Bicycle Thieves* (1948), and Luchino Visconti's *The Earth Trembles* (1948). Although there are no clear definitions of the term "neorealism," it is generally held that these filmmakers combined elements of documentary and fiction to depict social and economic malaises. They also typically used on-location shooting and non-professional actors who played roles very similar to their own lives, qualities which served to give a greater sense of authenticity to the films. While Scott's claim that this style, or "ethic", was "invented" in postwar Italy is questionable, it is undoubtedly the case that the films of this period have been a crucial model for many alternative and national cinemas throughout the twentieth and into the twenty-first century (Iannone).

Scott draws attention to Kelly Reichardt's *Wendy and Lucy* (2008), Anna Boden and Ryan Fleck's *Sugar* (2008), Lance Hammer's *Ballast* (2008); some of these filmmakers have since acknowledged the influence of Italian neorealism on their films. His main focus, however, is on writer-director Ramin Bahrani, whose films have so far engaged, at least in part, with the brutal nature of US capitalism, a somewhat taboo subject in American cinema. Bahrani's cinema also focuses mostly on working class characters while preserving a strong sense of location and using non-professional and inexperienced actors within roles similar to those that they have experienced in their own lives.

Although critics have recognized the influence of Italian neorealism and its legacy in Bahrani's films, they have

tended to present neorealism simply as an alternative form of realism. That is to say, they have failed to recognize the manner in which the fictional aspects of these films are as fundamental to their structure as their documentary tendencies. Bahrani himself has been critical of the use of this term to describe his films, noting that filmmakers had been using non-professional actors within narrative cinema long before the Italian neorealist movement. He particularly draws attention to the documentary films of Robert Flaherty such as *Nanook of the North* (1922) and *Man of Aran* (1934) ("The Films of Ramin Bahrani"). Indeed, in an article for Criterion, Bahrani himself has professed his admiration for Robert Flaherty above all other filmmakers. Bahrani here argues that Flaherty's cinema has "forever erased the line between fiction and documentary" and also implicitly appears to suggest that his films have had a shaping influence on Italian neorealism and some of the key figures of Iranian cinema. ("Ramin Bahrani's Top 10"). Within the same piece, however, Bahrani also appears to praise Flaherty's *Nanook of the North* as a documentary in traditional terms, showing how its director had the ability to "set his camera down and had the audacity and humanity to step back." Here Bahrani appears to be drawing on French film critic André Bazin's famous discussion of the depiction of a seal-hunting expedition in *Nanook of the North*, which Flaherty decided to show within a single, static long shot rather than create an edited scene from a number of different angles, as was prevalent within the classical Hollywood style and Soviet cinema of the time (Bazin). Bazin suggests that in this scene "[w]hat matters to Flaherty, confronted with

Nanook hunting the seal, is the relation between Nanook and the animal; the actual length of the waiting period." Bazin uses this scene as an example of how cinema's indexical character should be recognized as a key means by which the medium can express "reality." However, while there are some ambiguities and contradictions in Bazin's writing, he has been incorrectly misrepresented as a traditional realist. In fact, Bazin always recognized such use of cinema's indexical character as a technique existing within highly constructed film texts, rather than literally and simply providing "reality." This has recently been emphasized by Justin Horton who has noted that Bazin had a multiple understanding of the "real." Horton has further noted that Bazin, in his article "An Aesthetic of Reality: Neorealism," stated that "realism can be achieved in one way: through artifice" (Cited in Horton). In this article Bazin praised Italian neorealist cinema's use of images of Italy's war-torn cities within narrative films, describing such films as offering up the "image-fact." However, while this term might appear to suggest a more traditional form of realism, for Bazin the "image-fact" was to be understood primarily as a cinematic technique rather than an unfiltered vision of "reality."

Bahrani's cinema derives from an alternative cinematic vision to that upheld by those who consider cinema as a medium able to display an unfiltered vision of "reality." Although, as Bahrani's aforementioned comments suggest, he is certainly in part motivated by such a traditional form of realism, at the same time he draws on an "art cinema" tradition that has insisted on the

need to challenge not only the dominant concepts of "reality" within society, but also the notion of "reality" itself. French philosopher Gilles Deleuze has recognized such an alternative tradition, which he sees as having begun with Italian neorealist cinema. Deleuze's book *Cinema 1* presents pre-1945 cinema as dominated by what he calls "the movement-image," a phony version of "reality." Deleuze's *Cinema 2*, however, rejects this cinema in favour of some key post-1945 films which, in his view, emphasize what he calls "the time-image. "The primary distinction made between the two is that while in cinema of the movement-image, characters within the film's narrative are able to alter their existing situation, in cinema of the time-image such character intervention becomes impossible. This leads to paralysis within the film, which gives rise to pure optical and sound situations, what Deleuze calls the time-image. In Deleuze's theory, the time-image does not challenge simply one style of the depiction of "reality," but the nature of "reality" itself, its display of time itself. It does not simply show "reality," but throws it into question. While in other cinemas it may appear for other reasons, such inaction in Italian neorealist cinema developed as a result of the trauma of World War II. In Bahrani's cinema, this incapacitation is overtly presented in the central characters of *Man Push Cart*, *Chop Shop* and *Goodbye Solo*, all of whom are identified with a vehicle which, rather than allowing them freedom, actually restricts their potential for movement and what they are able to do within their lives.

To Deleuze, the time-image becomes visible in a

particular aspect of cinema that he calls "the crystal-image," an element which appears in a number of Bahrani's films. The crystal-image in cinema is an image that is capable of presenting something that appears at once as both "real" and "virtual," as though each mirrored the other to erase their difference. As Deleuze puts it, this involves "the coalescence of the actual image and the virtual image, the image with two sides, actual and virtual at the same time" (69). A key example of such an image literally has a mirror in it that makes the "real" person or thing indistinguishable from their reflection, but this is not in itself necessary for a crystal-image. Such an image draws attention to the fact that we typically privilege what we assume to be "reality," when this in itself actually springs from the virtual, which offers many more possibilities. Shohini Chaudhuri and Howard Finn assert that this imagery involves the presentation of time itself as central to the cinema of such Iranian filmmakers as Abbas Kiarostami, Mohsen Makhmalbaf and Jafar Panahi. Bahrani has acknowledged the centrality of Iranian cinema to his own films, particularly the work of Kiarostami (44). Horton has also recognized the use of the crystal-image in David Gordon Green's *George Washington* (2000) which, despite being made before 9/11, qualifies as an example of what A. O. Scott calls "neo-neorealist." The crystal-image can be seen in a number of Bahrani's films as well, but is particularly prominent in the manner in which the push-cart in *Man Push Cart* blurs the distinction between the "actual" and the "virtual." The push-cart is an incredibly ubiquitous "normal" image within New York City, and yet it is lit in such a way throughout the film that it appears

to have a "magical" quality to it.

A further framework within which we can understand Bahrani's cinema is the philosophy of existentialism which he has emphasized as a key to understanding much of his cinema. In this respect, a discussion of Albert Camus' ideas is instructive. Although notoriously difficult to define, we may say that in the face of many obstructions by which a person is controlled and constricted within modern life, existentialism focuses on the individual's need to gain his or her own independence through consciousness. Like Italian neorealism, Camus' version of existentialism was a response to the horrors of World War II. However, unlike neorealism, at the core of Camus' philosophy was the assertion that, despite the paralyzing absurdity of war, it was possible, and indeed essential, for the individual to remain conscious and to act. A central text for Bahrani is Albert Camus' *The Myth of Sisyphus* (1942), a book he read as a teenager and whose governing question is whether it is admissible to kill oneself in the face of life's often cruel absurdity. The book's central image is the figure of Sisyphus, a mythological figure who is condemned by the gods to roll a rock up a mountain for eternity. Bahrani has said that this was the guiding image for his depiction of Ahmad in *Man Push Cart*. A Pakistani immigrant, Ahmad is a street vendor who engages in the same repetitive struggle every day by pushing his cart as he takes it toward and away from his street-spot in New York City. The question of suicide in Camus' book, which is not overtly dealt with in this film, becomes central to *Goodbye Solo* (2008), in which William, a truculent, elderly

Southern white man asks his gregarious Senegalese taxi driver, Solo, to take him to Winston-Salem suicide-spot Blowing Rock in ten days time. Although Solo initially attempts to dissuade William from taking his life, he is ultimately compelled to acknowledge the authenticity of his newfound friendship by respecting William's independence as a conscious individual able to make his own decisions, no matter how flawed they may be.

It is worth mentioning that in Bahrani's films, since existentialist thought tends to emphasize the sovereignty of the individual's choice and to reject all elements that constrain this sovereignty, it consistently comes into conflict with social issues. Although Bahrani's films express sympathy for the suffering of his characters by depicting their oppressive working conditions, these films typically fall short of overtly siding with the working class as a whole or drawing attention directly to issues of class oppression. To some extent, Bahrani appears to be aware of this limitation since two of his short films, *Plastic Bag* (2009) and *Lemonade War* (2014), are underpinned by the irony of the use of existentialism in surprising situations, where it may actually be redundant. For instance, *Plastic Bag* was co-written with ecology consultant Jenni Jenkins and focuses on the Pacific Trash Vortex, yet instead of offering a traditional documentary-style presentation of the ecological issues involved here, it tells the story of a plastic bag's existential angst. Existentialist thought would equally initially appear to be redundant to Bahrani's short film *Lemonade War*, which was made as part of a series of shorts aimed at informing the public about issues related

to the economy. Yet while this short mostly provides a lively satire on the ways in which big business can suppress "the little guy," as two neighbours fight over their lemonade stands, it concludes with the deus-ex-machina arrival of Werner Herzog. Herzog magically solves the dilemma the characters face by absurdly quoting the existentialist philosophy of Arthur Schopenhauer about how human relations are like those of porcupines that must stay together to keep warm, and yet they should not get too close as they will prick one another. In each case Bahrani appears to willfully push the boundaries by which existentialist thought can be considered reasonably applicable, in part in order to leave a self-conscious authorial stamp onto the films.

A final factor worth mentioning is that of the financial and institutional constraints in which Bahrani has made his films. Bahrani has claimed that he slept on a friend's couch for some time while making *Man Push Cart*. Ahmad Razvi, his actor in that film, has said that during the filming he slept on Bahrani's couch in Midwood, as he was working 17 hours a day doing two jobs. This had allowed him to cut down travelling time, something Bahrani appears to have depicted in the film itself as Ahmad (the character) stays in Mohammed's flat ("Ahmad Razvi"). Although *Man Push Cart* was well-received critically and won the Fipresci prize at the 2006 London Film Festival, as Kristin Thompson has noted, it was not a commercial success, grossing only $56,000. Thompson has suggested that it may have been the support of the influential critic Roger Ebert that helped

Bahrani make *Chop Shop*, which was also acclaimed, even more so than *Man Push Cart*, but was only moderately successful at the box office (BoxOfficeMojo). Admittedly, *Goodbye Solo* was a definite commercial success making just under $1 million and soon after Bahrani won a prestigious Guggenheim Fellowship grant for Film in 2009 (Bordwell & Thompson). Nevertheless, Bahrani still supports himself by teaching film directing at Columbia University. It may be said that a combination of these concerns has played a role in Bahrani's approach to his next feature film, *At Any Price*, and his latest, *99 Homes*. These Hollywood style films have offered the comfort of a traditional paycheck, a familiar path for independent US filmmakers (Allen 175). Nonetheless, we should not doubt Bahrani's sincerity in making these more recent films, which are after all rare instances of social and political engagement within Hollywood. Both films demonstrate the problems of US capitalism to a mainstream audience. It is to be hoped, however, that with *99 Homes* and beyond, Bahrani's career can continue to retain the wide variety of influences and intellectual complexities that have characterized it thus far.

The Early Films

Ramin Bahrani was born in 1975 in Winston-Salem, North Carolina, and raised by parents who had emigrated from Iran. His father worked as a psychiatrist, treating patients from poor backgrounds both white and black. Bahrani received a BA in Film Studies from Columbia University in New York City and made a number of

short films which culminated in *Backgammon* (1998), a 10-minute film shot in color on 16mm film stock. Currently unavailable, the film is described on the website of Bahrani's company, Noruz Films, as telling "the story of a six-year old Iranian American girl (Sheema Regimand) who desperately wants to play backgammon with her stubborn grandfather (Manucher Marzban) who has recently arrived from Iran." Following this film, Bahrani moved to Tehran, Iran in 1998, where other members of his family live. He lived in Tehran for roughly three years, during which time he completed *Strangers* (2000), his thesis film. Shot again in color and now in 35 mm, a more expensive film stock, *Strangers* was 71 minutes long. Commenting on why he did not go to the graduate film school, Bahrani has noted that the cost of making *Strangers* was the same as a single year of grad school.

In *Strangers*, also unavailable, Bahrani continued the theme of cross-generational conflicts which had figured prominently in his previous film. At the same time, *Strangers* was a semi-autobiographical engagement with his own dual national identity. But while *Backgammon* involved an Iranian visiting the US, this film mirrored his own experience as a US citizen of Iranian heritage visiting Iran. Noruz Films' website describes *Strangers*, in which Bahrani himself plays the lead role, in this way:

> Kaveh, a young man from America, walks the roads of southern Iran searching for Dehdari, his recently deceased and estranged father's childhood home. Abdul Reza, a thirty year old truck driver plagued by financial needs

and family responsibilities, repairs his truck by the side of the road. Kaveh hires Abdul Reza as his guide, and together these two strangers embark on a three day journey that leads them from a tiny village to an ancient graveyard and in search of the man who murdered Kaveh's grandfather. (*"Strangers"*)

On *Strangers*, Bahrani worked with the veteran Iranian composer, Peyman Yazdanian, who had recently composed the score for Abbas Kiarostami's *The Wind Will Carry Us* (2000) and would go on to compose the music for Bahrani's next film, *Man Push Cart*. While in Iran, Bahrani also attempted to make "a Taiwanese style movie in Tehran," but has said that the money for that fell through after the events of 9/11 (Scott, "Neo-Neo Realism"). This incident ultimately led him to go to Paris and then return to New York, where he would make an "Iranian-style movie in New York."

Man Push Cart

Bahrani has described the germ of the idea for *Man Push Cart* as having come when he was in Paris in 2001 and visited the Pompidou centre art gallery. Bahrani says that there he witnessed a group of Afghans who were watching the footage of 9/11 attacks, a scene that made him realize that these people would now be treated as outsiders within France. At a time when the US President, George W. Bush, was pushing to send troops into Afghanistan, Bahrani decided he wanted to make a film that would counter the inevitable vilification of Afghans and other

ethnic minorities in New York City. Having an Afghan friend who worked as a push-cart vendor in New York City, Bahrani returned to the big apple in January 2002 ("Ahmad Razvi"). He then began roughly two years of first-hand research into the lives of push-cart vendors in the Midwood area of Brooklyn, talking with people in the area. During this time, Bahrani met Ahmad Razvi, a Pakistani-American who was running a café in the neighbourhood and was later cast by Bahrani to play a version of himself for the central role in the film. Razvi also worked on technical roles during the film, including securing locations, casting of extras and organization of food (*"Man Push Cart"*). In February 2002, Razvi's family had established the Council of Pakistan Organization (now the Council of People's Organization) in the building next to Razvi's café on Coney Island Avenue, a voluntary organization established to help those in the community due to the massive backlash against South Asians, Pakistanis, Afghans and Indians following the 9/11 terrorist attacks. During this time, a large segment of the population in the Midwood area disappeared, some have estimated roughly half, either due to going "underground," fleeing to Canada, or being arrested or deported (Rothkopf). Between 1,500 and 2,000 men from the neighbourhood were arrested by the FBI and the CIA during this time and in many cases their families were not informed that they were being held, an issue that Razvi's organization was trying to deal with ("Ahmad Razvi"). Bahrani inquired about Razvi's organization, as well as his personal life. Later in 2002, Bahrani worked for one week as an assistant on *India*, a short film by Mira

Nair, the New York-based Indian director. *India* was part of a compendium film of shorts from around the world in response to the 9/11 attacks entitled *11'09"01* (2002), all 11 minutes and 9 seconds in length. Razvi was also involved in helping to find the 75-100 extras necessary for the film's concluding funeral scene.

Nair's film can be understood simultaneously as both an interesting parallel with Bahrani's film and a marker of one of the key differences between Bahrani's treatment of his subject-matters and that which was typically expected from filmmakers. In *India*, Nair tells the true story of a mother's experiences as her son (Mohammad Salman Hamdani), a police cadet, goes missing after 9/11. Initially assuming that the F.B.I. has taken her son for questioning, she then realizes that he has disappeared because he is a suspect in the 9/11 attacks. The film bears witness to the cruelty of the media and some people within the local community who presume his guilt as a "terrorist" without any evidence other than the fact that he is a Muslim. Nair's film concludes with a funeral scene in which the mother criticizes representations of her son by saying that "first they called you a terrorist and now they call you a hero." She concludes with an implicit rejection of this "hero" status given to her son by saying that "If I had raised you with wrong values, at least you would be alive. Is this the price you pay for raising a compassionate human being?" An interesting parallel can be made between this film and a scene that occurs roughly two-thirds of the way through *Man Push Cart* in which Ahmad is alone in a bar and we hear a conversation at a

pool table, where one man is showing off the scar that his friend got when he was stabbed by a gang of youths who accused him of being a "terrorist." When another friend tells the first man to leave their friend alone, the first man tells him that the boy should be proud as he is a "hero." We then overhear others saying that this first man displays his friend's scar to people to attract girls' attention. This scene draws on a real-life incident told to Bahrani by Razvi, in which a young boy who was stabbed for supposedly being a "terrorist" had been taken to hospital by Razvi's brother. Furthermore, the real victim plays himself in the scene. However, by transforming the incident, Bahrani is able to provide a scene, which, like Nair's short film, stands as a challenge not only to the stereotypical image of the "terrorist" but also to that of the "hero" within a post-9/11 context. Yet while it is possible to interpret this scene as an all-out exposure of the flawed binary of hero/terrorist that existed in the US after 9/11, the scene at the same time differs significantly from Nair's approach as it questions, in an ambivalent way, the role of cinema itself, something that is also apparent throughout *Man Push Cart*. Although Nair's short film draws attention to the flawed nature of the media after 9/11, its inclusion of a long speech in its final scene appears to be a testament to its director's belief in cinema's capacity to challenge the current political situation. In contrast, as the young man's scar is cruelly exposed to those around him for his friend's benefit in *Man Push Cart*, it is also exposed to the cinema audiences. In fact, the scene itself can be considered to draw attention to the arguably prurient, voyeuristic nature of cinema, as well as that of the film's own semi-

ethnographic character.

As noted in the introduction to this essay, Bahrani is influenced by an "art cinema" tradition which challenges not only the dominant concepts of reality but also the notion of reality itself, a tradition that the French philosopher Gilles Deleuze has characterized as centered on what he calls the time-image and the crystal image. In cinema of the time-image, characters are no longer able to alter the circumstances within the film's narrative. In addition, narrative causality also falls apart. This leads to paralysis within the film, giving rise to pure optical and sound situations which display time in such a way that it throws reality into question. To Deleuze, the time-image becomes visible in a particular element of cinema that he calls the crystal-image. The crystal-image within cinema is an image capable of presenting something that appears at once as both "real" and "virtual," as though each element mirrors the other, so that their difference becomes indistinguishable. The time-image draws attention to the fact that we typically privilege what we assume to be reality when this, in fact, itself springs from the virtual in which there are many more possibilities. *Man Push Cart* can be understood as motivated by the time-image, particularly because the narrative "action" in most of the film, the promise of the rejuvenation of Ahmad's pop career and the possibility of a new romance, does not lead anywhere, with Ahmad's life characterized throughout by the static, repetitive cycle of his work tied to the push-cart. While such repetitive depictions of Ahmad's work can be seen as partly drawn from the documentary genre's emphasis on

the value of seeing the process and duration of a subject, they also allow for the appearance of the time-image within the film. In the place of narrative action, we have a number of images that involve the coincidence of the "real" and the "virtual," such as the images of the Chrysler building reflected through shop windows, misty weather and many other images of both Ahmad and the city seen through screens, windows, mirrors and frames-within-frames. However, the ultimate crystal-image in *Man Push Cart* is the push-cart itself, which blurs the "actual" and the "virtual", since its design is at once both incredibly ubiquitous within New York City—and so it would ordinarily be seen as simply "real"—and is given a magical "virtual" quality due particularly to the manipulation of the city's combination of artificial and natural lighting by cinematographer Michael Simmonds with whom Bahrani worked very closely on the film (Deleuze 69). The push-cart's stainless steel surface does not function in the manner of the example of the crystal-image discussed in the introduction, in which we cannot discern the difference between a thing or person and its reflection in a literal mirror seen within the image. Nevertheless, the stainless steel surface of the push-cart opens up a space for complicated, multiple possible "realities" brought on by the virtual. This occurs especially because blurred reflection and diamond-patterned surface of the push-cart does not provide a clear image of the world around, a quality which suggests a fractured social pattern.

The use of the push-cart as a crystal-image in *Man Push Cart* presents the possibility that object relations within

modern life could offer something beyond the dominant commodification processes of modern capitalism. Throughout *Man Push Cart*, commodity relations dominate Ahmad's life, forcing him into a situation where objects appear to have a life of their own while Ahmad becomes merely another object. As will be made clear later, such commodity relations are highly criticized in *Man Push Cart*. Nonetheless, the film retains a degree of ambivalence regarding whether to be only negative about these processes. Instead, it suggests that capitalist object relations may have merged with "natural" object relations, a synthesis which will give pleasure to life to such an extent that it may be necessary to accept some forms of capitalistic dominance in order to gain pleasure within life. This notion of object relations within the film as operating to present simply "natural" experience has been emphasized in Bahrani's director's statement in the film's Pressbook as he relates the film to the ancient Greek myth of Sisyphus. Bahrani has said that "[t]he image of Ahmad dragging his cart along the streets seemed to me a modern day version of that myth. This evocative image is what gave me the confidence to make the film" ("Director's Statement"). This engagement with object relations within capitalism is influenced by Camus' *The Myth of Sisyphus*, which uses the ancient Greek myth as, among other things, a metaphor for the monotonous cruelty of industrial capitalism, as on a factory production line. In the concluding line of his book Camus suggests that within this myth, "[t]he struggle itself towards the heights is itself enough to warm a man's heart. One must imagine Sisyphus happy" (50). Such a presentation of

object relations as not only oppressive external forces, but also a "natural" part of life from which pleasure can be gained can be seen in Bahrani's presentation of Ahmad's relation with his push-cart as a kind of elemental force. Indeed, the opening scene of the film uses abstract visuals in such a way that they come to suggest symbolically that Ahmad and his cart are being born into the world together—as we see first in near-darkness the slatted plastic-sheet entrance to the loading bay for the cart which is brightly lit. As Ahmad and his cart leave through this entrance-way, it is as though they were pushing through a symbolic birth canal and being born into the world. This attraction to such object relations in *Man Push Cart* has been recognized by some critics, such as the Village Voice critic Michael Atkinson who in an otherwise positive review of the film hints at it. Atkinson suggests that "Bahrani seems happiest capturing the meaningless [...] repartee that foreign nationals performing menial jobs have with their customers" ("Night Watch"). In the film, this "meaningless repartee" is certainly presented as more of a pleasure for the customers than for Ahmad, but it is not clear either that Ahmad does not take any pleasure from it in the way that Noemi (Leticia Dolera) asserts that she cannot. As Noemi says, she hates the job. Such an approach treats the day-to-day lives of the real push-cart operators with a certain degree of respect, giving their work a sense of grace. At the same time, like Flaherty's *Nanook of the North*, this approach also runs the risk of being accused of romanticizing its subject matter.

Yet while some attraction to the possibilities of the

"virtual" can be seen in *Man Push Cart*, the "virtual" is primarily associated in the film, like the "real", with capitalism, presented as artificial and seemingly all-encompassing and rejected for this reason. (The only alternative that is embraced is in the figure of the individual). This is stressed in the film specifically in the manner the push-cart is lit in the morning hours both by natural light from above and artificial light from the street lights and night-clubs (here, similar to its use in Martin Scorsese's *Taxi Driver* (1976), the artificial light suggests falsity and vice). While a number of artificial colours are reflected on the push-cart's surface, the dominant colour is red. The colour red, which is seen at the start of the film as the push-cart leaves the loading-bay, as well as a number of other times throughout the film, suggests the dangers of the city's "false" light; it even suggests that the film could be read as a journey through the underworld. Although, as already noted, the bright white light at the film's start can be seen as having a positive connotation, white lights throughout the film are used to express an exaggerated opulence, as in Mohammed's (Charles Daniel Sandoval's) large, brightly lit flat, as well as in the Christmas lights that surround Ahmad in the film's final scene. In both cases, this imagery contrasts with Ahmad's own desperate poverty. The film's anti-capitalist stance derives primarily less from an engagement with social class than an existentialist assertion of the individual's need to be free of all frameworks that constrict him. This is particularly emphasized by the use of push-cart itself as a visual frame. However, Ahmad does not seem able to free himself from the logic of such frames, as can be

seen in the way he places his money in a box on the top of wardrobe and the kitten that he finds on the street inside a box on the floor. Although there is nothing wrong with this on a literal level, such placing of items inside boxes, as well as the hierarchy in which money is placed at a high level, is symbolically presented as a flawed logic. The objective imagery used here, as the camera separates each part of the room, is probably modeled on a similar scene in Robert Bresson's *Pickpocket* (1959). Bresson's film equally presents capitalism's objective processes as all-encompassing as we see in an objective fashion the processes of picking pockets throughout the film. Bresson equally suggests the unlikely hope of escaping these processes in the film's conclusion when Michel (Martin La Salle), the central character, repents in jail and expresses his true love for Jeanne (Marika Green) from behind prison bars. This double-game in *Man Push Cart* is particularly encouraged by the inclusion of the image of Ahmad sleeping throughout the film. Demonstrating Ahmad's exhaustion from work, this image has at once the capacity to both entice the cinematic viewer into a dream-like state and to draw attention to Ahmad's inability to be fully conscious, a necessary component for the possibility of freedom in Camus' *The Myth of Sisyphus*.

Beyond such an emphasis on objective qualities within the film, whether of capitalism or of something more "natural," *Man Push Cart* also asserts the centrality of the individual (which appears first of all both in Ahmad the character and Ahmad Razvi the actor) achieved through the more traditional realist or "neorealist" approaches

praised by most critics in their discussion of the film. In the pressbook for *Man Push Cart*, Bahrani has emphasized his wish to depict lived experience: "I lean towards the poetics of life rather than the poetics of politics," which he says he achieved through the character of Ahmad for whom global politics does not matter. This emphasis on the individual can be seen in the film's refusal to make any clear-cut statement about society as a whole, even though it eventually appears to move towards such an end. For instance, Mohammed, Noemi and Noori (Panicker Upendran), the man from whom Ahmad buys the push-cart, can all stand for versions of the promise that Ahmad might escape his situation by entering into a higher class, which in the guise of these three characters respectively assumes cultural, intellectual and economic forms. But while they arguably point to class-based problems Ahmad is facing, these are ultimately presented as far less important to him than his personal experiences. For example, we are told that Ahmad's wife died when they traveled from Pakistan to the US and his step-parents blame him for her death and have taken his son away from him. Like his relations with the other characters in the film, these incidents refuse to offer any specific broader political meaning, particularly due to the ambiguity over the reason for the death of Ahmad's wife. However, the priority of these personal experiences for Ahmad over any social or political issues is emphasized in an idealized flashback scene of Ahmad waving to his wife and child while he is operating the push-cart. Here the individual's personal experience is presented as central. This existentialist outlook operates at the symbolic

level for the cinematic viewer, with Ahmad's experience demonstrating the point that we can, first and foremost, only understand our own individual lives. However, it is also central to the production process of the film itself as some of these elements are drawn from Razvi's own actual life, particularly the experience of having an "estranged son" (Ahmad Razvi"). Thus, on this level the film can be said to perform a functionalist role for Razvi, the real person, by allowing him to express his own personal experiences while maintaining still some distance from his actual life. This emphasis on Ahmad's individuality was intended from the start as Bahrani has noted that he is interested in showing real "interesting people" and that he will change the character to suit the actor. However, Bahrani has pointed out that Razvi's acting was so compelling that the film was greatly transformed in the editing room to emphasize Ahmad's character above all other details. This emphasis on individual details as separated from broader political issues can be seen in other traditional forms of "neorealist" technique within the film, such as in scenes where Bahrani claims to have captured Razvi on camera when the latter was not aware he was being filmed. One such example is the scene in which Razvi falls and is nearly run over by the push-cart. Elsewhere, an instance of guerrilla filmmaking equally serves to capture aspects of the city life that go beyond any specific social or political point, as in the scene in which Ahmad attempts to sell pornographic DVDs on the streets. In one of these scenes, a passerby suggests that he can buy the DVDs cheaper elsewhere in the city, unaware that he is on camera. These instances emphasize

that we can only know ourselves as individuals for whom the rest of the world, what goes on around us, remains meaningless and absurd.

Chop Shop

As in *Man Push Cart*, in *Chop Shop*, Bahrani's next film, the choice of focusing on a specific location was a crucial starting point in order to show the condition of the poorest people in New York City, who had been deprived both economically and representationally. This location is Willets Point, also known as the "Iron Triangle," a small 75-acre area of Queens which is taken up almost entirely by car parts and repair shops where stolen cars are delivered and dismantled for spare parts that are sold to new customers. The spot, largely unknown to most New Yorkers, appears to have been recommended to Bahrani by both his cinematographer Michael Simmonds (Tehrani) and actor Ahmad Razvi ("Ahmad Razvi"). This area of the city has a long history of destitution and F. Scott Fitzgerald used it as the model for his description of the "Valley of Ashes" in his 1925 book *The Great Gatsby*, as a symbol of the degeneration of the entire nation, hidden beneath the myth of the "Roaring Twenties":

> This is a valley of ashes -- a fantastic farm where ashes grow like wheat into ridges and hills and grotesque gardens; where ashes take the forms of houses and chimneys and rising smoke and, finally, with a transcendent effort, of men who move dimly and already crumbling through the powdery air. Occasionally a line

of gray cars crawls along an invisible track, gives out a ghastly creak, and comes to rest, and immediately the ash-gray men swarm up with leaden spades and stir up an impenetrable cloud, which screens their obscure operations from your sight. (26)

Although Fitzgerald was not describing the same precise operations as exist in the area now known as Willets Point, this did not stop the New York City mayor referring to Willets Point as the "valley of ashes" in 2012 in order to promote a vast redevelopment project. This redevelopment, which had been in the pipeline since before the making of *Chop Shop*, is an attempt at gentrification of the area and assumed a serious turn when a $3 billion redevelopment project for constructing retail and residential buildings in this area was approved on October 9, 2013 ("City Council"). This proposition had come after decades of failed proposals for urban renewal. During the time *Chop Shop* was filmed the impoverished area of Williets Point had no sidewalks or sewers and was flooded whenever there was heavy rain, as is depicted in the film.

Bahrani again dedicated a substantial amount of time to first-hand research of the area, which led to his discovery that even some children lived and worked there, a circumstance that was turned into the film's centerpiece and whose veracity was questioned by A. O. Scott (Scott, "Chop Shop"). Bahrani, however, has defended the truth of his film's account:

> I am flattered that they think I can make this

up. I would ask anyone who doubts that this film depicts a reality to follow the directions below to Willet's Point Queens, and when they arrive to ask for Rob at Jamaica auto body glass. (Tehrani)

At this point in the quoted interview, Bahrani proceeds to give detailed instructions of the directions a person can take to get to Rob's store. Although the film makes little reference to the past of its child protagonists Ale (Alejandro Polanco) and Isamar (Isamar Gonzales), their dark initial circumstances are explained in a very brief telephone conversation that Ale makes on a pay-phone at the start of the film. In this scene a social worker confirms to Ale that Isamar is now living in a "safe-house", a location for those escaping abuse, the place she will leave in order to join her brother in Willets Point.

In *Chop Shop*, Bahrani also cemented his early commitment to using non-professional actors, here an overtly conscious, politically-motivated choice. It could be argued that in *Man Push Cart*, Bahrani's use of the non-professional actor Ahmad Razvi was in part the result of the film's low budget, which means that this "realist" technique followed the path of some independent American filmmakers. Bahrani had met Razvi relatively early in the process of his research, and while he had talked with many people within the Midwood ethnic community and did not offer Razvi the role right away, Bahrani has not suggested that he considered other people for the role. In contrast, Bahrani in *Chop Shop* is committed to the principle of using non-professional

actors (he interviewed around 2000 children and filmed nearly 450 of them before picking Alejandro and Isamar to play the twelve-year-old boy and his sixteen-year-old sister). Also, in contrast to *Man Push Cart*, in which Bahrani used a number of professional actors, no one in the cast of *Chop Shop*, other than Ahmad Razvi, had acted in a film before. In addition, apart from Razvi, no actor returns from *Man Push Cart* to play a different character in *Chop Shop*. The casting process was by no means an easy one: Bahrani rehearsed for over six months with the children, using handicams to ensure that they would disregard the presence of cameras when the actual shooting would begin. Bahrani has suggested that his use of non-professional actors can be considered as a political choice:

> We must accept that I am making films about how the majority of people in this world live, and we must also accept that this majority is utterly ignored by Hollywood and independent film (or belittled and exploited by using famous rich actors to play the roles of the economically poor in order for said actors to try and win awards). Thus, you may say that the connection between the two films is there, but as relevant as saying I am making films about people and the human condition in the "modern" globalized world. (Tehrani)

Bahrani has made it clear that although he hired the young actors from another part of the city and not Willets Point, before he began the shooting, he made sure that

Alejandro became fully integrated within the area by working for months after school at the real auto parts store that we see in the film. Ale was earning $5 for each car he waved into the lot; and when he does this in the film, he is actually both earning that money and acting in the film.

Although *Chop Shop* can be considered as more committed to traditional versions of realism and neorealism, it also includes elements that extend beyond these cinematic schools. Bahrani has emphasized this tension in an interview by suggesting that he primarily wanted the cinematic viewers to feel that they were simply seeing "reality," but in order to do this, he had to exert a great deal of his own control, particularly over the profilmic reality through a manipulation of mise-en-scene:

> Nearly every scene happens in one shot, with complicated mise-en-scene. What you are seeing is usually take 30, even if it feels like take 1 or a documentary. It has all been planned out. Simmonds and I wanted to erase the camera and I wanted to erase myself. To be invisible and to film things as simply as possible-- or at least make you think it was simple and effortless. To direct everything without appearing to have directed anything. That was the goal. (Tehrani)

Yet while Bahrani certainly manipulates mise-en-scene throughout the film, a key way in which the film goes beyond a traditional "realist" outlook appears rather in

the selection of an element of the mise-en-scene whose reality appears more or less as it was originally found by the filmmaker. This element is the room in which Ale and Isamar live and sleep while at the chop-shop: Bahrani has said that he did not add anything to the location in which the film was shot and only slightly modified it to enable the camera to film it. However, Bahrani has also noted that when he saw the room first, he wanted to include it in his film, even if it meant letting the chop-shop's owner, Rob Sowulski, act in the film. Nonetheless, despite this "realist" element, the room also has a "magical" quality which, as in the push-cart in *Man Push Cart*, serves as a crystal-image that allows for the emergence of the simultaneous possibility of other "virtual" possibilities, as well as immediate "reality." This magical quality, embodied by the room's raised location in the shop which has to be accessed by a ladder, has been recognized by Jim Emerson who describes it in terms that evoke a tree-house: a "knocked together plywood room" (Emerson). Here the tree-house-like room at once displays the "reality" of the characters' social situation and the "virtual" other possibilities that they could create for themselves within it. On the one hand, since the structure could collapse at any time, the raised nature of the room points to the precariousness of Ale's and Isamar's life. On the other hand, since the room evokes the pleasures of a traditional middle class childhood, it also allows for the possibility that Ale and Isamar could get their childhood back in this "magical" location. It also serves to present the possibility that they, as a pair, might have a private location together, free from the troubles of the outside world.

Goodbye Solo

Goodbye Solo marked a new direction for Bahrani. Firstly, after two films which were set around the urban areas of New York, *Goodbye Solo* was Bahrani's first feature-length film which was set in a suburban area, his home-town of Winston-Salem. And secondly, it was his first film that used professional actors in its central roles. However, Bahrani was still concerned with maintaining a "realist" flavour within this film by paying as much attention to the detail of Winston-Salem and basing his characters on real people whom he had met there. The film was first conceived in 2005 soon after the premiere of *Man Push Cart* when producer Jason Orans, with Gigantic Pictures, advised Bahrani that ITVS was seeking ideas for films based on "ethnic characters" (*"Goodbye Solo"*). At this time Bahrani was still intent on using the non-professional actors who would play versions of themselves and initially thought of using a Senegalese Winston-Salem-based taxi driver named "O" whom he had met around 2002-2003 ("O" is a pseudonym Bahrani has given to this man, since the latter wished to remain anonymous). Bahrani first saw O at a kick-up soccer game with his own brother and a number of other Senegalese taxi drivers, a scene he eventually included in the film. On that occasion, Bahrani had thought of O as a good subject for a film. Soon after, he met O again in a local gas station, where O was working a second job, an unromantic truth about many low-paid workers, which Bahrani had already explored in *Man Push Cart* and *Chop Shop*, but did not include in *Goodbye Solo*. A further detail that Bahrani did include

in the film was the fact that O did not own the taxi he drove and, therefore, had to walk around the town to get to work or ask for rides from other taxi drivers to get to places further away. Even before the production of *Chop Shop* had been started, Bahrani spent the winter of 2006 following O for the purpose of research, but as it turned out, it turned out after one year of research O did not want to be in the film. This forced Bahrani to reassess his film idea, which led him to develop a second character, also based on a real person he had met in Winston-Salem. During Bahrani's return trip to Winston-Salem, he noticed that within this suburban area, elderly people would sit outside of their nursing homes in the street in the hope of seeing passers-by. Bahrani began regularly honking his horn at one particular man who waved back cheerfully whenever he saw him. According to Bahrani, although this gave him enjoyment, it also made him feel sad that elderly people were abandoned in nursing homes in the US, something he thought would neither happen in his parents' homeland of Iran nor in Senegal. Thus, Bahrani found his second character, whom he decided would be a surly, white Southern man, a significant contrast to the gregarious Senegalese Solo and thirty years older than him. Bahrani sought actors who were not too well-known, partly to retain the sense of "reality." He then cast the relatively new actor Souleymane Sy Savane, actually from the Ivory Coast, to play Solo (which is also the actor's nickname). Bahrani also cast the Southern actor Red West, who had been Elvis Presley's bodyguard and a character-actor in many Westerns (but never the lead), to play William, the elderly white Southern man

who first meets Solo in his cab.

It seems likely that, as well as allowing Bahrani to look around for professional actors, O's refusal to be in Bahrani's film also prompted the latter to impose his own personal outlook, drawn from existentialist philosophy, more forcefully on the script. As has already been noted, Bahrani's *Man Push Cart* drew its central imagery from Albert Camus' *The Myth of Sisyphus*. However, it was only with *Goodbye Solo* that Bahrani engaged directly with the central topic of Camus' book, the question of whether in the face of life's often cruel absurdity, it is legitimate to kill oneself. In *Goodbye Solo*, the centrality of this theme is asserted in the film's first scene in which William reminds Solo, the taxi driver, of a previous conversation in which he had offered to pay Solo $200 to drive him one-way to Blowing Rock, a famous North Carolina cliff-top, at a specific future date. When Solo appears not to take him seriously he raises the offer to $1000.

Bahrani has drawn the film's central narrative element from Abbas Kiarostami's *Taste of Cherry* (1997) in which, as in *Goodbye Solo*, one man is recruited to assist the other in his suicide. Significantly, in *Taste of Cherry* the character who intends to kill himself (who is actually the driver rather than the passenger in that film) is wealthy and seeks help for his suicide from three much poorer people on separate occasions. In contrast, Bahrani focuses on the interaction between two equally marginalized individuals. Thus, although each film engages with the reasons why people are unwilling to accept suicide as a legitimate option, in Kiarostami's film this idea is expressed in clear

terms only when the third passenger interacts with the protagonist who has decided to end his life. Bahrani's film presents the possibility of such an acceptance more overtly as its central theme.

This is expressed in the film's penultimate scene, which offers a crystal image by encouraging the cinematic viewers to use their conscious thought processes in one instance of time in order to consider seriously the possibility of whether they might kill themselves or not. Before this penultimate scene, Solo has driven William and Solo's stepdaughter Alex (Diana Franco Galindo) up to Blowing Rock and has walked halfway up with William before leaving him to go off in a different direction, while Solo and Alex have gone up to a separate point. In this penultimate scene, Alex and Solo go back up to the cliff where William has already climbed, but find no one there. After Alex and Solo test the myth that if you throw a stick down from Blowing Rock, it will fly back up in the air, Solo steps up to the furthest edge of the cliff and experiences a moment that we presume is identical to that of his friend William. Following Camus, it can be argued that the true danger in the process of killing oneself is not in the leap, but rather in the position one puts oneself immediately preceding the possibility of the leap. As Camus puts it "the leap does not represent an extreme danger...The danger, on the contrary, lies in the subtle instant that precedes the leap. Being able to remain on that dizzying crest—that is integrity and the rest is subterfuge." Thus, as Solo stands on the cliff's edge, Bahrani gives us a crystal-image: Solo and William

mirror one another as people on the edge who might kill themselves. Where suicide for most people seems to be either one "real" thing or another—something they will do or something they will not—this scene imposes the order of the "virtual" by presenting a moment where a suicide both does and does not happen. In the process, the scene forces the cinematic viewer to consider seriously the question of whether they would themselves do this. This is conveyed as Solo throws the stick over the edge of the cliff and we do not find out if the stick does indeed fly up, as the myth suggests, or if it falls. This image symbolically represents the need to be conscious of the simultaneous possibility of life and death within the moment of danger in the act of suicide. This existential emphasis on the need to be fully conscious is presented through Solo himself, who in this moment offers a surrogate figure for the cinematic viewer's experience of this process. A single long take that envelops Solo, as he throws the stick down the Blowing Rock, emphasizes that Solo's action is motivated by his conscious thought processes as the camera moves from behind his head down to his hand before he throws the stick.

Conclusion

The goal of this essay has been to pay attention to the range of influences and ideas in Ramin Bahrani's cinema and to consider some of the ways in which these interrelate. To accomplish this, I have analyzed Bahrani's films as they at once blend traditional "realism," "art cinema" neorealism and existentialism. Bahrani's cinema can be

considered in part to follow a traditional realist outlook whereby it would be possible for a film text to present reality simply as it is, a notion that is often reinforced by the medium's indexical nature, such as in discussion of the documentary genre. It is often implicit in discussion of such a traditional realism that it can serve to provide what is known as "social realism," a recognition of unfairness and injustice within society, particularly in terms of class inequalities. This can be seen to some degree in Bahrani's films in his depiction of impoverished locations and the use of non-professional actors, a tendency that is typical of the neorealist style. At the same time, Bahrani's cinema is aware of other aspects of neorealism that question the possibility that cinema could display "reality" and even question the existence of "reality" itself. In Italian neorealist cinema, as well as in much "art cinema" that has developed since, characters no longer have an impact on the world, meaning that the images and sounds that unfold in the films become devoid of an active meaning and open up time itself, forcing us to consider the multiple possible meanings that exist simultaneously in the image's role as at once "real" and "virtual." Such a notion appears in the largely passive and inactive characters in Bahrani's films and their inclusion of images that blur the border between "reality" and the "virtual" in such a manner that opens out of typically assumed "reality" towards other possibilities.

Furthermore, Bahrani's interest in existentialism is typically set partially against any traditional form of "realism," but at the same time it is not necessarily totally

at odds with a more traditional notion of "truth." In both *Man Push Cart* and *Goodbye Solo*, but particularly in the latter, existentialism functions in a manner that recognizes an inability to find a total, singular "reality" within an absurd universe. Nevertheless, the turn to existentialism still offers options that may allow the cinematic viewer to find his or her own relevant individual "truth" or meaning. It has not been the aim of this essay to present these multiple frameworks within Bahrani's cinema, either as entirely unified, logical and organized or as entirely contradictory, but rather to give an overview of Bahrani's career that draws attention, first of all, to its plurality.

There is plenty of room here for further analysis of the exact ways in which these different areas operate within Bahrani's cinema. Another critic analyzing the interaction between these areas in Bahrani's films may choose to take a more overt political stance in favour of one area or another regarding specific instances within the films, an approach which I, on the whole, have tried to avoid. It is further worth noting that all the areas discussed in this essay can operate equally within radical texts or more traditional ones. Given the fact that Bahrani's latest two films, *At Any Price* (2012) and *99 Homes* (2014) are Hollywood films, it will be interesting to see which areas become privileged, as well as what new ideas are put into the pot. A particularly positive element to note in these Hollywood films is that they have continued to emphasize the importance of social realism which has marked Bahrani's earlier cinema, with both films appearing as responses to the 2008 Financial Crisis. *At Any Price* sets its story around Iowa cornfields

and rejects romantic notions of farming to draw attention to the cut-throat nature of modern-day agriculture within the generic framework of the family melodrama. *99 Homes*, not currently released, is equally a genre film in the form of the thriller. This film promises to speak for the ninety-nine per cent of America's population who suffer economic inequality by focusing on a father's attempts to get back his home after his family is evicted. It will be interesting to see the development of Bahrani's career in the coming years and it is to be hoped that his films will continue to demonstrate the range of influences and ideas that have been apparent in his cinema so far.

Works Cited

Allen, Michael. "Going It Alone: Independent American Cinema." *Contemporary US Cinema*. Essex: Pearson, 2003.

"Ahmad Razvi." Personal Interview. 04 June 2015.

Atkinson, Michael. "Night Watch." *Village Voice* 29 Aug. 2006. Web. 12 Dec. 2014.

Bahrani, Ramin. "Director's Statement on *Man Push Cart*." *Pressbook*. Noruz Films. Web. 15 Dec. 2014.

Bahrani, Ramin. "Ramin Bahrani's Top 10." Criterion. Web. 12. Dec. 2014.

Bazin, Andre. "The Evolution of the Language of Cinema." *What is Cinema?* Vol I. Ed. Hugh Gray. London: University of California Press, 1967.

Camus, Albert. *The Myth of Sisyphus*. Middlesex: Penguin Books, 1971.

Chaudhuri, Shohini, and Howard Finn. "The Open Image: Poetic Realism and the New Iranian Cinema." *Screen*, 44, 2013: 38-57.

"City Council Approves Sweeping Redevelopment Plan for Willet Point." *CBS* 9 Oct. 2013. New York. Web 14 Dec. 2014.

Deleuze, Gilles. *Cinema 2: The Time-Image*. London: The Athlone Press, 2000.

Ebert, Roger. "*The New Great American Director.*" www. RogerEbert.com 22 March 2009. Web. 15 Dec. 2014.

Emerson, Jim. "Chop Shop." RogerEbert.com 20 March 2008. Web. 15 Dec. 2014.

Fitzgerald, F. Scott. *The Great Gatsby*. London: Penguin Books, 2000.

"*Goodbye Solo.*" BoxOfficeMojo.com. IMDb.com. Web. 17 Dec. 2014.

"*Goodbye Solo.*" Interview with Ramin Bahrani. 2008 [DVD].

Horton, Justin. "Mental Landscapes: Bazin, Deleuze and Neorealism (Then and Now). *Cinema Journal*, V. 52, no. 2, 2013: 23-45.

Iannone, Pasquale. "The Roots of Neorealism." *Sight and Sound* 13 June. 2014. Web. 18 Dec. 2014.

"*Man Push Cart.*" *Pressbook*. Noruz Films. Web. 15 Dec. 2014.

"Ramin Bahrani's Cinema." Email Conversation with Ramin Bahrani. 04 June 2014.

"Ramin Bahrani Talks about *Chop Shop.*" Interviewed by Bizhan Tehrani. 04 June 2014. *Cinema without Borders*. Web 14 Dec. 2014.

Rothkopf, Joshua. "Vend for Yourself." *Time Out* 7 Sept. 2006. Web. 14 Dec. 2014.

Scott, A. O. "*Chop Shop.*" *New York Times* 27 February 2008. Web. 18 Dec. 2014.

Scott, A. O. "Neo-Neo Realism." *New York Times* 17 March. 2009. Web. 15 Dec. 2014.

"*Strangers.*" Noruz Films 2000. Web. 12 Dec. 2014.

"The Films of Ramin Bahrani, or Life at Street-Level." Harvard Film Archive 2009. 10 June. 2015.

Bordwell, David, and Kristin Thompson. "Unveiling Ebertfest 2014." University of Wisconsin-Madison. Web. 15 Dec. 2014.

Guilty of Aural Pleasure: Gregg Araki, Connoisseurship, and Auteur Melomania

Adam Bagatavicius

> "My only regret in life is that I never saw Slowdive live." – Gregg Araki

This epigraph reveals how crucial and sacralized music is to independent filmmaker Gregg Araki. Slowdive is the name of a British group that disbanded in 1995 and is emblematic of shoegaze: one of the atmospheric musical subgenres and shrines at which Araki whole-heartedly worships. His avid musical connoisseurship and the way it becomes a manifest component of his cinema is the most effective and troublesome aspect of his films; it is the well-informed ground upon which he both succeeds and fails. Although Araki abides by a decidedly alternative musical sensibility that signals a shift from rock homosociality to his distinct brand of post-rock homosexuality—queering certain gender stereotypes that populated 1980's teen films in the process—he remains bound up in what Will Straw would identify, by way of his groundbreaking article "Sizing Up Record Collections," as "male practices of accumulation [that] take shape in an ongoing relationship

between the personal space of the collection and public, discursive systems of ordering or value" (Straw 6). The "circular process" of record collecting articulated by Straw earlier in that article (5) still amounts to an insular circuit of self-indulgent information-mongering at worst, and a widening gyroscope of subcultural engagement or niche-oriented taste-making at best.

Araki is a liminal connoisseur who straddles an uneasy line between countercultural edginess and MTV commercial viability—between uncompromising vision and marketability. In order to better probe the prickly nature of this connoisseurship as it is reflected in his work, Claudia Gorbman's concept of the *mélomane* (a music-obsessed director) will be reframed as a lightning rod that both perpetuates and challenges Straw's subcultural discourses on record collecting. After illustrating this discursive intersection and providing background information on Araki, it will be my goal in the remainder of this paper to: 1) survey and map out *melomania* across his body of work as a kind of authorial performance; 2) demonstrate how soundtrack authorship connects with and fleshes out the post-apocalyptic spaces of his films, with particular attention to how connoisseurship channels agency, collaboration, and hipness; and 3) investigate the subcultural capital generated at this intersection between connoisseurship and the "soundtrack auteur"[1] by asking whether Araki's obsessive creative approach is rife with insight and meaning, or nothing more than histrionic

1 A term coined by Michael Brendan Baker that will be defined and integrated in greater detail shortly.

self-indulgence and gratification.

Background

Araki emerged in the late 1980's/early 1990's as a pioneer of New Queer Cinema.[1] Referred to short-handedly as "Homo Pomo," this subversive wave of cinema often gave voice to marginalized members of the LGBTQ community, foregrounded the fluidity of alternative sexual identities, tackled the AIDS crisis, and defied formal cinematic conventions, often being full of pleasure through defiance, as well as being alternately minimalistic and excessive (Hart 6). More relevant to the scope of this paper is how ardently Araki marinates his films in the spirit of post-punk and displays a close symbiotic kinship with the attitude present in that music—one that picked up the mantle of punk's uncompromising behaviour where it left off by "embracing non-normativity and queerness in its numerous forms (including sexual orientation), rather than perpetuating homophobia" (4).

Araki's overt love for the darker side of musical subgenres[2] that originated in the 1980's and 1990's feeds directly into the mise-en-scène, scripting, and ethos of his films. Most interestingly, the subgenre he reveres most

1 A movement first coined in 1992 by B. Ruby Rich in Sight and Sound, and with which other independent directors like Todd Haynes, Gus van Sant and John Greyson were also affiliated.
2 A non-exhaustive list of subgenres includes: shoegaze (My Bloody Valentine), industrial (Nine Inch Nails), alternative rock (Radiohead), gothic rock (Cocteau Twins), post-rock (Explosions in the Sky), post-punk (This Mortal Coil), new wave (New Order), big beat (The Chemical Brothers), and trip-hop (Portishead).

of all (shoegaze) was short-lived and reached a zenith of popularity in the United States only after it had already dissolved in the United Kingdom (its land of origin). In an interview with Phelim O'Neill, Araki remarks first-hand that "[b]y the time we got a lot of the [shoegaze] records here, the bands were already finished, gone" ("The Guide: Sunshine Shoegazer" para. 6). Its brief emergent history as a subgenre and belated distribution in the U.S. in the mid-90's generated nostalgia for a wave of music that was already dead by the time it hit North American shores. This historically tempered nostalgia is an apt accompaniment to the sense of yearning evoked by the dreamy textures of the music itself. Once the subgenre became defunct, Araki picked up on this doubly imbricated nostalgia, deployed the music in his films, and in doing so, refashioned an alternative youth audience at the site of shoegaze's sonic graveyard by reinvigorating the music's legacy. Savvy creative strokes like this allow Araki to visually curate aural information about his favourite bands and records, using stylistic excess, countercultural Godardian hyperbole, postmodern homage, and a queer sensibility as a means to deliver the information.

While personal meaning, emotional adrenaline, and the queered tenets of post-punk are sonically inscribed into provocative offerings like *The Doom Generation* (1995) and *Mysterious Skin* (2004), even a thoughtfully assembled soundtrack cannot recuperate a critically lambasted film like *Splendor* (1999) from the cinematic wasteland. In order to expound what marks Araki's musical connoisseurship as both eminently productive and at times ineffectual,

Claudia Gorbman's notion of the *mélomane* will be teased out to better understand the methodology and expressivity that underlies a music-obsessed director.

Melomania

The *mélomane* can be defined as a record-loving director who not only absorbs curatorial duties from the music supervisor, but to whom, according to Gorbman, music becomes "a platform for the idiosyncratic expression of taste, and thus it conveys not only meaning in terms of plot and theme, but meaning as authorial signature itself" (151). While she mentions Quentin Tarantino, Martin Scorsese, and Jean-Luc Godard as key examples of the *mélomane*, I contend that Araki is the paradigmatic representative of auteur melomania for Generation Xers (those born between 1965 and 1981) and Millennials (born between 1982 and 2000) who have a predilection for alternative music.

From the band and song-influenced titles of his films (1997's *Nowhere* is named after both a Ride album and a song by Curve; 1992's *The Living End* is the name of a Jesus and Mary Chain song) to the intermittent digressions that characters take to discuss records, songs, and their nostalgic placement in postmodern spaces, music is without a doubt the most consistently present and vital blood-red thread that runs through Araki's films. This lends a unified authenticity[1] to his work that

1 Authenticity here defined in terms of an auteur's idiosyncratic slant, the vast subcultural capital they have accumulated, and how this subcultural wealth is a signifier of their integral and sincere devotion

is—somewhat paradoxically—encoded in fragmented narratives, hyper-stylized landscapes, and engrained in the "pathologically violent and shockingly indifferent" (Benjamin 34) characters that wander in them. Music is also the prime source of security and subcultural identity for these characters, recalling and revitalizing what Stuart Hall and Paddy Whannel say about songs as "express[ing] the drive for security in an uncertain and changeable emotional world" (31-2).

As evidenced in films like *Pretty in Pink* (1986), *Empire Records* (1995), and *High Fidelity* (2000), record shops manifest this "drive for security" as hubs that thrive off of (largely gendered) subcultural interaction and operate doubly as sites whereby filmmakers can use characters as mouthpieces to present, if not heatedly discuss, their favourite guilty aural pleasures. This is just one way a *mélomane* can forcefully insert their authorial presence into the diegesis. Araki's *Totally F***ed Up* (1993) showcases Sacramento's now-defunct Tower Records within the mise-en-scène of his pseudo-L.A. wasteland. In *The Doom Generation*, while Jordan White (James Duval) wears a t-shirt branded with the logo of the industrial band Ministry, Amy Blue (Rose McGowan) stares longingly into a This Mortal Coil box set cover in a record store, saying "I just wish I could crawl in here and disappear forever." The taste-seeking and taste-making nature of connoisseurship creates a condition in which value must be pre-inscribed by a subculture in order for a cue to resonate with the spectator beyond its immediate aesthetic impact;

to the "cause" of specific musical trends or genres.

some emotional imprint must precede the meaningful recognition of these songs. If the subcultural resonance of both filmic moments outlined above is predicated on the niche audience's pre-existent knowledge of these cues, what resonance—textual *or* extratextual—is left for those situated outside this hermetically sealed sphere of connoisseurship?

Although these cues can amplify a scene's effectiveness for those in the subcultural loop by instilling feelings of intimate familiarity and nostalgia, the commercial and critical success of Araki's films is not necessarily engendered *by* his auteur melomania. The insider nature of connoisseurship that emerges through the *mélomane*'s excessive tendencies can find itself at odds with the practical application of music within a film's narrative economy. By exploring how this "glorification of excess" (Gorbman 152) appears in Araki's work, we will be able to consider the contentious cultural, ontological and textual value of *mélomane* methodology from a wider angle, and settle on a more productive "transformed understanding" (152) of how music operates in these audacious films.

Soundtrack Authorship as Performance

To broaden the scope of auteur melomania in relation to connoisseurship before proceeding headlong into a whirlwind analysis of Araki's oeuvre, it will be useful at this point to introduce Michael Brendan Baker's re-articulation of the *mélomane* as "soundtrack auteur":

> A filmmaker whose investment in the power
> of pop music and moving images compels

them to establish a style wherein pop music's role within film is of paramount importance, and comes to stand in for the filmmaker's presence within the world of the film.

(Baker, October 28, 2013, University of British Columbia). Films thus become a vehicle for the soundtrack auteur's taste and establish the terms upon which audiences accept or reject his/her vision. While Gorbman's *mélomane* "comes close to redefining the auteur construct, re-emergent and commodified, as a form of music-making rather than an art of filmmaking" (Ashby 17), what is freshly unearthed in the soundtrack auteur is an emphasis on an audience of discerning listeners; the auteur's extratextual awareness meshes with the self-awareness of their film texts to open up authorship in a way genre cannot, giving agency to both *subject* and *object*.

Repositioning the *mélomane* as soundtrack auteur humanizes the individualist aspect of Gorbman's model and opens up the authorial strategy as something more actively collaborative, reifying Gorbman's notion that "the sky's the limit with respect to the possible relations between music and image and story" (151) and giving the *mélomane* the added Midas touch of agency along with shared, as opposed to hoarded, knowledge. There is a heightened awareness on our part of the creator's role in forging an experience since our investment in specific flavours of music mingles with theirs, and a complicit two-way communion emerges that links our near-cultic appreciation of music to their connoisseurship. The soundtrack auteur and *mélomane* catalyze subcultural discourses surrounding connoisseurship, but they do so

in a more inclusive way than "the rituals of homosocial interaction" that Straw (5) usually attributes to record collectors and the patriarchal hierarchy of distribution that encompasses them. Araki challenges this strictly "homosocial interaction" with films that are a clarion call to underrepresented members of the LGBTQ community—guys, girls, straight, gay, and every gender identity or sexual orientation in between are allowed into the record distribution circuit of his hyper-violent breakfast club.

Moreover, both the "music-making" implication of the *mélomane* and how any music that a soundtrack auteur incorporates "comes to stand in for the filmmaker's presence" suggest that this authorship is a kind of performance. When the "practices of accumulation" (Straw 6) in record collecting reach a virtuosic degree of connoisseurship, and this collected knowledge is displayed in the form of (often excessive) audiovisual cues, the effect is akin to a peacock unfurling its iridescent tail. That is to say: soundtrack authorship is not only an expression of love for specific media or a demonstration of one's subcultural credentials via connoisseurship; it can also be considered a coded performance which plays out on screen through a series of enunciations and sonic cues. Interpreting the soundtrack auteur as a performative figure allows a new theoretical lens to emerge through which one can read a film's narrative and mise-en-scène as gestures, giving active spectators an opportunity to decode texts they might have previously considered to be unremarkable or poorly assembled. Lastly, the efficaciousness of this

authorial performance can be unpacked in aesthetic *and* sociological terms, readily reconnecting it back to music culture as a whole.

The analysis that follows will adopt this theoretical lens in order to re-read, reevaluate, and explicate select insertions of authorial presence as instances of active sonic performance within Araki's films. By investigating his body of work, I will probe whether his sonic authorship is a meaningful investment that the audience can buy into on a textual and extratextual level. Does the intrinsic connoisseurship of the *mélomane* contribute to the success of Araki's film? Or does it make no difference at all, functioning instead as a highly customized wallpaper?

Analysis

In one of the many over-the-top sequences of *Nowhere*, Dark (James Duval) says to a character named Handjob (Alan Boyce): "It's been a gnarly day...In the last 18 hours, I've seen four people get abducted by a space alien, watched Ducky try to drown himself, plus I spent like 387 bucks on CDs at Aaron's." Handjob retorts: "Hey, what CDs you score?" and is then brutally murdered when an enraged Elvis (Thyme Lewis) laughs maniacally while pummeling Handjob's head with a can of Campbell's tomato soup as the song "Memorabilia" by Nine Inch Nails hovers over the scene.

The embedded subcultural tropes, emphasis on record collecting ("387 bucks on CDs"), and notion of excessive mass proliferation (the Warholian aesthetic of the Campbell's soup can, which leads to the darkly funny sight

gag of tomato soup blurring with blood) are so heavy-handed and superficial throughout this scene that they practically become self-evident and require no further explanation. While the grab bag of elements at play here might initially read as postmodern pastiche, when re-read as a performance of authorship, these authorial flourishes form a cohesive unity—a patchwork comforter of musical references laced with the acerbic impact of barbed wire. Such filmic moments can set the viewer on a path towards discovering what these authorial flourishes represent (if they are not already familiar with the cues) and cultivate a greater understanding of what makes Araki tick as a director whose main object of ritual observance is music.

Other salient music tropes in Araki's films include: a newly bought boom box that is used to bludgeon a gay-bashing punk in *The Living End* (1992); a bootlegged Nine Inch Nails concert tape is used to bribe a character into cheating on their significant other in *Totally F***ed Up*; Jordan in *The Doom Generation* somberly mentions how much a certain song reminds him of a friend named Scooter who committed suicide, and adds that "[r]ight in the middle of the song "Unloveable" [by The Smiths] he just started crying like crazy. He was REALLY into The Smiths."; a girl asks a guy in *Nowhere* if he's heard of the Rapture, and he asks if that's a Siouxsie and the Banshees song; the doomed MTV-funded pilot episode for *This is How the World Ends* (2000) opens with a dream sequence where a female love interest sings The Cure's "Love Song" and ends with Michael J. Anderson of *Twin Peaks* (David Lynch 1990-1991) holding up clerks at a record shop with

a gun after singing Sugar Ray's "Fly"; the lead character of *Kaboom* (2011)—named Smith (Thomas Dekker) after The Smiths—receives a signed copy of an Explosions in the Sky CD for his birthday around the same time that a song of theirs plays on the soundtrack and a secret college crush acquires said protagonist's contact info through their fan site; a sticker for the German industrial band KMFDM[1] is strategically placed on the back of a pickup truck in *White Bird in a Blizzard* (2014).

The painstakingly crafted intertextual references to alternative popular music are littered more wantonly in Araki's films than the violence, queer sensibilities and space aliens combined; they are lights shining beyond the sledgehammer-to-the-face approach of his kinetic visual style. These textual details are often positioned alongside a bevy of celebrity cameos drawn directly from alternative music culture,[2] further steeping each film's ambience in sonic references. Although a song might begin to play on a radio in a public space or be overtly non-diegetic and "amped" during chase scenes, sonic borders are blurred in Araki's films—one gets the sense that they are emanating directly from the auteur, illustrating the way "music participates forcefully in what used to be called, in the simpler days of auteurism, the director's worldview" (Gorbman 150). Each music cue is akin to Araki thinking and emotionalizing out loud in these scenes and

1 An abbreviation for Kein Mehrheit Für Die Mitleid, which loosely translates as "no pity for the majority."
2 For example, Perry Farrell (lead singer of Jane's Addiction) and Skinny Puppy both appear in *The Doom Generation*.

is a result of how his creativity recalibrates the viewer's musical appreciation once they clue in, and impacts their perception of the scene and movie as a whole.

As noted by Chris Garcia in a skeptical account of the contemporary movie soundtrack, any director can "graft" songs onto the completed product, but that often amounts to them becoming "unblushing marketing tools" as opposed to "organic outgrowths of what the film is trying to say" ("Mythology"). If there is one thing that can be deduced from Araki's connoisseurship and melomania, it is that no song is tacked on to a final cut in a careless way. If common functions of film music include inducing affective responses in the audience (i.e., shrill strings to heighten suspense), advancing moments of narrative drama or action (i.e., matching the tone of music to the pace and style of the cinematography), associating a recurrent musical phrase with one character, place, or idea (the leitmotif), and providing background score simply as arbitrary wallpaper to accompany visuals, Araki breaks the typical aesthetic and narrative impetus of these moulds by carefully selecting and repurposing songs to function synergistically.

To concretize this point, let us briefly consider the closing shot of *The Doom Generation*, which immediately follows the film's traumatic climax. When the song "Blue Skied an' Clear" by Slowdive plays as Amy Blue drives off into the horizon with a smiley face painted onto the hood of her car, the drifting ambiguity of the song complements the uncertain (and uncharacteristically silent) nature of the final scene; its title and soothing

textures, working together with the happy face on the hood of Amy's car, become ironically funny given how grisly the preceding castration scene was, and it provides a lush segue into the closing credits. While this single song fulfills multiple stylistic and narrative functions, it is also Araki's way of "having the last word" extratextually. Araki wields "Blue Skied an' Clear" as the final gesture of his authorial performance in *The Doom Generation* and uses it to broadcast reverence for one of his favourite bands, generate an implicit dialogue with those in the same circuit of subcultural appreciation and connoisseurship, and potentially introduce the uninitiated to shoegaze by letting the song play through until the very end when a spectator can immediately associate the song with its respective credit.

This is just one example of how deftly Araki curates his soundtracks and how a single cue can elicit a synergy of applications and meanings. If music can be framed as an opiate for the masses within his films, Araki is more intoxicated by it than any one of his characters. Music provides the literal building blocks for his cinematic space and he pulls it from the shadowy background directly into the spotlight. Emotionally speaking, the music *is* what Araki is trying to say, and he takes great measures not only to foster his own agency throughout his films, but also to provide agency and visibility to all the musicians that are heard or seen.

Agency

In the interview with O'Neill, Araki reminisces:

Looking back, as a fan, it's unbelievable that I've been able to have a relationship with so many of the bands I love. Often I've had to beg, make a little artist-to-artist plea, writing letters telling them how much their music means to me and how it will be used. I remember we had to have a little private screening of *Totally Fucked Up* for Trent Reznor so he could give us the OK on some of his music. ("The Guide: Sunshine Shoegazer" para. 11)

Various accounts like this, which Araki provides about being on the phone for hours trying to secure rights to use a specific song, having private screenings for his idols, and countless raves about how indispensable music is to the mood, spirit, and atmosphere of his films, demonstrate that it is undeniably the aspect of filmmaking that he takes most sincerely, seriously, and self-consciously.

To strike a few parallels with the late John Hughes, 1980's teen movie mogul and soundtrack marketing titan, Araki also takes "teens seriously as emotional beings [and] consumers" (Ostroff para. 9) and makes "soundtracks [that are] nearly as iconic as the films themselves" (Gross para. 1), albeit "iconic" in a more niche-oriented countercultural way. Authorial agency for both filmmakers extends from them to the musicians and bands on the soundtrack and is also fused to the target youth audience and alternative subculture at large. If a statement like "Hughes' influence on the tone and mood of 80's pop culture ran almost as deep as the [music] giants of the era" (Wener para. 11) posits him as the American forefather in terms of importing a

love for British alternative rock bands (Psychedelic Furs, The Smiths, the Jesus and Mary Chain) and infusing that burgeoning subculture with capital, Araki arguably picks up where Hughes left off by providing queer 90's youth subculture with agency by way of British post-punk and shoegaze.

For shoegaze bands, such as Lush, Curve, and Slowdive—all coming from the United Kingdom where shoegaze effectively fizzled out by 1994—the die-hard record collecting of a filmmaker like Araki can introduce these defunct bands to the U.S. market post-mortem, and in doing so, resurrect them to some degree by generating subcultural capital even at the furthermost reaches of the long tail. Connoisseurship can lead to exposure of antiquated media and what might be deemed trivial fan boy nostalgia can become a mode of productive publicity that shines a light back on forgotten niches of the music industry. Araki even seems to adopt the tone of these British bands as a manifesto in his filmmaking, claiming that they,

> were more atmospheric and experimental—
> music that you respond to on a purely emotional level. I've always been a huge music collector and I've always liked bands that do their own thing. It's a spirit I share in my filmmaking. I like bands that follow their drummer. (O'Neill para. 4)

The soundtrack auteur not only gratifies his own sonic obsessions and caters to members of a subculture who are seasoned enough to pick up on these obscure music cues,

but, like Hughes, the filmic exposure of bands increases their visibility and can introduce this music to new audiences for the first time. In addition, the knowledge-hungry nature of melomania can influence the future shape of current music by virtue of re-inserting older music back into the cultural melting pot.

Collaboration

This productive element of melomania can be extended to include Araki's collaborative efforts as well—the commissioned scores, remixes, and live performances which are an integral part of his films. Although a film like *Splendor* was unanimously slammed by critics, and not saved from this cold reception by a carefully arranged soundtrack, all of the remixes that were commissioned for its score can still be seen as revitalizing niche genres by pouring money and attention back into waning pockets of the music industry. Despite not turning a profit in the case of *Splendor*, a compilation of remixes then becomes, as an authorial gesture, less of a marketing ruse and more of a personal love letter from the director to these musicians. Even within the parameters of a 'failed film', the web of collaboration between big names in alternative rock and electronic music is widened (Moby remixing Blur; the Chemical Brothers remixing Spiritualized; Lush remixing My Bloody Valentine). Such collaboration provides these artists with creative opportunity in addition to agency. On the same note, the fact that Araki has further "managed to keep shoegazing going" (O'Neill para. 14)—by enlisting Robin Guthrie of the Cocteau Twins (who had never

previously scored a film) and Harold Budd (a collaborator of Brian Eno) to score 2004's *Mysterious Skin* and 2014's *White Bird in a Blizzard*, along with Ulrich Schnauss to score *Kaboom*—reinforces the connoisseur's propensity for creative collaboration as something more explorative, hands-on, and unprecedented for both musician and director than a mere grab-bag of songs on a compilation.

However, even such seemingly productive authorial gestures are further complicated by their proximity to trending fads. The fact that the late 1990's/early 2000's were steeped in remix culture at the time of *Splendor*'s release, or that the "Nu Gaze [...] stuff that's like a resurrection of the early 90's shoegaze sound" (Frank "Interview: Gregg Araki") largely featured in *Kaboom* ten years later (exemplified by bands such as the XX and Arial) had already seen a surge in popularity prior to the film's release, smacks of bandwagon jumping or trending, and can be leveled as a criticism against Araki's sheer audaciousness and integrity as a soundtrack auteur. Even if these authorial decisions are still rooted more in personal taste than a conscious submission to commercial fads, aligning with one or more commercialized trend in the hip public eye (even if only by happenstance), that is still enough to distance Araki from the uncompromising Godardian polemics of his earlier work, as well as the post-punk "go-against-the-corporate-mentality" (Smith para. 21) that Araki has articulated as being central to his filmmaking practice all along. In this conflicted light, the march-to-your-own-drummer approach that Araki highlights as key to the spirit of his filmmaking is at odds

with a thinly veiled impetus to be in the band, and the contradiction therein is also a new way one can interpret and apply the late Roger Ebert's critical observation that a filmmaker like Araki wants to "have his cake and eat it too" ("Review: *The Doom Generation*" para. 3).

Hipness

Straw argues that the "stances of hip require that knowledge and judgment be incorporated into bodily self-presentation" (9). That Araki injects his characters with this hipness and posturing to an almost pathological degree is an aspect of his filmmaking that has either been criticized for its one-dimensional superficiality[1] or lauded for its unabashedly brazen attitude and taste-making ability.[2] Hipness implies a cultivated mastery of knowledge that presents assumed omniscience in a blasé way. This raises another troublesome issue that Straw motions towards with his value-charged taxonomies of male identity, but does not explicitly discuss: the *elitist* aspect of connoisseurship and hipness that lies beyond gendered margins.

1 One need not look further than Ebert's notoriously scathing review of *The Doom Generation*, which he awarded zero stars, hypothesizing that Araki "has maybe seen too many movies, and is eager to have us know that he is above his subject matter" and is "like the sideshow impresario whose taste is too good to enter his own tent" ("Review: *The Doom Generation*").
2 B. Ruby Rich, the spearheader of the terms New Queer Cinema and "Homo-Pomo," is also Araki's personal champion. Rich divulges that she's always thought that Araki's films, filled with hip music and TV-star actors, offer an index to American pop culture that, if lined up from 1987 to now, would synthesize the tastes of the coolest teenagers" (94).

Like "a true renegade worthy of the alternative label," Araki once "took his film [*The Doom Generation*] directly to his audience, showing it in a tent on the Lollapalooza music tour all summer" (Pinsker para. 13). On the one hand, this can be construed as yanking that unrated film away from the moralizing world of adult responsibility and giving agency back to the youth audience—those who feed most readily into that countercultural hubbub. On the other hand, Gregg Araki was 36 at the time of the film's release, which is not old by any stretch of the imagination, but certainly does not make him a shoe-in for spritely teenager. There is indeed a "fine line between cool and trendy" (Pinsker para. 4) that tightrope auteurs such as Araki (and Hughes before him) have to walk in order to accommodate their younger audience. Although Araki has stated in the past that he has "never made an overly commercial movie" (Sélavy para. 7), all the moments of overt commerciality and hip codes of (mis)conduct in his films clash with this affirmation; idolatry is at odds with his iconoclasm. Whether the independent distribution of *The Doom Generation* at Lollapalooza is interpreted as an act of faith in the spirit of post-punk alternative counterculture, or as manufacturing "coolness" and pandering to a younger generation, hipness weaves issues of elitism, posturing and connoisseurship together in a complex way, often using nostalgia to bridge those gaps between outsider and mainstream, and allowing hip record collecting to converge "with those anti-consumerist ethics which tie the collector's investment in the obscure to the bohemian's refusal of the blatantly commercial" (Straw 10).

Conclusion

The intractable aspect of subcultural capital throughout this case study shows that while niche-oriented musical appreciation can generate interest, it cannot actually *buy* anything—each cue, collaboration, and permission gained via love letter to those bands is a highly personal sonic gesture on behalf of the filmmaker and not a strategy for huge commercial success. Tim J. Anderson's likening of music supervisors to Bourdieuian "cultural intermediaries who can make connections between old and new players and institutions" (374) is mirrored by the *mélomane*'s own taste-making abilities, with the difference being that the auteur is not a set of hired ears and does not usually adhere to the same promotional impetus to "help break records" (376). Furthermore, O'Neill explains that "[t]here is a lack of commercial viability in the repackaging of songs that have already 'made it big'" and Araki adds in the same interview that there is "no incentive for record companies to repackage their music" (para. 16). Although one might challenge this postulation about a total lack of incentive (which might be more context-based than Araki or O'Neill suggest), it can be asserted that the value-charged way of reading teen films of yesteryear has been hollowed out, remodeled, mutilated, and spit back in our faces hyperbolically by Araki's queered take on stereotypes, while the profits associated with soundtracks in this case have also been emptied out and filled only with subcultural capital. Nonetheless, if nostalgia "tends to cycle in 25-year increments" (Ostroff para. 1), then Araki's filmography offers an entire generation worth

of nostalgically inspired and inspiring work, even if the piggybank is empty. Although there is no way to quantify just how much cultural influence his re-invested cinematic focus on obscure or bygone cycles of music has had, it is curious—and based on the earlier epigraph, a dream come true for Araki—that Slowdive recently reunited and toured with Low for the first time in 20 years.

In the end, musical cues are not only signifiers of authorial taste and presence for Araki, but outgrowths of a productive connoisseurship that grants the audience a way: 1) to read the text of his films through the autobiographical lens of an alternative connoisseur; and 2) for subcultures to engage extratextually with his films and forge connections or establish dialogue with hallmark musicians through direct collaboration. Through Araki's "performance" of musical connoisseurship, the "masculine ideal of the listening room as refuge" (Straw 5) becomes an externalized public safe haven for marginalized LGBTQ communities—a site where music seems to be the only way to distill meaningful subcultural sense from the rampant senseless violence and anomie. Although Araki often foregrounds disaffected characters, purposefully heavy-handed dialogue, and decaying urban sprawls, he tends to soundtracks with the same amount of care that one would devote to a Japanese garden in sunny California.

Works Cited

Anderson, Tim J. "Music Supervision Taken Seriously: the Rise of the Music Supervisor in Converging Televisual Environments." *The Journal of Popular Music Studies* 25.3 (September 2013): 371-388. Print.

Ashby, Arved. "Introduction." *Popular Music and the New Auteur.* New York: Oxford University Press, 2013. 1-30. Print.

Baker, Michael Brendan. "Compilation Scores & the Pop Soundtrack I." Popular Music in Film. University of British Columbia. Royal Bank Cinema, Vancouver. 28 Oct. 2013. Lecture.

Benjamin, Richard. "The Sense of an Ending: Youth Apocalypse Films." *Journal of Film and Video* 56.4 (Winter 2004): 34-48. Print.

Ebert, Roger. "Review: *The Doom Generation.*" *The Sun Times* n.p. 10 Nov. 1995. 6 Nov. 2013. Web.

Frank, Alex. "Interview: Gregg Araki." *The Fader* n.p. 25 Jan. 2011. 27 Nov. 2013. Web.

Garcia, Chris. "The Mythology and Marketing of the Modern Movie Soundtrack." *Austin American-Statesman* 2 Jul. 1998. Print.

Gorbman, Claudia. "Auteur Music." *Beyond the Soundtrack: Representing Music in Cinema.* Ed. Daniel Goldmark et al. Berkeley: University of California Press, 2007. 149-162. Print.

"Narrative Film Music." *Yale French Studies* 60 Cinema/Sound (1980): 183-203. Print.

Gross, Joe. "Hughes' Soundtrack Choices Introduced Bands to Middle America." *Austin American-Statesman* 9 Aug. 2009. Print.

"Well-Done Soundtrack Creates a State of Mind." *American-Statesman* 20 Aug. 2004. Print.

Hall, Stuart, and Paddy Whannel. "The Young Audience (1964)." *On Record: Rock, Pop, & the Written Word.* Eds. Simon Frith and Andrew Goodwin. New York: Routledge, 1990. 27-37. Print.

Hart, Kylo-Patrick R. *Images for a Generation Doomed*. Maryland: Lexington Books, 2010. Print.

O'Neill, Phelim. "The Guide: Sunshine Shoegazer." *The Guardian* 6 Aug. 2011. Print.

Ostroff, Joshua. "Teen Angst's 1980s Auteur." *The Globe and Mail* 24 Mar. 2010. Print.

Pinsker, Beth. "The Stars Are the Soundtrack!" *The Salt Lake Tribune* 17 Oct. 1995. Print.

Rich, B. Ruby. "Beyond Doom: Gregg Araki's *Mysterious Film*." *New Queer Cinema: the Director's Cut*. Ed. B. Ruby Rich. Durham: Duke University Press, 2013. Print.

Sélavy, Virginie. "*Kaboom*: Interview with Gregg Araki." *Electric Sheep Magazine* n.p. 6 Jun. 2011. 27 Nov. Web.

Smith, Damon. "Rebel, Rebel: Interview with Gregg Araki." *Bright Lights Film Journal* 59 (February 2008). 28 Nov. Web.

Straw, Will. "Sizing Up Record Collections: Gender and Connoisseurship in Rock Music Culture." *Sexing the Groove: Popular Music and Gender*. Ed. Sheila Whiteley. New York: Routledge, 1997. 3–15. Print.

Wener, Ben. "John Hughes' Influence Stretched beyond Film." *The Orange County Register* 9 Aug. 2009. Print.

Filmography

The Living End. Dir. Gregg Araki. Perf. Mike Dytri, Craig Gilmore, Mark Finch. Strand, 1992. DVD.

*Totally F***ed Up*. Dir. Gregg Araki. Perf. James Duvall, Roko Belic, Susan Behshid. Strand, 1993. DVD.

The Doom Generation. Dir. Gregg Araki. Perf. James Duval, Rose McGowan, Johnathon Schaech. Lionsgate Home Entertainment, 1995. DVD.

Nowhere. Dir. Gregg Araki. Perf. James Duval, Rachel True, Nathan Bexton. Fine Line Features, 1997. DVD

Splendor. Dir. Gregg Araki. Perf. Kathleen Robertson, Johnathon Schaech, Matt Keeslar. Columbia TriStar, 1999. DVD.

This Is How the World Ends. Dir. Gregg Araki. Perf. Alan Simpson, Michael J. Anderson, Lucas Babin, Molly Brenner. MTV, 2000. TV Movie.

Mysterious Skin. Dir. Gregg Araki. Perf. Joseph Gordon-Levitt, Brady Corbet, Michelle Trachtenberg. Strand, 2004. DVD.

Kaboom. Dir. Gregg Araki. Perf. Thomas Dekker, Juno Temple, Haley Bennett. Sundance Selects, 2010. DVD.

White Bird in a Blizzard. Dir. Gregg Araki. Perf. Shailene Woodley, Eva Green, Christopher Meloni, Shiloh Fernandez. Magnolia Pictures, 2014. DVD.

Her, Everyday Utopianism and the Poverty of Concrete Imagination about the Future

Amir Ganjavie

Introduction

As a recent article on the Raw Story suggests, contemporary filmmakers are becoming more interested in utopian genres than ever before. Summit Entertainment Films' *Divergent* and *Ender's Game,* as well as Sony Pictures' *The Mortal Instruments: City of Bones,* Twentieth Century Fox's *Maze Runner,* as well as TriStar Pictures' *Elysium,* all released in 2013 or 2014, can be described as utopian movies. In fact, the popularity of *The Hunger Games* series is one of the main reasons why movie studios have become interested in projects exploring utopian themes. Thus, if the past several years saw cinema as interested in wizards, werewolves and vampires popularized by *Harry Potter* and *Twilight,* this fantasy has now given way to a trend of utopian movies, especially those portraying dystopias with dark images. This situation is not limited to American cinema, with *Snowpiercer* (2013) and *Les Combattants* (2013) being just two examples of recent utopian movies made outside of Hollywood. Granted, the relationship between cinema and utopia had a long history prior to the current period, but this is the first

time that cinema has given such serious attention to a political genre like utopia. This raises several questions. What can this interest tell us about the socio-economic structure of our time? How do these movies confront the shortcomings of the capitalist society? What types of alternative societies do they represent? What cinematic language do they utilize in those representations?

These questions deserve a dedicated research project since, firstly, it has been suggested that utopians have historically had enormous impacts on the development of society, cities, and socio-political affairs.[1] Utopian thinking is a method that gave birth to a society with fewer problems[2]. Throughout the ages, as utopians saw the problems of their respective times grow, they tried to propose a functional and universal panacea called "utopia" as a better alternative for their fellow citizens. For example, De Moncan argues that several attributes of contemporary cities are the direct results of utopian thinking (17). The separation of pedestrians from automobiles (Cabet, Garnier and Hénard), the separation of urban functions and zoning (Garnier), and the generalization of prefabricated systems (Le Corbusier) are just a few of the contributions made by utopian thinkers. It has also been suggested that the first feminists to propose sexually equal societies were utopians. In this way, we can think of utopian projects as provocative subversive ways of thinking critically about

1 For more on this see Picon, 2013; Solinis, 2006; Choay, 1965; Eaton, 2002; Stauffer, 2002.
2 For more on this see Fishman, 1977; De Moncan, 1998; Pinder, 2002; Solinis, 2006.

societal shortcomings. (Pinder, 2002).

Secondly, hope is a central part of human life (Bloch, 2000) and hope for a better life has been a central aspect of utopian claims throughout history (Choay, 1965; Pinder, 2002; Mumford, 1921). Thus, utopian models and literature secure the need to dream, the need for mystery, and sometimes even the desire to create poetry (Choay, 1965) in order to make us aware of the future. These projects are a means of escaping a monotonous existence the continuation of which could result in ongoing disinterest and frustration with life.

For the reasons mentioned above, it can be argued that utopian thinking has many benefits for society, which explains why utopia is currently a popular research topic. Today, several research centers are working on this subject, including the Centre for Utopian Studies at the University of Ohio. A number of political institutions, such as the Urban Forum of the United Nations in Vancouver, and various conferences, such as the Future for Cities held in Nancy in 2005, are concerned with or have recently worked on the theme of utopia. Therefore, contrary to Francis Fukuyama's famous claim regarding the end of history, utopian project as a mode of thinking positively about the future is alive and well (Pinder, 2002). In fact, utopia is currently an important domain of reflection, especially for feminists such as Leon Sandercock and Marion Young whose outlooks are inspired by utopian thinking (Pinder, 2002).

The works of previous scholars help us understand the historical societal significance of utopian thinking while

giving us information regarding the role, function, and characteristics of utopia. Nevertheless, to my knowledge, no one within the field of film studies has recently conducted a comprehensive analysis of utopian values of films. However, as Paquot argues, cinema is an excellent medium to scrutinize in order to discover contemporary utopian aspirations (Paquot, 1996). For Paquot, images of future societies represented in science-fiction works propel us back centuries to catch a glimpse of utopia (Paquot 1996). In this regard, a three-dimensional digital image is even more effective in suggesting an imaginary society than an excellent description of a society on paper since movies can indirectly shape the people's sense of an environment.

As Zizek argues (2006), "cinema is the ultimate pervert art. It doesn't give you what you desire—it tells you how to desire." In this sense, not only do movies directly shape our desires about the world, they also give cinemagoers, in Stanley Cavell's words (1979), an opportunity to feel being part of the world portrayed in front of their eyes. As Cavell argues, because of interruptions that modernity has caused in the relationship between human beings and nature, we lack the ability to comprehend our position in the world on many levels and, as a result, feel quite alienated. It is only through cinema that we can once again feel capable of controlling the world and becoming part of it.

Given the recent elaboration of utopia in cinema, the importance of cinema and its transcendental role in shaping the audience's outlooks, and the disproportionate

lack of discussion about utopia in relation to movies, I aim to explore how utopian society is portrayed and represented in contemporary cinema. In order to achieve this, I will analyze *Her* (2013), Spike Jonze's last film, through Michel De Certeau's conceptualization of utopia in his writings. I have selected *Her* because, first of all, it is a science-fiction movie in which we encounter an as yet unrealized alternative society. Secondly, this movie has received a significant number of critical reviews in the daily press, which can offer a starting point for completing a much more serious research project. Thirdly, *Her* is among the most popular movies produced during the two years of 2013 and 2014 and its popularity may be helpful in understanding the reason for the growing interest in the genre utopian cinema. The choice of De Certeau's theory as my critical lens is justified because of the importance of everyday utopianism in his writings, a concept that assumes a major function in shaping the story of *Her*.

Addiction to Technology

Her tells the story of a lonely writer, Theodore (*Joaquin Phoenix*), who forms an emotional relationship with Samantha (Scarlett Johansson), an intelligent operating system in his computer that responds to all of his needs. The movie is divided into three sections, the first of which charts the daily life of Theodore as a very depressed and lonely individual. Recently separated from his wife, Theodor is a workaholic who spends most of his time working on his computer. His work consists of writing

romantic letters for the clients who seem incapable of communicating and expressing their feelings for one another, a condition that appears as symptomatic of a society that suffers from severe emotional paralysis. Even couples who have lived together for 50 years rely on an intermediary to express their feelings. Theodore, too, suffers from the same predicament, and it is only through his acquaintance with Samantha that he manages to express his feelings. This is not the first time that Spike Jonze has turned to this motif. In *Being John Malkovich* (1999), people also communicate with each other through an intermediary in the form of John Malkovich whose body they can inhabit. This recurring motif may suggest that emotional interaction for Jonze is impossible in a direct form; rather, it can occur only through a mediating channel.

The rhythm of Theodore's life alters as soon as his relationship with Samantha begins. He becomes more interested in what is happening around him and if he is out, he pays attention to his surroundings, starts conversations with people, and have his pictures taken by Samantha. Even the rhythm of his physical movements changes. The third section of the film depicts the aftermath of Theodore's separation from Samantha. We discover that he is no longer lonely since the magic of love has changed his life patterns; he returns to his friends, sending a love letter to his former wife with the hope of returning to days of happiness.

De Certeau's writings on everyday utopianism are the best lens through which to interpret *Her* from a utopian

perspective. This theoretical lens is quite useful since Theodore employs different strategies to counterbalance the hegemony of everyday life and its accompanying routines. In fact, the first section of *Her* centers on the story of the lonely Theodore and his routinized, ordinary life; the second section narrates Theodore's acquaintance with Samantha and how this relationship transforms his monotonous life, providing him with moments of resistance; and the final section takes place after Theodore's separation from Samantha and shows how the journey structure of the plot has helped Theodore cope with loneliness and tediousness of everyday life. In order to elaborate these arguments more fully, I will now introduce the concept of everyday utopianism as De Certeau defines it.

De Certeau and everyday utopianism

Everyday life can be defined as consisting of repetitive work and experiences in a banal world that is not influenced by big events or extraordinary adventures (Featherstone, 1992). Henry Lefebvre (2002) argues that this form of life is characterized by alienation and consumerism, which penetrate all aspects of life and repress humans' capabilities by subjecting them to ceaseless advertisement. Given the centrality of everyday life in contemporary era, different scholars have attempted to first clarify the significance of "lived life," its relevance to understanding society and history, and the way this knowledge can help us create better social and political conditions in life. These scholars have tried to clarify how genuine sociality could be found

outside the institutions and structures of state. In addition, they have explored how it is possible to connect everyday experiences with the issue of human happiness, which is also related to phenomena such as desire, pleasure, and sensuality, as well as the role that these emotions can play in any project with emancipatory dimensions.

This explains why the literature on utopia provides extensive examples of scholars who investigate the meaning of everyday life and its utopian dimensions. This tradition includes the writings of Charles Fourrier, the Surrealist writings of Andre Breton, the work of Henri Lefebvre, and the writings of the Situationist International (SI). Among these traditions, de Certeau's socio-historical writings have a major significance for film studies, especially because of their emphasis on culture and its importance as a form of resistance.

De Certeau maintains a utopian view, which emphasizes the importance of human agency and the possibility of questioning the dictates of instrumental thought through everyday actions. His work started with a critical investigation of Foucault's conceptualization of power. De Certeau acknowledged the importance of Foucault's account of power and modernity as he argued that the latter's works help us understand how power functions and is exercised on a day-to-day basis. At the same time, he argued that the Foucauldian conceptualization of power aims to "reduce the functioning of a whole society to a single, dominant type of procedure" (1986, 188). He shared the Foucauldian perspective that the objective of disciplinary apparatuses was the effective surveillance

and control of different practices, but argued that it also existed in less visible or "subterranean" practices. As de Certeau puts it, "behind the "monotheism" of the dominant panoptical procedures, we might suspect the existence and survival of a "polytheism" of concealed or disseminated practices, dominated but not obliterated by the historical triumph of one of their number"(1986,188). He argues that the traditional way of conceptualizing power, including in Foucault's writings, can tell us nothing about such unofficial mechanisms, which remain "unprivileged by history [yet] continue to flourish in the interstices of the institutional technologies" (1986, 189). While the procedures, methods and techniques for which Foucault argues are clear manifestations of power and occupy a clear physical space in the academy, the clinic or the prison, unofficial or unauthorized mechanisms of power function without recourse to such a stabilized locus and are defined as "clandestine forms taken by the dispersed, tactical, and makeshift creativity of groups or individuals already caught in the nets of "discipline"" (1984, xiv). Contrary to Foucault, who wants to establish a genealogy of disciplines, de Certeau hopes to single out "anti-disciplines," the silent, unclear and unacknowledged forms and methods of resistance that "break through the grid of the established order and accepted disciplines" (1986, 197).

Given this, de Certeau maintains that consumers are able to use resources available to them in creative and innovative ways despite their powers being very limited. As he suggests, it is true that the socio-political activities

of non-producers of culture are generally "unsigned, unreadable, and unsymbolized" since they are not governed by formalized logic and do not follow the gaze of official power. Nevertheless, these non-producers or consumers are able to appropriate, use and give meaning to cultural artefacts in a variety of unexpected and undefined ways. Consumers "produce" with the use of "errant" or non-formalized practices, which act according to an internal logic that is in some cases unintelligible to an outsider. Although it is true that these practices must utilize the vocabularies and resources devised and suggested by elites, the actual trajectories employed reflect the "ruses of other interests and desires that are neither determined nor captured by the systems in which they develop" (1984, xviii). For de Certeau, this process of creative appropriation transforms the initial symbolic and physical materials embodied in the commodity and changes them into something quite new. As he puts it in *The Practice of Everyday Life*:

> In reality, a rationalized, expansionist, centralized, spectacular and clamorous production is confronted by an entirely different kind of production, called "consumption" and characterized by its ruses, fragmentation (the result of the circumstances), its poaching, its clandestine nature, its tireless but quiet activity, in short by its quasi-invisibility, since it shows itself not in its own products (where would it place them?) but in an art of using those imposed on it. (31)

Thus, de Certeau's central assumption is that most everyday activities of consumption have a "tactical" character. Similar to the trickster of pre-modern mythology, consumers use cunning, clever tricks, manoeuvres, feints of weakness, simulations, and poetic, as well as warlike, elements (in Greek, *metis*). According to de Certeau, these "tactics" contrast sharply with "strategies," which seek to colonize a visible, specific space that will function as a "home base" for the exercise of domination and power; they serve "to delimit one's own place in a world bewitched by the invisible powers of the Other" (36) while controlling space through the use of a combination of tried and tested panoptic practices which quantify a particular site. Historicity itself is regarded as a threat to this power, since it introduces a degree of change, difference, and temporal indeterminacy. In this sense, strategies work to negate time and memory by limiting them to functioning within an observable and readable system. In contrast, tactics are dispersed, hidden, ephemeral, and shaped in response to the concrete demands of what happens at each moment. They rely on the art of collective memory, on a classical tradition of a popular form of resistance passed from one generation to another. Similar to the art of rhetoric developed by the Sophists, the goal of tactics is to make the "weaker appear stronger," to help the powerless since they are unable to directly question or confront the existing power structure.

In order to demonstrate his point, de Certeau provides comprehensive readings of the consumption of televisual and cinematic images, the appropriation of space (i.e.,

walking and living spaces), the more literal consumption of food and drink, such as cooking techniques, and many other examples of everyday actions. In this process, he hopes to shed light on how the battles or games between the strong and the weak can be actualized and how the weak can create their own agency in this regard. For de Certeau, in all such tactical practices, non-producers develop "indeterminate trajectories" in contrast with the dominant rationality visibly actualized in the given space, text, or object. To de Certeau, such idiosyncratic and disparate trajectories "remain heterogeneous to the systems they infiltrate and in which they sketch out the guileful ruses of different interests and desires" (34).

It is through such analysis that de Certeau manages to show why everyday practices could resist and act against the translation and codification of an authoritative and formalized language. In fact, their incomprehensibility and non-translatability in the face of an instrumentalized and fixed rationality is a non-stopping source of vitality and strength. Although there is a concerted attempt to expunge otherness and to control and isolate individuals as subjects of power and knowledge, there exist "ghostly" voices in the "night-side of societies" which can be heard in "rambling, wily everyday stories" narrated by children, women, and the mad. These provide a clandestine peek into the creative and innovative practices of daily life based on the logic of the "gift" instead of exchange. These marginal and excluded voices escape from the "domination of a socio-cultural economy, from the organization of reason, from the grasp of education, from the power of

an elite and, finally, from the control of the enlightened consciousness" (158).

In these everyday practices and in their spaces of resistance, where justice is done and the powerful is dethroned, there exists a symbolic end to these continuing conflicts. This space cannot be colonized by dominant powers because it is a utopian space in the most literal sense; it is a "no-place." Consequently, it continues life as an unlimited symbolic resource for the excluded and as a well-spring for popular power resistance. In de Certeau's words, in such spaces of resistance

> ...can thus be revealed, dressed as gods or heroes, the models of good or bad ruses that can be used every day....The formality of everyday practices is indicated in these tales, which frequently reverse the relationships of power and, like the stories of miracles, ensure the victory of the unfortunate in a fabulous Utopian space. This space protects the weapons of the weak against the reality of the established order. It also hides them from the social categories which "make history" because they dominate it. And whereas historiography recounts in the past tense the strategies of instituted powers, these "fabulous" stories offer their audience a repertory. (23)

The limitation of space in this paper prevents me from spending more time discussing de Certeau, but this short introduction provides the key to his thought. The question that arises now is: what are the implications of

de Certeau's ideas for cinema studies? His idea of utopia has a tremendous impact on the way we treat popular culture since he analyzed such a wide range of cultural forms. In this sense, de Certeau takes a different position from the theorists who argue against mass products, such as Max Horkheimer and Theodore Adorno (2001). The latter's position on mass products, for instance, poses serious questions about the role and meaning of everyday films produced by wealthy companies. De Certeau's way of conceptualizing utopia is not based on either extremes of straightforward enthusiasm or total disdain of popular, everyday culture as mere commodification and manipulation. For him, if utopian aspirations are found in mass culture, then they are superior to pessimism or bourgeois nihilism. In this sense, de Certeau's position fits well with Richard Dyer's argument, since Dyer believes that mainstream Hollywood films are not totally in harmony with the capitalist ideology; rather, they offer moments of resistance or fantasy. In this reading, utopian ideas are pervasive and can be seen in many cultural forms (Dyer, 1981).

Furthermore, with de Certeau's help, we can argue that cinematic images provide two types of conception of time for viewers: real and utopian. Real time is the regular, abstract time of the clock and the calendar, the tick-tock time of everyday life; it consists of moments through which de Certeau's strategies are actualized in society. Real time functions as a form of disciplinary time and is made up of moments that comprise de Certeau's tactics with the mere goal of increasing production and

controlling human life. Utopian time, on the other hand, is a time of disruption and change. It is associated with heroism through which the passage of time feels as fluid, infinite, and actually outside of time itself. Maximum human satisfaction is experienced through utopian time. When the flow is passed, aside from the mere experience of satisfaction, we feel that something meaningful has occurred. In cinema, it is through utopian time that the viewer has a utopian, different and distanced perspective on ordinary reality. What we need in cinema studies is to detect these utopian instances of time and discuss their potentially disruptive qualities. In order to concretize these theoretical concepts, the following section aims to understand how utopian glimpses are pictured and represented in cinema by analyzing *Her*.

Reading *Her* through the concept of everyday utopianism

In the first section of *Her*, Theodore, as a product of the society in which he lives, leads a life of conformity as he unquestioningly follows what societal strategies dictate to him. As de Certeau argues, societal strategies aim to create an object of consumption out of the individual; the central goal is the creation of a citizen who could produce good commodities for society. With this in mind, it is understandable why Theodore is a mere object in the first section of the film as he cannot understand why he lives and what he is looking for in life. He is unable to think for himself; he knows things but has never thought about them before. As Hannah Arendt (2013) argues, there is a

difference between thinking and knowing. Thinking is the process of creating a dialogue with oneself; such dialogue creates awareness of nuances of existence. Thinking involves critical personal reflection; when we think, we test all our taken-for-granted assumptions. However, knowing depends on the acceptance of truth as external to individual perception. When we know something, we accept it as something that will never change. Somebody who thinks he knows exactly why he should act in a specific way is certain about his life and choices. Somebody who merely knows is a lazy person who only follows what is told to him. He is capable of killing tens of people if he receives an order to do so. In the first part of *Her*, Theodore is a perfect example of somebody who knows. He only follows what is dictated to him; he is a victim of life's routine and its strategies and cannot feel any enjoyment enacting them.

What tactics can be used to cope with everyday life? *Her* suggests that it is through love and its magic that Theodore manages to escape the tedious routine of his life. In this sense, reading the movie from Alain Badiou's perspective on love is quite instructive (2012). As Badiou argues, love has emancipatory political dimensions. When we are in love, we are trying to discover the universe through the magic of two and so love creates a new perspective from which to look at the world; it is an event. It helps us experience things through this event, to see things through the lens of this created world, through the lens of the other. Love in this sense means the moment when one is watching the world with a lover, such as a sunset, and

its meaning is modified by the experience being shared; the ordinary loses its meaning and becomes utopian. In de Certeau's view, these experiences, which Badiou calls "moments of love," help the individual develop tactics in order to free himself from the restraints of oppressive powers.

After falling in love, Theodore prevails over the monotony of his life and begins to see the world through new eyes, thus changing his attitude towards life as he starts to laugh and walk with more energy. What happens to Theodor after falling in love is similar to what de Certeau refers to as the exercise of a renter who turns an empty flat into something worth living in. Similar to the renter, Theodore imbues his life with subjective meaning. Through the arrangement and rearrangement of things and by playing with the location of events in his life, he conjures up new images, narratives, thoughts and desires. Thus, while the society's strategies attempt to control and govern Theodore' life through the creation of a dominant discourse, which introduces a normative set of meanings, the procedures of actualizing life after falling in love appear to constitute a person who knows how to insinuate his countless differences into the dominant structure of society. Theodore sometimes repeats the same action and sees the same mechanism applied in the practice of life, but the meaning of these actions is each time different for him. Here ordinary conversation consists of a complex practice that transforms the inherited system of life into an "oral fabric" with the goal of producing unique meanings for the concrete context of life experience.

The process of falling in love is more important for Theodore than what society views as the ultimate goal of life, i.e., having sex and reproducing the species. Although in the beginning, Samantha feels insecure because she cannot have a physical sexual relationship with Theodore, her perspective changes as the plot develops and, at the end of the movie, she even thinks that lacking physicality is a superior form of life. Ultimately, lack of a physical sexual connection does not deeply impact the relationship between Theodore and Samantha. As Badiou suggests (2012), we need to remember that sexuality is not the essence of love. Following Lacan, he argues that there is no sexual relationship, which means that when two people are in the bedroom engaged in sexual activities with each other, in reality no relationship emerges through this interaction. Each person only takes care of his/her own needs and ensures his/her satisfaction and will leave the other sexual organ as soon as the moment of orgasm arrives; no genuine relationship is developed through this process. That is why after the termination of sexual activity, as soon as we reach the moment of orgasm, we feel unsatisfied and want to repeat the action once again. As Badiou points out, it is only because of love that we can tolerate each other; it is love that makes us enjoy our sexual activities, an idea which *Her* beautifully demonstrates.

In *Her*, sexual relationship between Samantha and Theodore can never function normally, and it is only through their dreams and fantasy or, in de Certeau's words, through a variety of unexpected and undefined ways or

non-formalized practices that they could ponder sexuality. No scene captures this condition more powerfully than the dark images which follow their first sexual intercourse. Here, Spike Jonze uses sound as a special visual effect that compensates for Samantha's lack of a body. Unlike the orgasm that fades in white in Krzysztof Kieslowski's *White* (1994), Theodore and Samantha's love scene reaches its culmination in absolute darkness (Khoshchereh, 2013). The sound bears the burden of images and communicates the sexual pleasure of the two characters. Meanwhile, Jonze visually represents their lovemaking with darkness.

The fading of this erotic scene to black captures the essence of love effectively since it helps the viewer imagine and think about what happens in the scene while preparing spectators for the eventual death of the relationship between Theodore and Samantha. Employing de Certeau's ideas, we can argue that the societal goal of creating a sexual relationship is the creation of strategies which shape an ordinary normal citizen, a form of technocratic power, and a central wish element of the "scriptural economy." However, the darkness that prevails in this scene prevents us from gaining certainty about what is happening between Theodore and Samantha. To use de Certeau's words in another context, here the reader roams over the surface of the image, accepting certain images and facts, words or paragraphs while not paying attention to others. Through this process, the reader is invested with the possibility to create a "world of the text" that the author might have never envisaged or thought about. As de Certeau puts it, "[b]y its very nature

available to a plural reading, the text becomes a cultural weapon, a private hunting reserve, the pretext for a law that legitimizes as "literal" the interpretation given by socially authorized professionals and intellectuals" (1984, 171). From this perspective, this scene could be read as a cultural weapon, a proof that sexual relationship is not limited only to interaction between vagina and penis. This interpretation through de Certeau's lens is reminiscent of Freud when he asserted that a sexual relationship could be actualized through many outlets. In fact, it is only because of social norms that a particular form of sexual relationship dominates. As Freud suggests, kissing lips is, for example, a very dirty act with many microbes transferred through this process while it also serves no useful purpose since it will not lead to the reproduction of the species. Thus, from the hegemonic perspective, kissing could be read as a perversion. However, society gives value to this specific way of showing sexual attraction and rejects others. Why does this happen? Why should this act be called normal and not perverted? By asking these questions, Freud wants us to be critical of the process of normality in sexuality and how it has been shaped and produced through the struggle of knowledge and power. According to de Certeau, through such a reading of everyday practices and utilizing their spaces of resistance, justice is done and the powerful is dethroned. Such junctures are utopian moments that cannot be colonized by dominant powers; they have "no-place" and are the ultimate utopian moments.

The third section of *Her*, which begins after Theodore's

separation from Samantha, hints at Theodore's possibilities of emancipation from the routine of everyday life. Here the film suggests that Theodore wants to revolt against the boredom and monotony that has been characterizing his life before the appearance of Samantha, chiefly because he has now realized the value of love, acceptance of the other, and alterity. Thus, he writes a letter to his ex-wife in the hope of reconciling with her. However, this emancipatory project is at the same time not radical enough. First of all, the idea of heterosexual relationship maintains its primacy throughout the whole movie. Theodore has a relationship with an operating system, a thing. But from the start, this technological program anthropomorphizes as a woman who bears the name of Samantha and has a female voice. Within this process, Theodore wants to develop a monogamous relationship with her and cannot tolerate the fact that Samantha develops sexual relationships with others besides him. Therefore, as soon as he realizes that Samantha is in relationship with a number of other males, he becomes very frustrated. One could argue that this explains why at the end of the movie Theodore accepts Samantha's departure and prefers to return to his wife.

Secondly, *Her* rejects technology as the chief source of man's misery, at least as far as technology breeds alienation and distance between human beings. Although Samantha, despite being a technological device, at first stimulates Theodore emotionally, just as HAL 9000 in Kubrick's *2001: A Space Odyssey* (1968), she ultimately transcends her subservient status in relation to Theodore and, by extension, dethrones humanity. Hence the only

possible option for humans is to continue living without technology. *Her*, however, rejects technology without asking what is the political reason for producing technology in the first place. In this sense, the film represents a very limited discussion of society, its political structure, and its impact on technology.

In fact, a striking feature of *Her* is its total neglect of all socioeconomic structures. We see people like Theodore who are working all the time, but we do not know for whom and for what purpose. The impact of technology on human life is shown, but it is also suggested that technology by itself, and not because of societal pressure, creates problems for human life. The position of the movie in relation to technology is not very different from a technological determinist's, someone who believes that technology operates according to an inexorable inherent logic. From this perspective, technology is seen as part of the natural evolution of a better world, where it acts on its own terms rather than through human decisions about how it should be employed. As such, human control over the exact direction of technological development is minimal and technology, in a sense, has an independent life of its own. However, this is a fallacy and the idea that technology in itself can change people's perception of time is naive. Consider Facebook, a technological phenomenon which is not shaped simply by itself; in fact, there is someone who has created this structure and works to develop it. If there is concern about the erosion of privacy on Facebook, this issue is not created by the technology itself; it is caused by human decisions and their

political choices. Any concrete action to change the world would have to start with this premise and demonstrate, in practical terms, how human decisions can be changed, i.e., by transforming the prevailing legal structures that support current commodity production, questioning transnational corporate power and its neoliberal ideology, and criticizing existing national, state, and local political systems. *Her* does not touch on any of this, which explains why its position is beautiful but ultimately incapable of explaining reality. This lack of a critical attitude towards politics in the content of the film also impacts its form. In the next section, I will elaborate on the form of *Her* and the strategies it deploys to represent utopia.

Her and the question of style

As Choay (2000) argues, in utopia the passage from critique to project is materialized through a spatial model whose values perform a transformative function. While this spatial model plays a significant role in transmitting utopian demands, the visual quality of cinema also enables utopian thinkers to propose their spatial visions more effectively. A digital image in three dimensions is more effective in suggesting an imaginary society than even an excellent written description of a society (Ruppert, 1996). Form also plays a significant role in *Her* as it is brought into organic connection with the film's content. When humans do not think critically and, as a result, only obey the rules dictated to them, this also finds its corollary in the form of city life and its architecture. As Heidegger contends (1971), the quality of architecture

directly relates to the capacity of human thinking, a line of thought which he developed through the introduction of the concept of "dwelling." In fact, Heidegger employed "dwelling" to express a situation in which architecture becomes a place and lets a human "be" in the world and think about it. As soon as an individual builds his house on earth, he starts to live in the world. However, just when he is capable of dwelling, the world really becomes inside and he can experience it as a human being. Here, the act of dwelling describes the way that he "is," the way that humans "are" on earth, the activity which cannot happen just at any type of building and needs a proper and well-elaborated form of physicality. It is only at such proper physical places that humans can think.

Thus, for Heidegger, building a house is not just an act by humans to create a space to live in; it is a condition for them to enter the world, be in the world, have a world, and think about the world as mortals. What type of buildings and architectural designs could be called a proper place of dwelling? As Norberg-Schulz argues (1980), through the years places such as Prague, Rome, Boston, and Chicago have retained a unique spirit of place, or *genius loci*, a term which refers to the character or personality of a place that can persist in spite of profound changes in its components. For example, the mix of architectural styles, with the scenic hills, rivers, greenery, parks and islands, makes Prague one of the most beautiful cities in the world, with a unique character which, for Norberg-Schulz, represents the spirit of place. These are qualities that make a place a good dwelling, a proper place for

thinking and reflection. A good place for thinking in this sense is a metaphysical concept aiming to forge a bond between human and nature. Here, an authentic experience is defined as one rooted in place. In this definition of place, Toronto and Montreal are not just simple points on a map, but there should rather be a clear connection between places and their milieus. However, this is not the quality of the futuristic spaces in which Theodore lives, uniform and unvarying buildings which lack deep historical connections with their surrounding tissues. In fact, most buildings in the world of *Her* are merely mathematical-technological spaces which offer no sense of surprise or discovery. All qualities of good places are lost in these buildings and, in the manner that Norberg-Schulz describes, we can easily talk about "environmental crisis" in *Her*. Given this, it is no surprise that no one can dwell and think properly in most of these buildings.

In the first section of *Her*, Theodore never feels at home as he wanders in the streets without enjoying the experience of city life. We see him walking without motivation, without interacting with others, simply as a mere passerby. Here, we watch people passing each other, absorbed completely in listening to their mobile phones, a quality of spaces and human interaction which could better be understood through Simmel's writings on the metropolis (Jensen, 2006). Simmel believes that living in a metropolis offers more freedom to its citizens than living in a small city since in a big city there are fewer people who know each other and the inner unity is looser. That is why people are freer to do what they want. This

experience generally results in a heightened sense of individuality and greater freedom from group demands. However, this way of life has also negative consequences since no one feels as lost and lonely as when they are in a metropolitan crowd. For Simmel, this metropolitan loneliness is linked explicitly to an increase of mobility, and he portrays modern crowded mass transportation as the cradle of "loneliness in togetherness" (Jensen, 2006). Simmel argues that in the new space of transportation we are forced to look at our fellow consociates for minutes or even hours without ever communicating or even wanting to do so.

What one sees in the city streets of *Her* is similar to Simmel's description since there is no genuine interaction or even eye contact between passersby as everybody is busy with their own lives, a situation which strongly reflects the loneliness of the characters in *Her*. Simmel argues that people's connections and interactions are shaped by eye contact and facial expressions and that it is the look between people that produces extraordinary moments of intimacy since "one cannot take through the eye without at the same time giving," a condition which produces the "most complete reciprocity" of person-to-person, face-to-face interaction (Urry, 2004). In the environment that Jonze depicts, the experience of observing in the street is depersonalized and people interact through telecommunication channels, which are defined as the enemy of public life. This technological interaction splits homes and business districts, isolates people from their neighbors and communities, detaches them from their

surroundings, and thereby erodes town centers and public spaces.

In this regard, as the quality of spaces reflects the inner feelings of humans, *Her* employs different cinematic techniques to capture the loneliness of Theodore in its first section. The movie begins with a close-up of Theodore situated at the center of the frame, a subjective view that establishes him as a narcissistic character. This image gives us the impression that he is capable of controlling his life. However, a few moments later, a long shot of his workplace appears on the screen revealing a building with many windows and a number of employees isolated in separate cubicles; all of these employees are engaged in writing romantic letters for clients. This view exhibits the superficiality of our first impression and establishes the fact that Theodore is not very different from others and there is no reason for us to consider him a genuine narcissist. The close-up, and the long-shot which follows it, can be interpreted as an allegory about the nature of movies: what we see on the surface is deceptive and hides the reality since behind the happy voices of the characters lies a deep sorrow.

Theodore's cubicle has a rectangular, cell-like structure with all other cubicles situated at a distance from each other in an architectural form that we might describe as functionalist. Spaces in this architectural design are devoted to mere work, which is why everybody is occupied with their computers and there is very limited interaction between coworkers. Functionalist architecture has been criticized for its totalitarian dimensions. It is suggested that

in functionalist buildings, individuality is overwhelmed by abstract and inhuman spaces. This quality also defines the characters in the first section of *Her*, where we can clearly see the impact of Orson Welles's *Touch of Evil* and *The Trial* (Khoshchereh, 2013). In Welles's movies, the mise-en-scene is highly expressionistic intending to reflect the inner state of characters. For instance, in a famous scene in *The Trial*, Joseph K. runs through a tunnel-like space in which the sharp contrast between bars of light and shadow creates a prison-like atmosphere from which he tries to escape. The retreating tracking shot in this scene represents Joseph K.'s sense of fear and desperation. In the same manner, the mise-en-scene in *Her* reflects Theodore's emotional distance and mental isolation. In one of the scenes in *Her* which is framed in a long shot, Theodore is seen on the edge of a pavement with a large television screen behind him. A giant owl appears on the screen and the blocking within the mise-en-scene makes it appear as though the owl wanted to capture Theodore as its prey. While the image expresses Theodore's sense of angst and helplessness, it also conveys his overpowering feeling of alienation. Thus, the mise-en-scene in *Her* reflects Theodore's inner emotions as they find their objective correlations in the film's actual space. In many cases, the close-up of Theodore is surrounded by very dark shadows over his face. Sometimes darkness is caused by an object, such as a shade, which imprisons Theodore mentally. In this regard, the contrast of dark and shadow in the shots, while expressing Theodore's loneliness, reflects a noir style that partially haunts the film. This explains why when Theodore converses with

Amy (Amy Adams), his friend who also relies on an operating system to escape isolation and loneliness, Jonze avoids two shots and, instead, employs shot/reverse shot, a technique which communicates the entrapment of characters in a confined private space.

By introducing such devices, Jonze attempts to propose a dark scenario in order to provoke thought. The history of utopia and dystopia demonstrates various types of similar experiences with shocking images, as in Aldous Huxley's *Brave New World*, which depicts a society that is the direct descendant of the Athenian civilization as imagined by Plato twenty-three centuries earlier in *The Republic*. Contrary to Plato's imagining, Huxley creates a world in which the leaders who claim to act for the good of mankind seek only to satisfy their own personal desires. This aspect of utopia has been utilized by Archizoom in the famous project Non-Stop City, which is a cold urban representation of a factory-like building in which graphic presentations are black and white. For Archizoom, this project is a total realization of a capitalist city. As Aureli argues, the dark images of Non-Stop City have been used as a model to shock readers and make them think about the gaps in the capitalist society (Aureli, 2008). In this context, proposing such models is a means of resistance against the existing mode of socioeconomic development. Through the dystopian mode of presentation, and by using provocative methods, these imaginative models question the structure of the world and propose a new humanistic way of being. As Levitas argues (2010), the point in utopia is not to go "elsewhere," but rather to

use elsewhere as a reflection on where we are in order to grasp the limitations and benefits of a utopian society that incorporates all these elements. In line with Levitas, the dystopian vision of *Her* enables spectators to easily imagine the limitations of their own world. In this regard, the movie can be read as an educational tool which can make individuals think about their lives in the world. The movie can therefore spark debate among citizens and sensitize them to think critically about their world. In this process, some glimpses of alternative images of the world can be seen in the second section of the movie.

The utopian moments in the second section of *Her* are exemplified in the scenes where Theodore and Samantha converse with each other in the streets while benefiting from the urban quality of life. The meaning of the same ordinary experiences has now changed significantly through the new feeling of love that Samantha has triggered in Theodore. Thus, the movie suggests that sense of a place is not stable. As Seamon (1980) argues, a place is not a fixed entity with measurable attributes. Places are occupied by individuals engaging in diverse activities and so they are never fixed, but rather constantly changing (Thrift, 1994); they are never finished, but always becoming. According to Seamon (1980), through daily performances and participation, human beings become familiar with a place and consider themselves as part of it. Thus, human agency in a given place is not merely controlled by social structures since these structures can be challenged by the daily and repetitive performances of human beings. *Her* beautifully demonstrates this

point since the meaning of the same place is altered by the experience of love between Samantha and Theodore; visiting the same location now provides them with a new possibility to enjoy the space. Within this framework, the dark noir spaces lose their initial negative meaning and, through daily performances, participation, and repetition, the main actors become familiar with the space, develop feelings about it, and transform it into a *place*. In this regard, in the same sense that de Certeau understands, *Her* suggests that place is not just controlled by the social structure. This structure can be challenged by the daily and repetitive performances of human beings, especially through the manipulation of art and camera and creation of utopian drives.

Having said this, although *Her* strives to be a futuristic film, its formal structure remains quite conventional. Clearly, *Her* lacks a futuristic style of shooting, editing, acting and mise-en-scene. The movie is captured by digital cinema and is about technology, but the impact of technology on the movie's form is minimal since *Her* still follows the style of conventional movies produced in Hollywood. In this regard, the same problem that Rodowick identifies in relation to the experience of using digital cinema could be found in *Her*. In fact, according to Rodowick (2009), the *invisibility* of artificiality is the main issue with digital cinema. "The deepest paradox of perceptual realism in the emergence of digital cinema," Rodowick argues, "is its presentation of images that appear to be, and want to be "photographic," only more so." The example of *The Matrix*, to which Rodowick refers, is worth

repeating in order to better understand his argument. As he notes, the character of Morpheus in the film is able to read images through computer codes; he can look at a code and say what it represents. For example, he watches a combination of ones and zeroes and claims that it is a tree. However, the character of Neo is unfamiliar with the logic of the digital medium and is unable to read more from this. Rodowick (2009) contends that this is a central issue with digital images. As he puts it, we have not yet developed the images that correspond to the logic of the new media and we still use digital technology to recreate the past experience. Other scholars have also made this point. Michael Allen, for instance, argues that

> digital imaging technologies and techniques are striving to replicate what already exists: the photographic representation of reality. The success or failure of any digital image lies in the degree to which it persuades its spectator that it is not digital, but it is photographic. (825).

Thus, I believe that a real revolution in applying digital technology in futuristic movies will happen only when new images can relate to the logic of digital technology. However, such a revolution does not taken place in *Her*. Although it is a science-fiction film captured by the digital camera, everything in this movie gives us the sense of familiarity. Still, a deeper analysis of form shows that a regressive tendency is fully present in the movie.

Conclusion

There are certainly some merits in the criticism that Spike Jonze levels against our current social system in *Her* as he incorporates some previous criticism of contemporary computer-addicted society into a single project. *Her* emphasizes the limitations of a world centered on mobile technologies which beset human life. Before watching this movie, we as the spectators are unaware of how such "elsewhere" projects would look and function. Here, the "elsewhere" project provides an opportunity to answer this question. For example, thanks to *Her*, it is easy to imagine where the residents of such a society live, how they get to work, and how they come into contact with other people through technological means. Thus, thanks to *Her*, we can envision such a society. In fact, this scenario offers us the tools to assess the "acceptability" of such a society and will help us identify and improve upon its less attractive aspects. Ultimately, the issues at the core of *Her* can be diagnosed by the audience and used as a lantern to understand the difficulty of living in the society it depicts and the ways by which we can reduce its gaps.

As Karl Marx points out, the role of philosophy is not to interpret the world, but to change it. Could Jonze's perspective provide a useful tool to politically address the problem of a computer-addicted society? It is difficult to answer this question. First of all, Jonze does not seriously take into account the reality of capitalism. Simply put, the structure of capitalist society and its emphasis on greed and fierce competition limits the possibility of individual heroism. In fact, one of Marx's main criticisms of

capitalist society is the fact that the value of commodities is determined according to the abstract concept of socially necessary time. Through the implementation of this process, capitalist forces define the value of labour while also disciplining and controlling workers. As Marx showed, these procedures are shaped through universal laws and need to be addressed collectively. Given this, there is a need for individuals to work together in solidarity, or else they will risk competing instead of supporting each other. Jonze does not take this aspect seriously, which is a major flaw in *Her*. There is no mention of a collective struggle in the movie, and so there is a real danger of essentializing individual, rather than collective, struggles as the site of political resistance against the hegemony of globalization. This could be seen as an "individualist trap" that pays no serious attention to the transformation required for cross-scale mobilisation.

Secondly, and in continuity with the previous argument, the abstract values that Marx discusses result from force and will not magically vanish just because of the goodwill of some individuals who believe in a world without computers. As argued above, Jonze remains silent about the transition to a world without computers, and it seems that he expects this transition will just happen magically. The super-intelligent computer came into this world one day unexpectedly and Jonze seems to believe that it will vanish one day in a similar fashion. Here, the description of a concrete project is not based on a deep understanding of existing society and the proposals for future improvements do not take into account the existing world; such strategies

appear to be more wishful than wilful. Thus Jonze fails to offer any discussion of the relationship between the political structure and technology in this world. Failing to couple its position on technology with a critique of the existing structures of society confines the film, despite offering interesting insights, within the realm of essentialism and fantasy. Without a serious engagement with how the world actually works and a realistic attitude towards the production and use of technology, *Her* must remain in the category of the interesting but trivial.

Work cited

Allen, Michael. "The Impact of Digital Technologies on Film Aesthetics." *Film Theory & Criticism*. Eds. LeoBaurdy and Marshal Cohen. London: Oxford University Press, 2002, pp. 824-834.

Arendt, Hannah. *The Human Condition*. Chicago: University of Chicago Press, 2013.

Aureli, Pier Vittorio. "The Project of Autonomy: Politics and Architecture within and against Capitalism." Vol. 4. Princeton: *Princeton Architectural Press*, 2008.

Badiou, Alain, and Nicolas Truong. *In Praise of Love*. Profile Books, 2012.

Bloch, Ernst. *The Spirit of Utopia*. Stanford: Stanford University Press, 2000.

Cavell, Stanley. *The World Viewed: Reflections on the Ontology of Film*. Cambridge: Harvard University Press, 1979.

Choay, Françoise. "L'Utopie et la Statut Philosophique de l'Espace Edifié." *Utopie: La Quête de la Société Idéale en Occident*.

Eds. LT Sargent and R. Schaer. Bibliothèque Nationale de France & New York Public Library, 2000.

Choay, Françoise. *L'Urbanisme: Utopiesetréalités: Uneanthologie.* Paris: Editions du Seuil, 1965.

De Certeau, Michel. *Heterologies: Discourse on the Other.* Minneapolis: University of Minnesota Press, 1986.

De Certeau, Michel. *The Practice of Everyday Life.* Berkeley: University of California Press, 1984.

De Moncan, Patrice, and Phillipe Chiambaretta. *Villesrêvées.* Paris: Les Éditions du Mécène, 1998.

Dyer, Richard. "Entertainment and Utopia." *Genre, the Musical: A Reader.* Ed. Rick Altman. London: Routledge, 1981.

Eaton, Ruth. *Ideal Cities: Utopianism and the (Un)Built Environment.* London: Thames & Hudson, 2002.

Featherstone, Mike. "The Heroic Life and Everyday Life." *Theory, Culture & Society*, 9.1, 1992, pp. 159-182.

Fishman, Robert. *Urban Utopias in the Twentieth Century.* Cambridge: MIT Press, 1977.

Heidegger, Martin. "Building Dwelling Thinking." *Poetry, Language, Thought.* 1971.

Adorno, Theodor W., and Max Horkheimer. "The Culture Industry: Enlightenment as Mass Deception." *Media and Cultural Studies: Keyworks*, 2001, pp. 41-72.

Jensen, Ole B. ""Facework," Flow and the City: Simmel, Goffman, and Mobility in the Contemporary City." *Mobilities* 1.2, 2006, pp. 143-165.

Khoshchereh, Mahmood, "On Her." *Cine-eye* (7), 2013.

Lefebvre, Henri. *Critique of Everyday Life*. Vol. 2. London: Verso, 2002.

Levitas, Ruth. *The Concept of Utopia*. London: Phillip Allan, 1990.

Marx, Karl. *Capital: Vol. 1: a Critique of Political Economy.* Harmondsworth: Penguin Books,1992.

Mumford, Lewis. *The Story of Utopias*. New York: Viking Press, 1921.

Norberg-Schulz, Christian. *Genius Loci: Towards a Phenomenology of Architecture*. New York: Rizzoli, 1980.

Paquot, Thierry. *L'Utopie: Oul'Idéalpiégé*. Paris: Hatier, 1996.

Picon, Antoine. "Learning from Utopia: Contemporary Architecture and the Quest for Political and Social Relevance." *Journal of Architectural Education*, 67.1, 2013, pp 17-23.

Pinder, David. "In Defence of Utopian Urbanism: Imagining Cities after the "End of Utopia"." *Geografiska Annaler: Series B, Human Geography*, 84.3‾4, 2002, pp. 229-241.

Rodowick, David Norman. *The Virtual Life of Film*. Boston: Harvard University Press, 2009.

Ruppert, Peter. "Tracing Utopia: Film, Spectatorship and Desire." *Utopian Studies*, 7.2, 1996, pp. 139-152.

Seamon, David. "Body-Subject, Time-Space Routines, and Place Ballets." *The Human Experience of Space and Place*. Eds. Anne Buttimer and David Seamon.1980, pp. 148-165. Solinís, Germán. "Utopia, the Origins and Invention of Western Urban Design." *Diogenes*, 53.1, 2006, pp.79-87.

Stauffer, Marie Therese. "Utopian Reflections, Reflected Utopias: Urban Designs by Archizoom and Superstudio." *AA files*, 2002, pp. 23-36.

Urry, John. "The System of Automobility." *Theory, Culture & Society*, 21.4-5, 2004, pp. 25-39.

Zizek, Slavoj, *The Pervert's Guide to Cinema: Parts 1, 2, 3*. Microcinema International, 2006.

Space as a Field of Social Contention: a Look at Wes Anderson's Cinema

Mahmood Khoshchereh

As Marx would say, all objects in space at once embody and dissimulate social relations in space. In fact, Marx would have been quite accurate if he had used this insight to describe the films of Wes Anderson. This paper aims to show how Anderson employs particular formal strategies in his films to reveal the hypercomplexity of their social space. The ideological weight that charges the framing and physical position of characters in Anderson's films turns the space in which they interact into a field of social contention. From a Marxian perspective, none of the characters in Anderson's films can be taken "in themselves" or as isolated from other characters since they essentially figure as the sides of a continuous exchange within a social context. According to Henry Lefebvre, the capitalist ideology "fragments space and cuts it up into pieces" (89) in order to exert its control over individuals more effectively. This divisional or reifying practice also transforms space into "truncated parts," creating "mental barriers and practico-social frontiers" (89). Anderson criticizes this reifying practice by concentrating his

attention on what Lefebvre calls "the production of space and the social relationships inherent to it" (90); he rejects the treatment of space in terms of "spatiality," that is to say, fetishizing space in a "way reminiscent of commodities" by viewing it in abstraction and as a "thing in itself" (90). Instead, through the production of space, Anderson succeeds in unmasking the social relations that in his films always assume an unstable character. Anderson renounces the perception of space as a passive receptacle and, instead, employs space in an active way to uncover the dialectics of mastery and oppression.

Notwithstanding an oedipal tension that hovers in the background, Foxy (George Clooney) and his family in *Fantastic Mr. Fox* (2009), after choosing a tree as their home, turn it into an intimate space in which a sense of comfort and concentration becomes accumulated. But this idyllic serenity soon collapses as the three chicken farmers, Bean (Michael Gambon), Boggis (Robin Hurlstone) and Bunce (Hugo Guinness), in response to Foxy's reckless robberies from their farms that have left them in disarray, execute a calamitous revenge plot. After the battle breaks out, the tree, the locus of ease and leisure for Foxy's family, is transformed into the site of war and disintegration. Here, as the tree is uprooted, the condensation and centered sense of being that has characterized the life of Foxy and his family is dispersed as they are forced into the cavernous sewers underground. In this way, as the interior space of domesticity is shattered by the merciless raid of the farmers, the exterior space— in fact, its most marginal space, i.e., the sewers—begins

to lose what Gaston Bachelard calls its "void" quality (291) by being activated into a space of resistance. In fact, the sewers are transformed into a center from which the animals plan and orchestrate their counterattack against the farmers. Throughout the history of cinema, sewer tunnels have often been depicted as places of betrayal and demise as in Carol Reed's *The Third Man* (1949). Perhaps, *Fantastic Mr. Fox* comes closer to Andrej Wajda's *Kanal* (1957) in its use of sewers as a site of resistance and a space of survival. However, the sewers in *Kanal*, instead of facilitating escape, ironically turn into a labyrinth from which no release is possible; they essentially remain a hellish zone of imprisonment, death and destruction. In addition, *Fantastic Mr. Fox* differs from Fritz Lang's *Metropolis* (1927), where the underground, as a crowded and oppressive environment, is the space of enslavement and subjugation by the elite above-ground.

By transforming the sewers, Foxy and his friends, in their battle with the farmers, produce a space which, in a manner similar to John Ford's films, is shaped by communal solidarity. Ford's films depict a spatial duality in which the dwellings of homesteaders, as the embodiment of civilization, can only be sustained by negating the wilderness, the uninhabitable place to which only outcasts and savages belong. Anderson reverses this duality, which is inherent in the hierarchy of a hegemonic conception of space, by investing the uninhabitable underground, a non-space, with the values of Heidegerrian "dwelling," an almost scared, quasi-religious space which gathers together the animals around a common cause. In *Fantastic*

Mr. Fox, the space of the sewers gradually assumes the features that Gston Bachelard attributes to the "shell," a "secret and directly experienced space" (121), a space which produces sanctuary and strengthens social bonds. In terms of Heidegger's ontology, by altering the sewers into "dwelling," a place that figures as an antinomy to "wandering," Foxy and his friends reverse the process of dispersion that had afflicted them at the outset of the assault by Beans, Boggis and Bunce.

Kristin Ross speaks about the houses, which militant workers had turned into the sites of revolutionary struggle against the bourgeois regime during the Paris Commune. According to Ross, these spaces had been reactivated by a "non-passive spatiality" that provided the workers with "mobility on their side" while denying any targets to the enemy (35). The revolutionaries utilized the strategy of "piercing the houses," which enabled them "to move freely in all directions through the passageways and networks of communication joining houses together" (37). For the insurgents, this strategy of "mobility" and "displacement" radically socialized all private spaces by transforming them into aspects of the continuous and interconnected space of social struggle. Driven out of their homes, the animals in *Fantastic Mr. Fox* transform the passive space of the sewers, into which only waste and refuse is dumped, into an active social space which functions both as home and as a rallying point for resistance against oppression. It is from this activated social space that the animals stage their *class* war against the wealthy farmers.

Unlike Lang's *Metropolis*, where the underground is a

purely passive space which oppresses the proletariat, the underground in *Fantastic Mr. Fox* is a totally politicized or, more pointedly, revolutionary space which gives the animals the necessary time and respite for reprisal against the capitalist and anti-ecological socioeconomic structure that has wiped out their entire natural habitat. (Obviously, just as in Hayao Miyazaki's films, we can read *Fantastic Mr. Fox* as an ecologically conscious film which protests against the destruction of nature by capitalist greed). By activating the passive space of the sewers, which enables the animals to repair their fractured social relations and increasingly invest them with insurrectionary collective sentiments against the bourgeois regime above ground, Foxy and his friends are spurred to face off the latter and even infiltrate into its very center of power, a supermarket owned by Bean, Bunce and Boggis. Through vertical piercing, which takes the subversive form of ascending from bottom to top, Foxy and his friends enter the supermarket in order to appropriate this ultimate symbol of capitalist consumption as part of the spoils of their class war.

In Ross's words, "revolution consists in transforming the nature of space/time" (41). After all, Marx had pronounced the emphatic task of "transforming the world," including its spatial relations, as the chief goal of the revolutionary ideology. In the same fashion, Foxy and his fellow animals transform their world by activizing the passive space of the sewer, by altering the space of waste into the transformative site of class struggle.[1] Indeed,

1 The battle in *Fantastic Mr. Fox* is essentially a class war as the

the relations, which are established among the fugitive animals inside the sewer, assume a commune-like form as solidarity and a participatory social structure take root, where all live, cook and eat together.

Ross suggests that the Paris Commune acted as a critique of a specific "geographic zoning" which legitimized a particular form of socioeconomic power (41). In fact, the Commune, albeit for only a short juncture, succeeded in dismantling the spaces of social and economic inequality that this geographic zoning had implemented. In *Fantastic Mr. Fox*, the supermarket that belongs to the wealthy farmers, the ultimate space in which commodified relations hold sway, loses its status of privilege as Foxy and his family, during a blitz, transform it into an adjunct, an extension, of their now activized sewers. By inverting the notion of top and bottom, above and below, the rebel animals break down all spatial hierarchies, an idea that becomes even more resonant as the animals, by appropriating (plundering) the goods inside the supermarket, nullify the entire process of capitalist exchange. Ross uses the term "*detournemnet*" to describe the process which replaces the hegemonic space of capitalist inequality by the counter-hegemonic space of equality (42). This is precisely what Foxy and his insurgent comrades accomplish as they intrude into the space of the dominant social order in order to appropriate it for their

three antagonistic farmers posses the wealth and the commodities that the animals are deprived of. The farmers also own and control the supermarket, the ultimate symbol of consumer culture in the capitalist system. Their destruction of nature can also be seen as a preparatory stage for capitalistic development projects.

own ends. Unlike, say, Kubrick's *The Shining* (1980), where the character is passive *vis-à-vis space and is* controlled by it (Kolker 117), Foxy and his friends in *Fantastic Mr. Fox* actively produce a condition in which they redefine social relations by undermining the very spaces that perpetuate the structures of power.

Ideological contradictions inherent in relations of power are also brought to the fore through movement in space in *The Life Aquatic with Steve Zissou* (2004). In the scene that climaxes in the oedipal clash between Zissou (Bill Murray) and Ned (Owen Wilson) over Jane (Kate Blanchet) as the shared object their love, the pair ascends from the ship's lowest level to its highest point through a combination of horizontal and vertical movements captured by an unbroken tracking shot. While the horizontal line, which traverses the spaces of production (laboratory, editing room, kitchen, and finally library as the site of intellectual work), reproduces social relations in terms of specialized (rationalized) labour, the vertical piercing of space reflects naked relations of power as Zissou tries to assert his authority as both the ship's captain and the castrating father vis-à-vis Ned.

As Henry Lefebvre points out, space is a realm of social activity in which particular paths are invested with "special value": angles, shifts or turns in space may be, for instance, "sinister" or auspicious (191). Consider the sequence of the prison break in *The Grand Budapest Hotel* (2013), where Gustav (Ralph Fiennes) and four other convicts actively redefine the prison space by transforming its labyrinthine turns and swerves into routes of escape

and freedom. Their combined horizontal and vertical piercing of space and shifts to right and left produce an emancipatory condition which is totally at odds with the confining nature of the very space in which they move. In Lefebvre's terms, they also perform a social activity in this space by producing new social relations inside it, by investing it with new values. In fact, through their escape, the prison's space begins to generate a set of new power relations. For example, the prison's kitchen and laundry room, through which the convicts must pass in order to break free, are the sites where the Hegelian master-slave narrative is re-enacted as power is exercised by exploiting the prisoners' labour. However, Gustav and his fellow convicts liberate these spaces of exploitation and unfreedom by turning them into a trajectory to freedom. To formulate this in Marxian terminology, by replacing use value for exchange value, Gustav and his fellow prisoners emancipate these spaces from their purely functional role, which perpetuate the existing power relations of domination and subordination. In fact, just as in the Paris Commune, as the convicts pierce through the prison's space, i.e., by sawing off the bars to move forward in space, they undermine its sectioned off structure, which is designed to confine and control the prisoners more efficiently by confining them within a segmented and rationalized space. By producing a continuous space, the convicts shatter the sense of control that the fragmented spaces of the prison are designed to exert on prisoners.

In Anderson's films, the placement of bodies in space often initially conveys a sense of stability that is nonetheless

always on the verge of collapse. Although a chief formal signature of Anderson is to center his characters in the frame in order to emphasize their position of authority or at least the centrality of their situation, he tends to break up this framing quickly by unmasking the disruptive pressure that is exerted by marginal figures from outside the frame. This forces Anderson to reframe the mise-en-scene by moving his camera to the point outside the frame, where the pressure is generated. In fact, as it will become clear a little later in this essay, the pressure from margin or outside of the frame on the supposed stability that the centering of a character conveys transforms the space in Anderson's films into a field of contending forces and fluctuating power relations.

When a flashback in the beginning of *The Grand Budapest Hotel* resurrects the dead author (Tom Wilkinson), he is presented in a frontal posture in close up at the center of the frame. As the author speaks to the camera, a zoom back, which slowly widens our angle of vision and expands the mise-en-scene, prepares the ground for the intrusion of another character in the frame. The expansion of space by zooming back makes the Cartesian space of the centered subject vulnerable to assault by a force whose disruptive entry into the frame introduces social relations, which in Anderson's films are inherently unstable. In this scene, the moment that fractures the illusion of a controlled space and marks the shift to a space fraught with social tensions is signalled by a swish pan to the right side of the frame and outside it. Here social tensions appear specifically in oedipal terms

as the camera takes note of what is outside of the frame: the author's son who shoots at his father with a toy gun. Apart from the figuration of this oedipal element, which shapes the plots of all Anderson's films and sets the tone for the events that tie Gustav to Zero (Tony Revolori) and ultimately unravel their bond in *The Grand Budapest Hotel*,[1] this peculiar technique of Anderson shows that space, as Lefebvre suggests, is a realm of objectivity (192), that is to say, it is a sphere in which the dialectics of social relations unfolds. From this perspective, space is a social field where contending forces collide while trying to dominate and destabilize each other.

Ultimately, space in Anderson's films turns into a site of confrontation between hegemonic and marginal forces. Within this context, the authority that the frontal position of the author at the center of the scene conveys only provokes resistance from the frame's margin. In fact, precisely at the moment that the author seems to be in total control of the space in the frame, the camera, as if stricken by a sudden awareness of an intrusive force, pans rapidly to the right and then extends its trajectory to explore the space outside the frame. It then registers the disruptive entrance of the author's son whose presence generates new social relations, i.e., the subversion of his father's authority, in the readjusted frame. In this way, Anderson breaks up, even though momentarily, the frame's homogeneous space to communicate a sense of divergence, influx and diffusion. Of course, this disruptive

1 I will later explain the form that this oedipal relationship between Zero and Gustav assumes.

force is always re-contained as the character of authority is eventually re-centered in the frame. Nonetheless, the sudden intrusion from the margin exposes the fragility of existing power relations.

In many ways, Anderson's films are about "the struggle for recognition," a Hegelian condition that as Jean Hyppolite puts it, is "a category of historical life" (170). From a Hegelian perspective, the struggle for recognition is inherent in the master-slave narrative in which the master, who possesses "self-consciousness," abstracts his existence as a "being-for-itself," a free and independent identity that controls the flow of life around him. On the other hand, the salve is linked to "life" in a fashion that is devoid of self-consciousness as he is subjected to the fear of death and punishment by the master. As long as this vertical relationship between self-consciousness and death remains unchanged, the master exerts absolute dominance over the salve. However, within the Hegelian movement of consciousness, a dialectical reversal is bound to shatter the ascendancy of the master and liberate the slave from his repressive hold. While still in control, the master's self-consciousness is purely abstract, that is to say, it is a "consciousness for-itself." Enabling the master to live a life of joy, this abstraction, however, results from the mediation of the labour which the slave performs. Nonetheless, through a dialectical process, this mediation in the form of the slave's labour also nullifies the master's independence. In Hyppolite's words, "[t]he master is master only because he is recognized by the slave; his autonomy depends on the mediation of another self-

consciousness, that of the slave" (173). Since the master merely consumes the fruits of the slave's labour without engaging in productive activity himself, his consciousness remains passive and static. In contrast, since the slave, through his labour, transforms the world, his consciousness assumes an active and evolving form. As Hegel puts it, the slave arranges the world through his productive activity

> so that the master can negate it purely and simply, that is, enjoy it. The master consumes the essence of the world; the slave elaborates it. The master values negation, which grants him immediate self-certainty; the slave values production, that is, the transformation of the world—which is "a delayed enjoyment" (quoted in Hyppolite 238).

Within the dialectical dynamics of historical movement, the master achieves only a "transitory enjoyment" without being able to raise his self-consciousness above the level of abstraction, that is to say, he views himself as independent of social relations. On the other hand, within the Hegelian dialectics, the slave, through his labour, succeeds in elevating his consciousness above the abstraction that characterizes the master. As a consequence, the slave's labour necessitates "contemplation of an independent being as well as of himself"; that is to say, it introduces the concept of social relations.

Perhaps, some examples from *The Life Aquatic of Steve Zissou, Moonrise Kingdom* (2012) and *The Grand Budapest Hotel* can illustrate the process in which the dynamics of space are produced in terms of the master-slave narrative in

Anderson's films. Anderson first centers a character in the frame to communicate its sense of mastery and control. By this visual strategy, the centered character abstracts himself from the forces that linger outside the frame, which, as it turns out, possess the potential to burst into the scene and render the master's sense of control illusory. As such, the centered character is an instance of the Hegelian master who, as long as retains his centeredness within the frame's visual construction, a sign of its mastery, exhibits an abstract self-consciousness, an independent existence that fails to recognize the social relations which shape every space. But as in *The Life Aquatic*, this abstraction of self-consciousness proves chimerical because the character that is kept outside of the frame, whose recognition, similar to the Hegelian salve, is denied within the film's visual plane, always breaks into the frame through its margins to destabilize the sense of mastery that the centeredness of a character has conveyed. There is a scene in *The Life Aquatic* in which Zissou is interviewed by Jane on the ship's deck. While Jane leans to the right side of the frame, Zissou's image is centered to underline his superiority in the ship's hierarchy of power. As a zoom in gives even more emphasis to Zissou's privileged status and position of mastery by turning him into the unchallenged focus of the mise-en-scene, he turns his head to the left and orders one of his crew members to bring him a Campari on the rocks. Immediately, a swish pan to the left reframes the scene to focus on an intern who is engaged in some kind of labour and to whom Zissou's command was addressed. While the swish pan exposes the Hegelian relations of domination and servitude between Zissou and the intern

as Zissou imposes his authority on the latter, it also takes cognizance of the intern as a productive force by including him almost in the center of the reframed scene. Since from a Hegelian perspective, labour is the element which produces consciousness, and since the very autonomy of the master depends on the mediation of this labour, the inclusion of the intern in the frame by a swish pan, which maintains the continuity of space without fragmenting it through editing, shatters the abstraction and detachment from the social relations that the centered position of Zissou has conveyed. By giving recognition to the intern through his inclusion in the visual plane, this abrupt reframing even leaves Zissou out of the frame, a condition that momentarily reverses power relations. By means of this visual strategy, Anderson unmasks the social relations that Zissou's illusion of mastery has concealed.

To sum up, the centring of a character in the frame reduces social relations to abstraction in order to neutralize the disruptive threat that a social space may present. One of Anderson's recurrent strategies is to begin a scene with this reduction and then, by an abrupt camera movement, restore what this reduction has excluded. In this sense, Anderson's technique of reduction never leads to what Lefebvre calls an "abuse of *reductionism.*" Instead, it aims to expose relations of domination and servitude by critiquing the limitations that such reduction entails. The centring of character within an abstract space also intends to conceal the very origin of such a space, the social relations on which it is based. Through such concealment or, what Fredric Jameson calls "containment," the centrality

of character presents itself as absolute and unchallenged. And yet Anderson always undermines this tendency for abstraction by introducing the very social relations that the centring of the "master" in the frame has obscured.

Moonrise Kingdom presents its dichotomy of oppression and freedom both in terms of the opposition between the rationalized space of the Bishop home (with its formal boundaries which isolate characters from each other by artificial divisions) and the open natural space of the Chickchaw territory into which Sam (Jared Gilman) and Suzy (Kara Hayward) escape. This is basically the same antinomy which, as Peter Wollen suggests, shapes John Ford's films. For instance, Ethan Edwards (John Wayne) in *The Searchers* (1956) remains an outsider, a "wanderer," a lonely figure "outside the law" who belongs to the wilderness. In contrast, the space of home, or what Wollen calls "the garden," which is cultivated by women, as in *My Darling Clementine* (1946), turns into the central symbol of a civilizing life (Wollen 80). The opposition between wilderness and home also fractures *Moonrise Kingdom* into two contending notions of space. In the beginning of *Moonrise Kingdom*, a rational or technological tendency tries to master nature by sectioning it off into specialized spaces. Morning inspection by Scout Master Ward (Edward Norton) in Camp Ivanhoe begins as a travelling shot follows his unbroken lateral movement in space. Accompanied by a military march, Ward's movement translates into an invasion of nature which is divided into specialized segments by his khaki scouts (while one scout installs a latrine in one space, the

second scout is building a tree-house in another space, and a third is engaged in pest control in yet another space). As Ward carries out his inspection by moving from one specialized space to another, he also reproduces the master-slave relations **vis-à-vis** his khaki scouts by imposing his authority on them. Nonetheless, just as in *The Life Aquatic*, the camera's abrupt movement breaks up the centered position that Ward occupies to introduce social relations into the abstract space he seems to control. This happens when Ward spot-checks the khaki scout Nickleby (Tommy Nelson). To assert Ward's authority and his position of dominance, not only does Anderson place him in the frame's center but also makes Gadge (Chandler Frantz) to tag along after him as a submissive lackey. Walking with march-like steps, Ward suddenly stops as he takes cognizance of Nickleby who, in a dishevelled and disorderly state, is in the as yet unseen space outside the frame. Ward's "recognition" of Nickleby, if we wish to use Hegel's term, is signalled by a tilt downward away from his occupation of the frame's center into the unseen space outside of it, where Nickleby, in a seated posture, while carrying out pest control, takes up the center of the readjusted frame. Here is a scene in which contradictions in terms of relations of dominance and servitude unravel as the reifying effect of a rationalized space is offset by an abrupt downward tilt, which reframes the scene by shifting the focus to Nickleby, an oppressed figure within the hierarchy of power. In this way, Anderson sets in motion a process of exchange through which power relations are both destabilized and reconfigured as Ward (the master) loses his centrality in order for Nickleby (the

slave) to appropriate it within the continuous space of the same frame. (Anderson rejects the rationalization of space by refusing to join the spaces that Ward and Nickleby occupy through cutting and editing. Instead, he employs a moving camera to establish the continuity of space within the same take and, thereby, underscore its social character). Of course, it is customary with Anderson to restore and re-establish the centrality of the master figure after the latter's momentary lapse and decline, but even the short-lived intervention by the character in the margin succeeds in shattering the sense of an abstract space in which the master supposedly has wielded total control. What all this amounts to is the unmasking of the social relations that have been concealed within a reified space. As Lefebvre holds, this reified space, just as the commodities that "hide something very important," i.e., relations of labour (81), is a fetishized space.

The conflict between domination and servitude in Anderson's films is played out through the production of space. His films defy the reifying tendency of the capitalist ideology which conceives of space as "abstract spatiality" or "segmented space." Attacking the concept of abstract spatiality, Anderson produces space as a field of contention between social forces. The scene in which Gustav first meets Zero in *The Grand Budapest Hotel* is quite instructive in this respect. Here Anderson utilizes other visual strategies in combination with the abrupt tilt of the camera to undermine the relations of domination and subordination. While Gustav's close up fills the right side of the scene's foreground, Zero appears in a long shot

behind him on the left side of the same scene's background. The presence of both Gustav and Zero in the same frame, as they assume emphatically unequal importance in terms of their spatial position and distance to us, invests Gustav, who is in close up, with unquestionable mastery while Zero's stature remains diminished in the background. And yet, from this very first encounter, Gustav's ascendancy remains precarious as he enters into a complex relationship with Zero, a relationship which also manifests deeply oedipal dimensions. Perhaps, the best way to describe the oedipal aspect of their relationship is to articulate it in terms of history, in terms of a nostalgic and comically chivalrous past that is doomed (obviously associated with Gustav) and a new era of loneliness, angst and guilt, which the old Zero, Mr. Mustafa (F. Murray Abraham), evokes. After all, the very unconcealment of social relations in space stirs up the forces of history of which the militarization of the Grand Budapest Hotel is an obvious metaphor as war in all its enormity sets in. Needless to say, Gustav cannot survive the historical transition that relegates the utopian space of the hotel, whose values he embodies, to a space of decay and shared loneliness.

Let us return to the scene of the first encounter between Gustav and Zero. Here the placement of Gustav in the scene's foreground and Zero in its background initially articulates their status of mastery and subservience respectively. However, a straight cut to Zero's close up, which centers him in the frame, suddenly reconfigures relations of power; it is as if Zero had all of sudden usurped

Gustav's position of authority. The unstable relations between the two continue to fluctuate as Anderson cuts to Gustav's close up standing alone in the right side of a frame whose left side remains empty, a visual move that restores Gustav's mastery within an abstract space from which social relations have been expelled. But Zero immediately enters the frame from the right and a conflict ensues which finds expression in Zero's urge to take from Gustav's hand the coin which Madam D (Tilda Swinton) has given to the famous concierge to light a candle for her in the sacristy of the Cathedral of Santa Maria. Here oedipal rivalry transpires in spatial terms as equal, but counterbalancing, pressure by both characters to occupy the center, ironically keeps them both fixed on the margin on the right and left sides of the frame. The instability of power relations and the battle for centrality is further complicated as a sudden tilt upward turns the camera's attention away from Gustav and Zero to Mosher (Larry Pine), an assistant of Gustav, who emerges from a window above them. The use of the upward tilt reframes the scene by turning it into a low angle shot from Gustav and Zero's point of view, a technique which communicates their position of inferiority *vis-à-vis* Mosher. The upward tilt visually punctuates the transfer of power to Mosher as he takes up the frame's center in a continuous and yet unstable space of social relations. This symbolic exchange of power is further emphasized by a cut to Mosher's point of view, which frames Gustav and Zero within a high angle shot, a technique that invests Mosher's point of view with a position of mastery. This process of symbolic exchange, or shift in power relations, appears as an ongoing process

in Anderson's films. The analysis of these series of scenes only shows how complex is the use of space by Anderson as he impregnates it with constant fluctuations of social relations and a perpetual competition for mastery.

What all this tells us about Anderson's cinema? What distinguishes Anderson from the majority of contemporary filmmakers is his critique of what Fredric Jameson calls "layering or sedimentation" (201) in a text, a repression of the ideologically undesired content by keeping the focus of the narrative on a central character. In Jamesonian terms, Anderson unmasks this strategy of containment, which inscribes a particular representational space to exclude all threatening ideological investment. Anderson's visual strategies expose what Jameson calls the "underside or *impense* or *non-dit*" of the film's text, a move that brings to the fore the underlying fractures and tensions that are rife in the social space of his films.

--------------------------------- **Works Cited** ---------------------------------

Bachelard, Gaston. *The Poetics of Space.* Trans. Maria Jolas. New York: Orion Press, 1964.

Hyppolite, Jean. *Genesis and Structure of Hegel's Phenomenology of Spirit.* Trans. Samuel Cherniak & John Heckman. Evanston: Northwestern University Press, 1974.

Jameson, Fredric. *The Political Unconscious: Narrative as a Socially Symbolic Act.* New York: Cornell University Press, 1981.

Kolker, Robert. *A Cinema of Loneliness: Penn, Stone, Kubrick, Scorsese, Spielberg, Altman.* Oxford: Oxford University Press, 2011.

Lefebvre, Henry. *The Production of Space*. Trans. Donald Nicholson-Smith. Oxford: Blackwell, 1991.

Ross, Kristin. *The Emergence of Social Space: Rimbaud and the Paris Commune*. Minneapolis: University of Minnesota Press, 1988.

Wollen, Peter. *Signs and Meaning in the Cinema*. New York: Palgrave Macmillan, 2013.

Empathy, Disgust, and the Primal Aesthetic of Steve McQueen III[1]

Nojang Khatami

> I would hurl words into this darkness and
> wait for an echo, and if an echo sounded, no
> matter how faintly, I would send other words
> to tell, to march, to fight, to create a sense of
> the hunger for life that gnaws in us all, to keep
> alive in our hearts a sense of the inexpressibly
> human.
> —Richard Wright, *Black Boy (American*
> *Hunger)*

> …what would art be, as the writing of history,
> if it shook off the memory of accumulated
> suffering [?]
> —Theodor Adorno, *Aesthetic Theory*

Hunger (2008), Steve McQueen's feature directorial
debut, opens with a black screen and a distant roar. The
clamour crescendos, and when it reaches a steady climax,
its source comes into view: protestors clattering tin plates

1 I would like to thank the editors, Amir Ganjavie and Mahmood
Khoshchereh, for their helpful comments, and Martha Nussbaum for
insights and clarification about her work.

against a concrete surface. Later, in what is perhaps the film's most disturbing scene, a similar din reverberates. This time, riot police are in the act of subduing prisoners, beating them with clubs, prodding and probing them like cattle, and forcefully washing them. All the while, they bang their batons against their shields to create the same steady, pulsing noise that lingers faintly throughout the silence of the other scenes. One of the policemen is so unsettled by the violence that he escapes to a corner where he cries uncontrollably. As viewers, some of us may be affected in a similar way and ask why we subject ourselves to watching this kind of film in the first place! What is it that makes McQueen's films worth seeing and thinking about? What relation do his themes of defilement, disgust, suffering and perseverance have to modern life?

I want to argue that McQueen is essentially a modern tragedian whose function as an artist is to evoke primordial impulses in the same way that ancient dramatists have presented them. Taking Greek tragedy as my starting point in this paper, I map out the ancient Greeks' preoccupations with defilement and purity while connecting them to the modern notion of empathy. McQueen's work, I maintain, represents the same spirit of empathic bonding that the ancient Greeks promoted through theatre. His films provoke a strong reaction in viewers through repulsion and distress, aiming to extend their emotional capacities and making them more responsive to sensory stimuli, particularly the pain of others. They compel modern audiences to take the perspectives of characters that persevere through extreme

circumstances for the sake of understanding those others at a deeper level. To supplement this analysis, I engage with the theories of Paul Ricoeur, Martha Nussbaum, Michel Foucault, and Giorgio Agamben, who together illuminate the importance of inclusion in the political sphere. This leads me to identify McQueen's work as notable in its attempts to create space for dialogue and inclusion, helping to forge empathic connections among people from all walks of life.

Throughout the course of my inquiry, I emphasize the point that McQueen's modern conception of tragedy – while still focusing on human fallibility, debasement and purification through catharsis – is above all concerned with *resilience*. Critically examining his major films and offering an interpretation of their social value, I conclude that *12 Years a Slave* is his most significant work, combining a compelling narrative with empathic force and social critique. It also marks McQueen as an American filmmaker insofar as he is concerned with questions that relate to the American political ethos. In drawing on a primal aesthetic to delineate his themes, McQueen stands out among contemporaries as a masterful modern tragedian and an important voice for political inclusion.

Defilement and catharsis in ancient tragedy

The ancient Greeks passed on the magic of theatre to the western world. They were, of course, not the only peoples to practice this art, but the profound way in which they elaborated it and the scope of their influence make it safe to say that they cast a spell of enchantment

over myriad peoples and civilizations after them. The Greeks recognized that there was something mysterious and profound in theatre. They saw the practice of this art as confrontation with Dionysus, the god of wine, madness and ecstasy, the patron and epitome of theatrical art. To be engaged with theatre was to stare Dionysus in the face, wide-eyed and mouth agape, an expression of awe, terror and pity. Actors in Athenian plays wore masks to convey these feelings. If we bear in mind that for the Greeks the word for mask (*prosopon*) also literally meant "face," we begin to see the significance of *imitation* as central in the purpose of theatre.

The symbolic confrontation with Dionysus in theatre evoked powerful emotions: audiences were meant to mirror his overwhelming image, to feel overwhelmed, in order to lose themselves in this imitative act. Friedrich Nietzsche describes this experience memorably in *The Birth of Tragedy* when he speaks of the terror which seizes individuals when they lose their sense of individuality. Nietzsche expands this idea more fully in the following way: "If we add to this terror the blissful ecstasy that wells from the innermost depths of man, indeed of nature, at this collapse of the *principium individuationis*, we steal a glimpse into the nature of the *Dionysian*, which is brought home to us most intimately by the analogy of intoxication" (36). Engaging with Dionysus through art is analogous to drinking wine, letting go of oneself so as to enter into communion with others and with the world:

Under the charm of the Dionysian not only is the union between man and man reaffirmed, but nature which has become

alienated, hostile, or subjugated, celebrates once more her reconciliation with her lost son, man... Now, with the gospel of universal harmony, each one feels himself not only united, reconciled, and fused with his neighbour, but as one with him, as if the veil of *maya* had been torn aside and were now merely fluttering in tatters before the mysterious primordial unity. (37)

Nietzsche thus highlights the vital function the Dionysian fulfils in affirming life and transforming individuals into something better, something more. But how is tragedy supposed to achieve this goal? How can something so dark and somber lead to transcendence and a celebration of life?

To answer this question, it helps to go back to Aristotle, who affirmed that the concept of *mimesis* is central to poetic arts. At a fundamental level, mimesis simply means imitation, but the term has been employed in many different ways and, therefore, exhibits a much greater complexity. "It is an instinct of human beings," Aristotle claimed, "to engage in mimesis" (*Poetics* 1448b4-5). This means that we naturally like to imitate one another and represent things in various ways so we can contemplate them. But when employed in art, and particularly in tragedy, mimesis acquires greater weight and importance. Aristotle defined tragedy as "mimesis of an action which is elevated, complete, and of magnitude" (1449b23-25). The word he used for "elevated" is *spoudaios*, which implies gravity of tone and ethical importance. Put simply, tragedy is significant in the sense that through mimesis of action—the imitation of real life in the imaginary world of the stage—it creates a spectacle with meaningful ethical

implications. Tragedy transforms its audience. By taking the form of a ritual, its purpose is to bring about *pathos* or suffering in the performer. Tragedy invokes pity and fear, processing those same emotions through catharsis. It is important to note that the point of catharsis was not simply to cry for the sake of crying. The idea was for observers to genuinely feel for the actors or, more in line with the literal definition of empathy, *feel into* their state of mind and suffer for the sake of understanding. Hence mimesis allowed those entering the realm of Dionysus to take part in a ritual sacrifice and, in so doing, reinforce bonds among themselves.

Building on Aristotle's account, Paul Ricoeur has left us with a concise demonstration of the transformative power of tragedy. In *The Symbolism of Evil*, he traces the role of defilement in shaping our concepts of sin and how it leads to feelings of guilt. Throughout his monumental study, he also explains how we as humans shed those negative feelings and, in so doing, come to better understand one another. What this genealogy offers to those interested in theatre, both ancient and contemporary, is very instructive.

Defilement is a concept that all civilizations live with, a constant source of anxiety we all bear. "Dread of the impure and rites of purification," Ricoeur tells us, "are in the background of all our feelings and all our behaviour relating to fault" (25). This striking claim is intuitively verifiable. We fear germs, we avoid dirt, we are made uneasy by disorder, we eschew those who are diseased, and the list goes on. These feelings constitute a kind of obsession that equates "civilization" with cleanliness and

purity, and though it has become more pronounced in the past two centuries,[1] it remains an elemental emotion. What is truly significant about this primal instinct is the tremendous *symbolic* power it wields over our collective imagination.

As Ricoeur reminds us, myths, religions and other human inventions have appropriated our impulsive reactions to abhorrent things in the world and institutionalized them. Defilement "furnishes the imaginative model on the basis of which the fundamental ideas of *philosophical purification* are constructed" (34). It is a "symbolic stain" that we try to remove by purgation. Think of the imaginary blood on Macbeth's hands after he has murdered King Duncan, the sense of dread and guilt that consumes him as he cries: "Will all great Neptune's ocean wash this blood/ Clean from my hand?" Lady Macbeth follows these famous lines with two of her own: "My hands are of your colour; but I shame/To wear a heart so white." In our worst moments, through all actions we consider immoral, we are guided by a primal repulsion toward defilement and a longing for symbolic purity.

The sense of defilement, along with the repulsion it engenders, is practically useful in many ways—and perhaps crucial to the development of civilization—but it

1 Consider Freud's assertion that "the development of civilization might be charted according to increases in the use of soap": "[A]s civilization progresses the fear of what cannot be tolerated by it – for example, dirt – is all the more acute. Soap is meant to help preserve the self from harbouring whatever might stick to it – and get into it – from outside." Quoted in Ross Wilson, Theodor Adorno (London: Routledge, 2007), 21.

can also wear the ugly masks of exclusion and oppression. The thing or person that has been defiled is also seen as capable of defiling others; it is a contamination, a source of disgust, a pollutant; therefore it must be cast out so that "we" can keep ourselves pure. While that remains a concern in many different contexts, the point to be stressed about tragedy is that it helps us to go *beyond* disgust rather than exclude those associated with it. One final example about the ancient Greeks will illustrate how they sought to transcend defilement, not only to purify themselves ritualistically but also to humanize others.

In the *Philoctetes* of Sophocles, we find the title character on the desert island of Lemnos. He has been banished here on account of the grievous injury to his foot after being bitten by a venomous snake. His pain gave his fellow Grecians "no peace" and his "discordant screams and savage yells" were too much for them to take (8-10); and so he was dragged here and left behind by Odysseus with only "savage beasts" to keep him company. Odysseus becomes the play's antagonist. Having abandoned Philoctetes to cruel exile, he now returns with Neoptolemus and a group of sailors to "entangle Philoctetes by deceit" and bring him back to help win the war against Troy. The play then unfolds as a fascinating confrontation between this once-forgotten, dehumanized figure and the men who now need him.

When Odysseus and Neoptolemus first enter Philoctetes' cave, they are surprised at the wounded man's wretched

living condition, and the latter exclaims, "Faugh![1] and here/ Spread in the sun to dry, are filthy rags/Dank with the ooze of some malignant sore" (38-39). Immediately, Philoctetes is seen as despised, as a source of revulsion. The fact that the audience has not yet seen Philoctetes distances him even more as Odysseus refers to him only through dismissive comments. Odysseus is even reluctant to tell Philoctetes' story and sees him merely as a means to an end: "what skills it now/To tell [his] tale? No time for large discourse/That might betray our presence and undo/ The plot I've laid to catch him presently" (10-13). But as Neoptolemus finds out more about the man, so too does the audience gain a better understanding of his condition.

On first encountering Neoptolemus, Philoctetes evokes pathos and asks him to take his perspective:

> Picture, my son, when I awoke and found All gone, what waking then was mine; what tears, What lamentations, when I saw the ships In which I sailed all vanished; not a soul To share my solitude or tend my wound. All ways I gazed and nothing found by pain. (278-283)

This pain is fully felt by the chorus, whose members exclaim, "Pity, my chief!/pity a tale of agonizing grief!/ Pray god no friend/Of mine may ever come to such an end! (507-509). Witnessing his agony, Neoptolemus is also moved as he and the chorus cast aside their fear of

1 The original Greek text reads ἰοὺ ἰού, an expression of surprise or disgust. The Jebb translation of the text renders this simply as "Ha!" See The Complete Plays of Sophocles, ed. Moses Hadas (New York, Bantam Books, 1967).

coming in "closer contact with [Philoctetes's] malady."
Neoptolemus says his heart is "strangely wrought" and
since encountering Philoctetes, he has "been moved
with pity for the man" (963). He is so moved that he
tells Philoctetes about Odysseus' stratagem and is even
ready to fight his former ally. In one of the play's most
interesting lines, he tells Philoctetes that he has come
to him as "another man" (1274), a statement that points
to his transformation through pathos. The play in a way
ends happily as Philoctetes is eventually convinced to go
willingly to fight against Troy, but it is still viewed as an
edifying example of tragedy.

As Martha Nussbaum reminds us, tragic compassion
was outlined by Aristotle in a way that remains quite
relevant today. His list of common occasions for tragic
compassion is divided into the categories of painful
things, and things resulting from bad luck (263). More
specifically, Nussbaum shows almost all of the elements
within these categories are found in the *Philoctetes*:

> In the first group are deaths, bodily damages,
> bodily afflictions, old age, illnesses, and lack of
> food. In the second group are friendlessness;
> having few friends; being separated from
> one's friends and relations; ugliness; weakness;
> deformity; getting something bad from
> a source from which you were expecting
> something good; having that happen many
> times; the coming of good after the worst
> has happened; and that no good should befall
> someone at all, or that one should not be able

to enjoy it when it does. Philoctetes has every item on this list excepting old age. (263)

Nussbaum's exploration of disgust and compassion frames Philoctetes in a useful way: "As the men of the chorus vividly imagine the life of a man whom no human eye has seen for ten years, a man whose very humanity has been rendered invisible by ostracism and stigma, they stand in for, and allude to, the mental life of the spectators" (258). In other words, the audience members were meant to view the dehumanized protagonist in such a way that they too would feel what Neoptolemus expressed, having their hearts "strangely wrought" for Philoctetes. Nussbaum puts this succinctly in light of her argument: "Tragic spectatorship cultivates emotional awareness of shared human possibilities rooted in bodily vulnerability" (258).

This bodily vulnerability is a reminder that we are all human beings, that we can all be subjected to the hardships and sufferings in Aristotle's tragic categories. The Greeks held theatrical performances in festivals to keep reminding themselves of this, and in these plays, "the accent was on civic reflection and instruction" (260). Such plays aimed to humanize audiences, to overcome disgust, which "operates by representing the other as a base animal, utterly unlike the (allegedly) pure and transcendent self" (262). Going back to Ricoeur's analysis, we can see how ritual purification could involve an immersion *into* what is considered disgusting and defiled, only to emerge *out of* it feeling changed.

The civic function of tragedy for the Greeks lay in

the fact that it was viewed as an obligation and a ritual. Performance and sacrifice went hand in hand for them, clarifying the purpose of drama: the expurgation of pollution. Pollution was anything that defiled, dirtied, or made people impure. According to Ricoeur's analysis, it operated at a complex figurative level, though it was grounded in a reaction to real physical presences. For the Greeks, the symbolic purification of the individual and the polis was enacted in part through the ritual of theatre: "Through the spectacle the ordinary man enters into the "chorus" which weeps and sings with the hero; the place of tragic reconciliation is the "chorus" and its lyricism. By entering into the tragic "chorus," we also pass from the Dionysiac illusion to the specific ecstasy of tragic wisdom" (Ricoeur 231).[1]

Theatre was a particularly fruitful venue for mutual understanding because it allowed for the mimetic faculties of compassion and perspective-taking to be immediately felt. It permitted the Greeks to feel into one another's

1 Another example of this is found in Oedipus Tyrannos. As this play shows, the pollution (or "miasma") of the individual is also the pollution of the city-state. By killing his father, Oedipus engages in "miasma-making" (miaiphonein) and in so doing contaminates the polis. According to Aristotle's Poetics (1449b, 24-28), the antidote to this miasma is katharsis, or, again, ritual purification. In the drama, Oedipus was to sacrifice himself in order to set things right, to reintegrate the cosmos. Hence in Oedipus at Colonus, he is swallowed up by the earth, turning into a benevolent power that will serve as an eternal defence for Athens. While this was enacted in the play, it was also meant to be felt by the audience who, through suffering with the hero, were meant to set things right in their own minds. For this analysis, I'm indebted to Gregory Nagy's Harvard lectures on ancient Greek civilization.

experiences and reinforce bonds among themselves through empathy. Clearly, this remains relevant for us in the twenty-first century, not only at the level of particular political communities but on a global scale.[1] Martha Nussbaum's oeuvre is notable in its efforts to keep these feelings alive. In *Political Emotions: Why Love Matters for Social Justice*, she uses the example of Philoctetes among others to argue that

> [a]ll societies need to manage public grief in ways that do not defeat aspiration, and to extend compassion from the local to the general in appropriate ways. All need, too, to create an attitude to the bodies of others that helps citizens overcome a bodily disgust that can easily turn aggressive. Large modern nations cannot precisely replicate the dramatic festivals of ancient Athens, but they can try to understand their political role and find their own analogues—using political rhetoric, publicly sponsored visual art, the design of public parks and monuments, public book discussions, and the choice and content of public holidays and celebrations. (261)

While she goes on to say more about these possibilities

1 Numerous books have been published in the past few years precisely on this subject. See, for example, Jeremy Rifkin, The Empathic Civilization (New York: Penguin, 2009); Frans de Waal, The Age of Empathy (New York: Three Rivers Press, 2010); J.D. Trout, Why Empathy Matters (New York: Penguin, 2010); and Bruce D. Perry and Maia Szalavitz, Born for Love: Why Empathy is Essential—and Endangered (New York: HarperCollins, 2010).

with brilliant examples, Nussbaum says very little about cinema.[1] I would argue that modern cinema is our closest equivalent to ancient festivals. As one scholar has put it, film for us moderns is a way of reliving the primordial feelings that the ancients experienced through myth, theatre and spiritual ceremonies: watching a film "in our modern trance state, we feel elated. We feel scared, threatened. We become horrified. We anticipate psychic healing and receive it" (Hill 20). In modern societies, these powerful affective drives are no longer practiced through tribal dances or dramatic festivals sanctioned by the city-state; yet we engage with the same emotions through other means, as in the voluntary act of going to the movie theatre: "As ironic modern worshipers we congregate at the cinematic temple… we hush in reverent anticipation as the lights go down and the celluloid magic begins. Throughout the filmic narrative we identify with the hero. We vilify the antihero. We vicariously exult in the victories of the drama" (3). Even if this is not *exactly* what the Greeks did in their engagement with theatre, it is hard to deny that the typical movie-goer's experience is something very similar to the mimetic confrontation with Dionysus: forgetting ourselves, losing ourselves briefly in

1 She does mention Lagaan, a Bollywood film that exemplifies the festive spirit of pluralism in modern India, but in discussing tragedy and injustice in the United States, she speaks only about rhetoric, memorials, and literary works like Native Son. These are very useful examples, and the lack of further engagement with cinema should take nothing away from her thought-provoking analysis. I would only aim to supplement the work carried on by her and others by drawing more on film, which in my view is closely analogous to the tragic and comic festivals of the Greeks.

the lives of others. In that sense, the function of theatre as a channel for empathizing with and understanding others remains very much with us. And it is perhaps best exemplified in the work of Steve McQueen III.

McQueen's *Hunger*

Returning to that opening scene from *Hunger*, we should ask again what McQueen is showing us and what this means for our understanding of defilement, disgust and empathy. That gradual build-up of noise in the beginning can be seen as signifying the primordial forces that flow like magma beneath the seemingly undisturbed surface of everyday life. If we contrast the clatter with the silence of the scenes that follow, this foreshadowing becomes clearer. In the beginning, the setting and context are explained: Northern Ireland, 1981, at the height of "the Troubles." The British government has withdrawn the political status of all paramilitary prisoners. Those in the Maze Prison are on a "blanket" and "no wash" protest. All these facts carry ominous undertones, but McQueen is very patient in developing them.

Though violence is a constant presence in the film, it is only hinted at in the first few scenes. As prison officer (Raymond Lohan) stands over a sink and dips his bloodied knuckles into the water, it is clear that he is in pain, but the source of the pain is not yet revealed. Is his partially hidden suffering over the sink, as he looks at himself briefly in the mirror, the result of beating prisoners or did he hurt himself in some other way? Following him through his meticulous morning routine, we are shown

not only the banal beginning to the policeman's day but also the paranoid inspection of his surroundings, further suggesting impending violence. Several close shots of his knuckles help build tension and urgency; he grows quieter; the scenes grow bleaker. Then we hear the first of two excerpts from Margaret Thatcher's speeches: "There is no such thing as political murder, political bombing or political violence. There is only criminal murder, criminal bombing and criminal violence. We will not compromise on this. There will be no political status." The political status of the prisoners in the Maze will not be recognized because they have committed violence against the state. Turning his gaze toward these prisoners, McQueen begins to detail their dehumanization, the violence that is done to them.

When the first prisoner (Davey Gillen) shown in the film arrives at the Maze, he demands to wear his own clothes; he is listed as a non-conforming prisoner and the camera lingers in the scene as he undresses. The officers watch him silently and, when he is naked, take him away. In the next scene, he is shown walking with blood on his head. The violence and defilement that McQueen has so far concealed begin to materialize on the screen. When Davey is locked up in his new cell, the filth is immediately visible. Ubiquitous excrement – the camera traces it across the floor, over a blanket with a bible, and on the walls, where it almost looks like art. Davey is overwhelmed at first. Seeing his new cellmate, he does not know how to greet him. After they begin talking – the first real dialogue in the movie – their united purpose is spelled

out. Their aim is to immerse themselves in defilement, to use disgust as a form of protest. They spill their urine from under their cell door into the corridor. They live with maggots and flies. They masturbate in secret. Debasement and disorder swell.

In a fascinating analysis of political power, Elias Canetti writes:

> Anyone who wants to rule men first tries to humiliate them, to trick them out of their rights and their capacity for resistance, until they are as powerless before him as animals. He uses them like animals and, even if he does not tell them so, in himself he always knows quite clearly that they mean just as little to him; when he speaks to his intimates he will call them sheep or cattle. His ultimate aim is to incorporate them into himself and to suck the substance out of them. What remains of them afterwards does not matter to him. The worse he has treated them, the more he despises them. When they are no more use at all, he disposes of them as he does of his excrement, simply seeing to it that they do not poison the air of his house. (245)

There are several connections between this passage and McQueen's film. Both of them are getting at something very important in the exercise of bio-power, a term that helps to clarify the film's depiction of the control of bodies within the prison. Over and above the typical disciplinary power of the sovereign to control bodies,

Foucault uses bio-power to "designate what brought life and its mechanisms into the realm of explicit calculations and made knowledge-power an agent of transformation of human life" (*The History* 143). Bio-power is not merely the capacity of the sovereign to have people put to death; rather, it claims to know what kind of life is best for subjects in order to regularize them accordingly (*Society* 246). Considering Thatcher's abovementioned speech, we can see how the British government ordained that the prisoners lacked political rights because it "knew" that they were not political dissidents but rather criminals; and as such, their bodies had to be regulated and controlled to the point of being treated like cattle. They were given food and clothing and were expected to use these to sustain a bare life. They were to be kept clean. The state, not killing them outright, opted for the supposedly more humane route of "making live and letting die" (247). In their extreme circumstances, however, they could be treated as less than human because they were stripped of political rights.

Taking Foucault's arguments a step further, Giorgio Agamben has famously outlined the paradox of *homo sacer*: the man who is sacred (untouchable) in one sense, but also a non-person in that he can be killed with impunity (71-72). The Sovereign – again embodied in McQueen's film in Thatcher's voice – can decide to suspend law in the state of exception and designate who is and who is not included in the political realm. Those placed outside the political sphere are not truly citizens: they live a bare

life that is excluded from what the state decrees as good.[1] As such, *homo sacer* may be dispensed with in the same unceremonious way as is done with excrement.

What is striking about McQueen's portrayal of events in *Hunger* is the way in which he takes precisely this element of *desecration* to show how the prisoners resist bio-power and what form the attempts to reduce them to *homo sacer* take. Through their protests and wilful acts of defilement, the prisoners *re*-humanize themselves and refuse to be dispensed with easily. They poison and contaminate the air and spread this pollution to the state to voice their demand for recognition.

The resilience of the Irish Republican volunteers is felt most emphatically with the appearance of Bobby Sands (Michael Fassbender). The first time we see him, he is being battered by the prison guards who forcefully cut his hair, smear him with blood and carry his limp body back to his cell. Through the escalating violence, we are shown the cause of prison officer Lohan's wound as he strikes the wall while trying to hit Sands. The experience seems to wound Lohan in other ways, and we could say he has also figuratively come up against a wall. Caught in a game of violence he had not anticipated, he becomes disconnected from those around him. Later, as he tries to speak to his unresponsive mother in a nursing home, he is abruptly

1 In Agamben's summary, "The sovereign sphere is the sphere in which it is permitted to kill without committing homicide and without celebrating a sacrifice, and sacred life - that is, life that may be killed but not sacrificed - is the life that has been captured in this sphere" (83, original emphasis).

shot in the head by a member of the IRA, falling pitifully into her lap and covering her with blood. It is at this point, when the violence seems to be consuming everyone, that McQueen shifts his focus to Bobby Sands, trying to give some insight into why all this is happening and what Sands' motivation is for continuing on his chosen path.

In the film's most famous scene—a single take spanning over seventeen minutes—Sands sits down with a moderate Belfast priest and reveals the source of his beliefs, his spirit. After some "idle banter," the conversation turns to religion and the aims of the Irish Republican movement. Sands refuses to negotiate with the British government until the protestors' demand for political status is recognized. Incredulous, the priest asks Sands where he gets his energy from. "I was a cross-country runner as a boy," he replies. This, as the priest says, explains a lot about Sands. Growing more fervent in his self-expression, Sands declares he is starting a hunger strike and is ready to die. His intention, like that of the protestors joining him, is to expose the state's brutality and humiliating actions by subjecting himself to bodily deterioration. In this sense, it is as though the corrosion of the body from hunger is meant to serve as an analogy for the state whose members are meant to become aware of bodily vulnerability and reconsider what is being done to these dehumanized subjects. Sands sees his impending death not as suicide but as murder. By letting him die, he implies, the state is killing him. He has been thrown into these circumstances, bound to his conviction. This is why he is ready to die. "I have my belief," he says, "and in all its simplicity it is

a most powerful thing." By this succinct remark, Sands conveys the essentially tragic element of the film and its subject: like a hero out of Greek tragedy, he believes that his own ruin will tune others into a different perspective.[1] Though McQueen insists his movie is not meant to be political,[2] he allows his characters to tell their stories and in so doing enable viewers to feel into their very human circumstances, their beliefs, and their vulnerabilities. As Bobby Sands says near the end of his narrative, "you need the revolutionary, you need the political soldier, to give life a pulse, to give life a direction." Whether or not viewers agree with this principle, the point is for them to try to understand why someone would think in such terms and be willing to die for it.

Following Sands' account, the state again tries to regulate the situation. As a prison guard ritualistically cleans the urine-soaked corridor, we hear again Thatcher's voice, countering the contamination with a sterile narrative:

> Faced now with the failure of their discredited cause, the men of violence have chosen, in recent months, to play what may well be their last card. They have turned their violence against themselves through the prison hunger strike to death. They seek to work on the most

1 I've discussed these themes above in relation to Philoctetes, but another example worth considering would be Sophocles' Antigone, which is more obviously political and contains many parallels to McQueen's film.

2 See "Director interview: Steve McQueen," Time Out, at http://www.timeout.com/london/film/director-interview-steve-mcqueen. Accessed October 9, 2014.

basic of human emotions, pity, as a means of creating tension and stroking the fires of bitterness and hatred."

It is remarkable that Thatcher here alludes to pity, only to deny it to the prisoners because they are men of violence. Her claim bears repeating: they have turned violence *against themselves*. From the point of view of the state, they remain *homo sacer*: unworthy of pity. And yet McQueen has portrayed the events in his film and explicitly evoked Thatcher's speeches to refigure the audience's sympathies, show them an alternate view and, in so doing, awaken tragic compassion.

The last twenty minutes of the film graphically detail Sands' deterioration. A description of his steady breakdown is accompanied by shots of his emaciated body, his sores, his muscles wasting away. Difficult as it is to watch, we may feel at this point that we cannot look away. Our empathy has already been triggered and, as distressing as it seems, we are *involved* in the scenes. Sands' suffering becomes our own. We may wince or even feel nauseated, but it is through these visceral reactions that we feel the tragedy most powerfully. Sands' bodily vulnerability makes us recognize our own (as with Philoctetes) and this gives us further entry into his perspective. As he revisits his childhood in his final moments, Sands becomes humanized in his act of shedding a tear; and maybe we shed a tear for him, with him. This all-too-human act (Vingerhoets 16-33)[1] is McQueen's reminder about

1 Vingerhoets emphasizes, beyond the physiological reasons, the cultural and behavioural origins of crying, which he summarizes as

the power of emotions in relation to tragedy, and it has become something like a signature in his work.

Narrative power and purification in *12 Years a Slave*

All three of Steve McQueen's feature films have ended with tears. The catharsis that he seeks to draw from the audience is enacted by the characters he depicts on the screen. If we take him at his word that his films have no strictly political purpose, it would seem as though he only wanted us to see the humanity of others, whoever they may be. But I would argue that this act itself is ethical and, by extension, political. In a sense, McQueen helps us understand how others suffer and thereby invites us to include them in our thoughts and our discussions in the political sphere.

Yet while I have said a lot about evoking emotions for this purpose, it is important to add that plot and narrative play an equally important role in the process. It is hard to take the perspective of just any character that we come across, and sometimes doing so would compromise our moral values. Consider the example of Alfred Hitchcock's *Psycho* (1960). As critics have noted, it is not unusual to empathize with Norman Bates, even after the famous scene in which he has just killed Marion Crane (Grodal 1997). We may feel the same sense of initial alarm in encountering her dead body; we may even undergo the same trepidation and anxiety as he meticulously cleans all traces of blood from the bathroom. But that

"the eliciting of care and protection, the promotion of social bonding, and the reduction of aggression" (33).

is because empathy on its own is capricious. It has to be led by reason and judgment in order to assume a moral dimension. Moreover, in feeling tragic compassion, we should remember Aristotle's categories mentioned earlier in the paper; in short, we have to know the story of the subject in order to feel that it is right to empathize with her. Otherwise we may be manipulated.

I have less to say about McQueen's second film, *Shame* (2011), largely due to the problems I have just mentioned. *Shame* seems not to live up to the precedent set by *Hunger* because the narrative does not seem as compelling. In this second effort, Brandon, played again by Michael Fassbender, struggles with his addiction to sex with such graphic intensity that it becomes difficult not to feel *something* as a viewer. But the underlying problem with *Shame* is that many viewers may not be able to explain exactly what they feel. Even in the final sequences when Brandon completely gives himself over to his addiction by immersing in the depths of debauchery and then experiencing a cathartic release after nearly losing his sister, it is hard to identify with him. As one critic sums it up, "we never know much about Brandon, let alone why he has his situation," and so our sympathy is likely to remain suspended.[1] The narrative does not seem powerful

1 See David Thomson's review at http://www.newrepublic.com/article/film/98146/shame-fassbender-mcqueen-mulligan. This of course does not reflect everyone's view of the film, but presents a strong case for rethinking why a character deserves our sympathy. Speaking about the character of Brandon, McQueen himself claims that "he's like us" in the sense that "we're all tragic,"; meaning he struggles with a recurring problem as all people do. But because

enough to induce strong tragic compassion. The case of
12 Years a Slave (2013) is, however, quite different.

McQueen's *12 Years a Slave* was, of course, adapted from
a slave narrative written in 1853 by Solomon Northup.
Recounting his disbelief after discovering the seemingly
forgotten story, McQueen writes: "This was astonishing!
An important tale told with so much heart and beauty
needed to be more widely recognized" ("Foreword" xiii).
Clearly, the narrative that provided the basis for the film's
script was already quite gripping, but there is something
more to be said about the particular power of the cinematic
version, which affects viewers at a deeper level. Aside
from the fact that many more people have seen the movie
than read the book, there is the phenomenological point
to be made about the *vision* of cinema. The experience of
watching a film is different from and more direct than
other modes. In seeing the images on the screen, we as
viewers are confronted by them; it is hard for us to imagine
things outside the way they are represented. In watching a
film, we are constantly engaged in making meaning out of
the words and images before us:

> Cinema thus makes the phenomenological
> concept of "intentionality" explicit; it becomes
> *sensible* as a materially-embodied and actively

we don't know why this is happening to him, and to what extent it
is his own doing (again going back to Aristotle's criteria for tragic
compassion), some of us may withhold sympathy to some degree.
For McQueen's take, see http://arts.nationalpost.com/2011/11/29/
shame-director-steve-mcqueen-on-sex-addiction-and-shame-its-
about-necessity-you-dont-enjoy-it/. Both articles accessed October
12, 2014.

directed structure through which meaning is constituted in an on-going sensual, reflexive, and reflective process that, entailed with the world and others, is always creating its own provisional history or narrative of becoming. In effect, *the cinema enacts what is also being enacted by its viewer.* (Sobchack 192, original emphasis)

This point is more instructive when viewed once more in relation to the ancient Greeks' uses of representation or mimesis. Again, through theatre, we face a different reality, which in turn affects our reality, our immediately felt sensations and our grasp on the world. McQueen's ability to harness this potential within a fascinating narrative gives *12 Years a Slave* not only empathic force but also ethical weight.

In the film's opening scene, we are instantly confronted with the watching faces of slaves in a field, waiting for their instructions. We know nothing about them as yet except that they already appear weary. As he did in *Hunger*, McQueen begins with banality: the tedium of work in the fields, the lulling melodies of "sorrow songs," the quotidian routines of sleeping and eating together, the general bleakness of life. Like the prisoners in the earlier film, the slaves say very little and simply persist through their bare lives. McQueen slowly draws us into that life in all its dullness, all the while foreshadowing the more palpable horrors to come.

The tragedy of Solomon Northup (Chiwetelu Ejiofor)is conveyed most cogently through the play of contrast in the

film. After the glimpse into his circumstances as a slave, we see Solomon at home with his wife, tuning and playing his violin, living a decent life. When the men from the circus arrive, there is already an ominous sense of fear and tension. In fact, we already know exactly what is going to happen, and we may worry about him. These feelings are confirmed soon after when, after a night of drinking with the men, Solomon wakes up to find himself in chains. He moves from astonishment to rage as he tries to free himself, and when his captors arrive they sadistically drive home the point that he is no longer free. As throughout most of the film, the depiction is mercilessly faithful to the original narrative: "Blow after blow was inflicted upon my naked body. When his unrelenting arm grew tired, he stopped and asked if I still insisted I was a free man. I did insist upon it, and then the blows were renewed, faster and more energetically, if possible, than before" (Northup 23). When the paddle breaks, his holder switches to a whip and beats him until he is reduced to sobbing and whimpering. The violence is already disturbing but, as in *Hunger*, we do not see his wounds right away. They are only implied through the beating and through the torn, bloody shirt that he exchanges for a new one. Here, the contrast with his former life is felt most painfully. The shirt he is forced to give away was a gift from his wife— the last physical link he had to her and to that world. Taking it away from him, his captor repeats "rags and tatters" as though alluding more figuratively to Solomon's identity.

Solomon's plight is rooted in nakedness. He is stripped

bare, forced to bathe in this state with the other captives in the yard. This is another motif that McQueen uses frequently in his films. Like *Hunger* and *Shame*, *12 Years a Slave* is full of nudity, which clearly has deliberate symbolic intent. Nakedness is analogous to bareness, vulnerability and humanity in its most uncovered form. Here in the yard, as later when they are put on display by the slave seller Freeman (Paul Giamatti), the black bodies are exposed in order to be dehumanized; they are stripped naked in order to be claimed by their scornful owners as property. Yet McQueen's conscious choice[1] is to lay bare the human animal's body in order to remind the viewers of their own animal bodies, their own vulnerabilities. Through this act, again, he re-humanizes the characters and admonishes his audience: as any of us can go through such defilement, we should be sensitive to the pain of others who go through it. Beyond this, he also wants to show us that Solomon, like all of us, does not simply want to persist through such a bare existence. Debating whether to risk death by fighting his captives or merely keep his head down and stay alive, he expresses this sentiment in what is probably the film's most poignant line: "I don't want to survive. I want to live."

Life on the plantation wavers between anguish and hope, and the audience is taken along with Solomon through this journey in all its tormented details. Beyond the moving story of Eliza (Adepero Oduye), who is separated from her children, we witness numerous disturbing scenes

1 In this case he actually strays from Solomon's narrative, where the captives are actually clothed prior to being sold. See Northup, 47.

ranging from grotesque to ironic. Solomon's first two masters, Ford (Benedict Cumberbatch) and Tibeats (Paul Dano), while portrayed as very different in character, turn out to be two sides of the same coin. Ford seems benevolent and caring toward his slaves, but as Eliza points out, he is still a slave-owner and sees her and Solomon as nothing more than property. And like so many others, he is happy to use Christianity in the service of this institution, conveniently ignoring its message of inclusivity and love. Tibeats, meanwhile, openly tortures and dehumanizes his slaves. His ugly song about runaway slaves demonstrates the senseless nature of life in these circumstances: singing that is supposed to bring joy ends up conveying nothing more than vain cruelty. His treatment of Solomon, almost amusing at first because of his arrogance, soon turns nearly fatal. In one of the film's most unsettling scenes, Tibeats taunts Solomon and tries to punish him for no reason. After Solomon fights back and whips him, he returns with two other men, binds Solomon with ropes and prepares to hang him. The overseer Chapin (J.D. Evermore) arrives to rescue Solomon, but even as Tibeats and the other men flee, Solomon is left hanging there with the noose around his neck, his feet barely touching the ground to prevent him from suffocating. McQueen unflinchingly portrays this horror before our eyes. As we watch Solomon struggle for a full three minutes, his gagging and grunting are felt more viscerally. With the exception of one fellow slave who at one point offers him water, others carry on as usual around him. His condition becomes harder and harder to bear—for the audience as for him.

The primal impulse I have referred to throughout this essay is probably most powerful in *12 Years a Slave* because of the way the plot and the representations on the screen draw the viewer into its world. The images are felt viscerally and processed cognitively, leading to a kind of merging between the viewers and the world viewed. Boundaries break down and, through the horrors witnessed, we enter a liminal space. This condition is comparable to Julia Kristeva's account of abjection in *Powers of Horror*. In her account, abjection is approached through exposure to what is improper and unclean—filth, waste, muck or anything that defiles—but this alone does not cause the condition. Rather, we reach it through a symbolic collapse of borders: "It is thus not lack of cleanliness or health that causes abjection but what disturbs identity, system, order. What does not respect borders, positions, rules. The in-between, the ambiguous, the composite" (Kristeva 4). With abjection, just as with Nietzsche's Dionysian moment, the principium individuationis collapses, and the "I" loses itself in the other. Ambiguity takes over. The subject, insofar as it tries to reassert itself, responds by resorting to convulsions and sobs. This is an instinctive reaction, reaching for elemental emotions. And it is through exactly this experience that we strive for catharsis again.

Returning to Aristotle's conception of catharsis, we should recall his point that its intent was not to achieve perfect purity, but rather to absorb contamination. As Kristeva reiterates,

Aristotelian catharsis is closer to sacred

incantation. It is the one that has bequeathed its name to the common, esthetic concept of catharsis. Through the mimesis of passions... the soul reaches *orgy* and *purity* at the same time....To Platonic *death*, which owned, so to speak, the state of purity, Aristotle opposed the act of *poetic purification*—in itself an impure process that protects from the abject only by dint of being immersed in it. The abject, mimed through sound and meaning, is *repeated*. Getting rid of it is out of the question." (28, original emphases)

This account is extremely useful in relation to McQueen's films, particularly *12 Years a Slave*. What McQueen seeks to do is to rivet viewers into the world he depicts and have them feel what the characters feel. The point is not to achieve anything like objectivity or a view from a distance. The condition of slavery in particular is not something to simply observe; it is to be relived so that we understand it in all its horror. Thus, the abjection, the defilement and the violence are far from gratuitous—they are necessary elements of the cinematic experience McQueen creates.

In the denouement of the story, we witness Solomon being whipped on numerous occasions, we see the flesh torn from his back, and we live with his wounds. Yet we may be even more disturbed by what happens to Patsey (Lupita Nyong'o), the female slave with whom the slave-owner Epps (Michael Fassbender) has an obsessive relationship. Caught between Epps' depraved desires and his wife's jealousy, Patsey begs Solomon to kill her, to put

her out of her misery. Solomon refuses and has to live with the guilt of this decision as Patsey is subjected to various atrocities. Near the end, in a scene heavy with symbolism, Patsey returns from another man's plantation with a bar of soap in her hand. In his jealousy, Epps confronts her and asks where she's been. Her honest reply is heartrending: she went to get some soap to clean the filth from her body. She stinks so bad, she says, that she makes herself gag. She is fully debased and longs for a modicum of relief through cleanliness. Incredulous and unmoved, Epps ties her up to the whipping pole and forces Solomon to start beating her. In this scene, we somehow witness Solomon losing part of himself as he becomes complicit in the terror and absorbed in guilt. As she faints from the pain, Patsey drops the bar of soap to the ground. Through all these ordeals, it seems, any form of purity remains out of reach.

In the end, the purification offered up to the audience is poetic and tragic. The hope for some redemption remains with us, as it does with Solomon. Through all the horrors— even after he breaks his violin in an act of despondent rage—Solomon still longs for happiness and freedom. When the hired labourer Samuel Bass (Brad Pitt) arrives and denounces Epps' treatment of his slaves, Solomon sees him as his last hope. He begs Bass to write to his family in the north. In the next scene, as he waits to see if Bass will deliver on his promise, he translates the possibility of salvation with an expectant gaze. In fact, his look in this scene tells us much more than that. Rendered poignantly by Chiwetel Ejiofor, the play of Solomon's

eyes, as he scans the distance and turns to stare almost directly into the camera, retells the whole anguished journey without any words. We feel his freedom coming, but when it does we see that it is wrought with the pain of all that he has been through. The weight of the tragedy remains in the lost years, in Patsey's desolation as he rides away in the carriage that will take him back home. The end is a pure cathartic release. Tears flow without restraint in the final scene as Solomon is reunited with his wife and children. After twelve years of separation, they are like strangers to each other, and this seemingly happy ending is tinged with sadness. Catharsis is more than purgation: the experience, the suffering, and the wounds remain very much with us.

Conclusion

> Even if a man has repressed his evil impulses into the unconscious and would like to tell himself afterwards that he is not responsible for them, he is nevertheless bound to be aware of this responsibility as a sense of guilt whose basis is unknown to him. (Freud, *Introductory* 411-412)

As Freud contended, living with our unconscious desires, our discontent, and our guilt is an onerous task. His grim outlook on humanity hinged on the question of "whether, and to what extent, the development of its civilization will manage to overcome the disturbance of communal life caused by the human drive for aggression and self-destruction" (Freud, *Civilization* 106). Many

today would say that we are "over" Freud, that things have gotten much better since the war-plagued time in which he was writing, and that human civilization has stood up to his challenge. Thus, Steven Pinker summarizes his authoritative tome on the subject: "For all the tribulations in our lives, for all the troubles that remain in the world, the decline of violence is an accomplishment we can savour, and an impetus to cherish the forces of civilization and enlightenment that made it possible" (696). Yet this account gives us pause for reflection—it is precisely the "troubles that remain" that are worth thinking about today. Political exclusion, racism and the many other legacies of more palpably violent times are still undeniable presences in the twenty-first century. We are, in many ways, still haunted by them.

How do we face the realities of injustice and exclusion? One way, as I have suggested in analyzing the work of Steve McQueen, is to recognize the stains of those evils within ourselves and confront them directly. This act would require us to move beyond repression, which Simon Gikandi delineates in two ways: in the form of "an operation whereby the subject attempts to repel, or to confine to the unconscious, representations (thoughts, images, memories) which are bound to an instinct"; and "as a defence, part of a group of operations intended to reduce and eliminate "any change liable to threaten the integrity of the bio-psychological individual"" (109). Gikandi vividly develops this account in relation to slavery as it operated in the eighteenth and nineteenth centuries, shedding light on the world depicted in McQueen's

film. He documents how its horrors were obscured and relegated to the unconscious, how the dullness of its day-to-day procedures glossed the fear of contamination (165-166). The pain of slaves was somehow unreal and unworthy of sympathy:

> [T]he regime of punishment, pain, and torture demanded the routinization of an efficient system of subjection. What this meant was that pain was not shared between masters and slaves nor did it demand or imply empathy. (180)

In no way were the dehumanized figures of the slaves to contaminate the purity of the masters' world. As I have argued, empathy and abjection are forms of emotional contamination, precisely the kinds of things that *should* disturb the integrity and stability of the self if that self is to be cultivated. This is what Steve McQueen offers to those in the present seeking to overcome the bitter legacies of the past. Instead of repressing disgust and other stirrings of the unconscious, he brings them to the surface.

Watching McQueen's films is undoubtedly difficult. In light of racial tensions and the scars of slavery and segregation, this may especially be true for an American audience. Yet in this sense, despite his British origins, McQueen is an American filmmaker and artist *par excellence*. Martha Nussbaum stresses the impactful role of art in inviting Americans to reassess their values: "there is nothing wrong with a nation's taking a stand, including an emotional stand, and a stand made vivid through the arts" (391). Like the great American artists she refers to in

her book, Steve McQueen takes a stand, albeit within the fluid, borderless state of humanity.

Humanity remains the most essential theme in McQueen's work. Whether dealing with political exclusion, addiction, or racism, his main purpose is to reassert the primacy of resilience in the face of all the forces with which we struggle. *Hunger, Shame* and *12 Years a Slave* confront us with this humanity. Evoking primordial impulses, they force us to reimagine lives we are unlikely to think about in our day-to-day activities; they shake off banality and disrupt the ordinary. In that sense, McQueen is to modern societies what tragedians were to classical Greece. He serves not only as a creative interpreter of the past, but also a dissident voice for the present. Rebelling against dehumanization, he reminds us that all our tribulations are a common struggle, and that we should therefore try to view the world through one another's eyes. In this sense, McQueen's films are reflections of both the pitiful depths and dignified heights of humanity.

Works Cited

Agamben, Giorgio. *Homo Sacer: Sovereign Power and Bare Life*. Trans. Daniel Heller-Roazen. Stanford: Stanford University Press, 1998.

Aristotle. *Poetics*. Trans. and Ed. Stephen Halliwell. Cambridge: Harvard University Press, 1995.

Canetti, Elias. *Crowds and Power*. New York: Penguin Books, 1981.

Foucault, Michel. *The History of Sexuality Vol.1: An Introduction.* New York: Pantheon Books, 1978.

Foucault, Michel. *Society Must Be Defended: Lectures at the College de France, 1975-1976.* New York: Picador, 2003.

Freud, Sigmund. *Introductory Lectures on Psycho-Analysis.* Trans. and Ed. James Strachey. New York: W.W. Norton & Company, 1966.

Freud, Sigmund. *Civilization and its Discontents.* New York: Penguin Books, 2002.

Gikandi, Simon. *Slavery and the Culture of Taste.* Princeton: Princeton University Press, 2011.

Grodal, Torben. *Moving Pictures: A New Theory of Film Genres, Feelings, and Cognition.* Oxford: Clarendon Press, 1977.

Hill, Geoffrey. *Illuminating Shadows: The Mythic Power of Film.* Boston: Shambhala Publications, 1992.

Kristeva, Julia. *Powers of Horror: An Essay on Abjection.* New York: Columbia University Press, 1982.

McQueen, Steve. "Foreword." *Twelve Years a Slave.* Solomon Northup. Ed. Henry Louis Gates, Jr. New York: Penguin Books, 2013.

Nietzsche, Friedrich. *Basic Writings of Nietzsche.* Trans. Walter Kaufmann. New York: Modern Library, 2000.

Northup, Solomon. *Twelve Years a Slave.* Ed. Henry Louis Gates, Jr. New York: Penguin Books, 2013.

Nussbaum, Martha. *Political Emotions: Why Love Matters for Justice.* Cambridge: Harvard University Press, 2013.

Pinker, Steven. *The Better Angels of Our Nature: Why Violence has Declined.* New York: Penguin Books, 2011.

Ricoeur, Paul. *The Symbolism of Evil.* Boston: Beacon Press, 1967.

Sobchack, Vivian. "Fleshing Out the Image." *New Takes in Film-Philosophy.* Eds. Havi Carel and Greg Tuck. New York: Palgrave Macmillan, 2011.

Sophocles. *Philoctetes.* Trans. F. Storr. Cambridge.: Harvard University Press, 1962.

Vingerhoets, Ad. *Why Only Human Weep: Unravelling the Mysteries of Tears.* Oxford: Oxford University Press, 2013.

Wright, Richard. *Black Boy (American Hunger).* New York: Perennial Classics, 1998.

On the Cinema of Paul Thomas Anderson

Borna Hadighi

Ramin Alaei

Translated by Nojan Norouzi

Introduction

When the New Wave era of modern cinema took place, the studio system was on the verge of collapse and the first generation of auteurs was coming of age. At the same time, television was becoming a serious rival to the cinema and its impact on American culture was so great that Hollywood had no option but to go through major changes. During this period, the existing socioeconomic backgrounds were incongruent with the type of monopolistic production historically practiced in Hollywood, where the production system was previously a very practical manifestation of the post-Fordist capitalist system. This meant cinema was following the same paradigm of capitalism that was dominant after the First World War while seriously reforming the methods of the capitalist production system. This also involved a move from post-Fordist capitalism to the Package Dealing system. As a result, the massive Hollywood production industry had to adapt to the situation with no other alternative but to change

the system of preparation, production and distribution of films. Thus, the hierarchical vertical system or the trust-cartels of the 1930's, 40's, and 50's slowly gave way to a new system of work division: small studios produced the films and then another distribution company took responsibility for distribution and display.

Reforming the production system enabled the emergence of independent producers and directors outside the control of large studios and their monopolies. This in turn enabled the production of works that were more independent, radical and problem-oriented. With the intermediary help of inexpensive production, filmmakers turned to the younger people who had learned the grammar of cinema from European filmmakers rather than Hollywood directors. It is within this new economic ethos that Roger Corman became a symbol of independent producers and guided many young inexperienced filmmakers who would later become America's biggest names in film industry, including Martin Scorsese, Francis Ford Coppola and Bob Rafelson. Although Corman could not give any salary or money to these young filmmakers, he provided them with facilities and creative freedom, thus creating new experiences and opportunities for the young people who had recently graduated from film schools to combine their theoretical knowledge of the history of cinema with Corman's desired pragmatism, a union that enabled this new generation to dominate the cinema for the next decade.

However, it is important to clarify that what was called "Modern American Cinema" in the 1970's, and what we

view as the mode of production, representation, narration, and aesthetics in modern American cinema started exactly in 1967 with films such as *The Graduate* (Mike Nichols, 1967), *Bonnie and Clyde* (Arthur Penn, 1967), *Easy Rider* (Dennis Hopper, 1969), *Butch Cassidy and the Sundance Kid* (George Roy Hill, 1969) and *Midnight Cowboy* (John Schlesinger, 1969). This trend continued until the end of 1970's, especially 1977, with the predominance of American blockbusters, reaching its climax in the works of George Lucas and Steven Spielberg (See Robin Woods' *Hollywood from Vietnam to Reagan*). However, after this period, the rise of the Reagan and Thatcher era marked the establishment of a political discourse in the West which prioritized the entertainment-based space within the pattern of the cultural neoliberalism of 1980's. This meant that entertainment became an alternative to serious high art, a situation which naturally diminished all possibilities for the expression of radical, fundamental, and serious issues in cinema. Because politics lost priority in this period and gave way to entertainment and ordinary life in all its forms (in films from 1980s, elements of dancing and dance classes, amusement, teenage comedies, Arnold/Stallone action films, as well as collective pleasure became dominant), independent cinema was also stripped of its importance. Overall, if we sum up the evolution of American cinema from 1960 to 1980 in one sentence, we have to mention how John Wayne as an iconic American hero of the 60's was transformed into Woody Allen in the 70's, and then a further transformation produced the iconic bodybuilder heroes of the 80's. As Richard Corliss suggests, in addition to the special effects that were

used in action movies of the 80's, the bodies of stars also functioned as a type of special effect. The typical hero of the 80's action films is, in fact, a regression to the 60's and earlier.

Let us now look at the main source of inspiration which differentiates American independent cinema of 1980 onwards form the cinema of the previous decade. The 1970's generation was caught in-between the classical tradition of Hollywood studio system and the realm of modern European cinema. This situation, which turned them into an intermediary link between American classic cinema and its modern version, enabled them to function as catalysts for an inevitable transition. While believing in both genres and forms of classical cinema, they also gave expression to their own revisionary views about the principles on which these genres were based. Moreover, the concept of academic film studies is a significant key to understanding this generation. With its theoretical knowledge of cinema and unparalleled mastery of film history, this generation developed a penchant for modern pragmatism and created a context in which it could radically separate itself from predefined rules and conventions within the film industry. From one perspective, the American society and its emerging movements, such as equality-demanding civil movements of African-Americans in the 60's, anti-war movements of the 60's and 70's, and feminist movements of the 70's helped produce the conditions for a revisionary approach to filmmaking. The Vietnam War and the pictures and reports that informed the public about the catastrophe

that was taking place in that country gave such a dark and bitter twist to the tastes of the American society that the previous models of representation were no longer viable. As a consequence, issues and problems were expressed in much more biting fashions.

On the other hand, not only did the independent American cinema of the 80's have its roots in the classical tradition of Hollywood studio system and modern European cinema, it was also influenced by the American cinema of previous decade. At the same time, the position of the filmmakers who had graduated from universities from the 80's onwards was inconsistent with the position of American cinema during the previous decade. Therefore, some key directors in American cinema, such as Jim Jarmusch and Paul Thomas Anderson quit film schools before venturing into filmmaking. Another key aspect of the 80's independent cinema was the thematic conflict between this cinema and the dominant ideology of American cinema. If the problem-oriented and radical cinema of the 70's was inspired by social movements and was somehow born from them, the independent cinema, in the first place, stands in opposition to the cultural, political, and social ruling systems. For this reason, many fundamental features and themes of modern American cinema in the 70's were redeployed in the independent works of the 1980's and onward. The heroes in these films continued revealing complex and weary characters whose problems were fundamentally existential and, as a result, they had been left with no room for heroic action. The protagonists in most of these films resembled their

predecessors in previous decades that embodied all the virtues and tendencies of American middle-class heroes. However, existential despair and disappointment with peripheral relations and interactions compelled these heroes to abandon American middle-class values, such as work, family and social status, in order to pursue some kind of liberated individualism. This new and innovative type of hero-making in the 1970's, which is remembered as the period of traumatic heroes, defined the main characters of independent cinema during this period. These were characters whose wounds and sufferings did not heal at all in the end.

Another important and common aspect of filmmakers during this period was a quality of reflexivity or intertextuality that was full of tributes and praises for the history of cinema and works of other filmmakers. Quentin Tarantino, the Coen Brothers, Paul Thomas Anderson and Jim Jarmusch, among others, resembled the directors of the 1970's in that their movies, which were quite complex, paid tribute to their favorite films and filmmakers, a tribute which was the result of this generation's awareness of the history of cinema. From this perspective, the history of cinema is reflected in a fine and sophisticated form in their movies, an approach that is the result of their self-consciousness in this respect. Thus, these movies reveal a problematic tendency as they produce a series of unappeased heroes who are the direct outcome of social and political circumstances in this period in American history. For this reason, studying the favorite films and filmmakers of these directors can pave

the way for entering into their mental worlds.

If we look at the list of top ten favorite films of Paul Thomas Anderson, the first is *Putney Swope* (Robert Downey Sr., 1969), the second is *Nashville* (Robert Altman, 1975), and the third is *Good fellas* (Martin Scorsese, 1990). Of course, these choices confirm our claim raised in the introduction regarding the influences which filmmakers in the 80's and later on received from the previous generation of independent American filmmakers. However, the presence of Scorsese and Altman, as well as a close scrutiny of Anderson's career, will show that these two filmmakers have had the most thematic and formal impact on Anderson's films. Hence, exploring the common grounds between Anderson's films and the works of Altman and Scorsese would result in a more comprehensive and correct understanding of Anderson's cinema. The first thing that should be considered prior to the analysis of Anderson's films is that he always refers to a specific theme and moves from one person to another, sometimes expanding the subtle variations of that theme and at other times just repeating them. For this reason, it can be argued that in the American generation to which Anderson belongs, it is unlikely to find another filmmaker who imposes such a strong demand on the audience to see his films as a whole. This is notwithstanding whether we believe in the theoretical ideas about the auteur in the 60's or not. Therefore, we would base our analysis on the thematic elements and models that Anderson has borrowed, expanded and transformed throughout his career as a filmmaker.

America

As the creator of *Hard* Eight (1996), *Boogie Nights* (1997), *Magnolia* (1999), *Punch-Drunk Love* (2002), *There Will be Blood* (2007) and *The Master* (2012), Anderson, beyond mere semblances, examines the sentiments of a particular period in contemporary American history. For example, the world that Anderson creates around the porn industry in *Boogie Nights* reflects the 70's mood, whose differences with the ethos of the 80's are clearly emphasized. In the same fashion, *There Will be Blood* focuses on exhibiting the formation of modern America and the concepts of capitalism and colonialism, which stretch into early twentieth century. Similarly, the post-war America seems to be the most suitable period to portray the psychoanalytical trauma of *The Master*. This tendency reveals that America as a whole, and in its different periods, has always been a major issue for Anderson. However, sometimes capturing the sentiments of a particular period in American history gives way to an element, problem or concept that one can only understand and analyze by reading it in the context of America's historical, political, social, cultural and artistic structures. For instance, the central focus and dramatic form of Anderson's first two films, i.e., gambling in *Hard Eight* and pornographic industry in *Boogie Nights*, constitute concepts that can be read and expanded only within America's cultural and capitalist system. Additionally, the presentation of these concepts in *Hard Eight* and *Boogie Nights* is closely woven into the fabric of different lifestyles, which are linked respectively to Las Vegas and Los Angles, chiefly because

these two cities and their lifestyles have become equally important as the sites of gambling and pornography within the economic and cultural frameworks of America. Anderson's attempt to correspond the concept of America to the cultural and economic features of its representative areas is, of course, inspired by his favorite filmmakers. Look at the methods of depicting America in Altman's specifically place-oriented films, such as *The Long Goodbye* (1973), *The Player* (1992) and *Short Cuts* (1993), all of which are set in Los Angeles. In fact, location in Altman's films (specifically, visual characteristics in the case of a city) manifests specific behavioral traits that are familiar and tangible to the audience. Since the location in Altman's films is recognized immediately by the audiences, it easily involves them with its specificities. In fact, precisely because of their presence in a specific location, characters in Altman's films get the chance to express themselves. The very concreteness of Hollywood as the main location in *The Player* confirms this point. On the other hand, the presence of Los Angeles as a border-city in *The Long Goodbye*, with its marvelous architectural designs, figures as a counter-habit to film noir sub-genre in Hollywood's fully generic system of filmmaking. After all, everyone knows that a city like Los Angles can rarely be the site of a film noir. On the other hand, there are films, such as Altman's *Short Cuts* and Anderson's *Magnolia*, in which the lifestyles of residents have practically altered the shape of a city. With regard to Scorsese, the same claim can be made due to the frequent use of New York as the main location in his work. The type of location that Scorsese uses reflects his state of mind through the characters he

creates. Within this framework, New York in Scorsese's films is the force that gives his characters their identity and leads them to their ends.

Family

Freud believed that in contemporary society, the foundation of family was the principle of patriarchy in which the masculine and phallus-oriented side was always dominant. Explaining the capitalist discourse, Marx considered the concept of capital as a patriarchal and phallic entity that created the foundation of the capitalist economy. Since the Hollywood system has historically been a representation of the American society and its dominant ideology, it has firmly internalized this patriarchal element in its representation of the family structure. For this reason, the most fundamental themes of problem-oriented and radical films in America's cinematic history show family as an essentially problematic entity. In the same vein, the concept of family has become the most important thematic core of all Anderson's films. The efforts to build a family have always propelled the major actions of Anderson's characters, and this is a theme which creates a strong link between the works of Anderson and Scorsese. For this reason, we will analyze the concept of family in Anderson's films through a short and general thematic analysis of Scorsese's cinema.

In almost all of Scorsese's films, the issue of family has implicitly or explicitly been expressed, with family generally falling into two basic categories: either the family, as in *Cape Fear* (1991), is the central element that constitutes the

world of the film, or else its absence motivates and drives forward the actions of characters. In one sense, we can even say that the absence of family is far more important than its presence in Scorsese's films. *The Departed* (2006) is an excellent example in which the main character's lack of family is one of the key elements of the film's thematic world. In general, the failure of heterosexual relationships, or the impossibility of a successful relationship between man and woman which would result in marriage and building a family within a patriarchal structure, shapes the core of Scorsese's approach to the concept of family. Many of his films, including *New York, New York* (1977), are painful and shocking portrayals of the impossibility of an emotional relationship between men and women in a culture founded on inequality. Men experience ongoing conflict due to their need for dominance, and women experience stupendous shifts in mood between rebellion and complexity, both of which conditions are based on the peculiarities of the relationship between the director, the star, and the audience.

At the same time, Scorsese has never been under the illusion of introducing homosexual relationships as a solution to the crisis that hinders authentic relations between heterosexual couples in films such as *Raging Bull* (1980) and *Wolf of Wall Street* (2013). These two films begin with the illusion of building a successful family, but the hierarchical/patriarchal order results in the eventual collapse of the family system in them. Anderson is close to Scorsese's ways of portraying the concept of family. In fact, the family for Anderson is either the core element

of his films, as in *Magnolia* and *There Will Be Blood*, or it provides the basic point of reference for the film by its very absence or weakness, as in *Hard Eight* and *Boogie Nights*. But if the main conflict in Scorsese's films is between man and woman for building a conventional family based on marriage, there is an apparent lack of conventional family in Anderson's films. As an example, the characters in *Magnolia* aim to repair the families that have ostensibly had a conventional form in the past, but now are either collapsing or in crisis. Alternatively, like Sydney (Philip Baker Hall) in *Hard Eight* and Jack Horner (Burt Reynolds) in *Boogie Nights*, Anderson's characters aim to build symbolic families because, from their sociological viewpoint, a conventional family does not offer peace and bonding; rather, it is a battlefield full of stress and tension. The collapsed families of Dirk Diggler (Mark Whalberg) and Amber Waves (Julianne Moore) in *Boogie Nights* are useful examples in this regard.

Within the framework of this overarching thematic element, the main opposition in Anderson's films is not between men and women, but between two men. From his first film, *Hard Eight*, in which a binary opposition divides Sydney and John, relationships between men constantly turn into different variations of the same central dichotomy: father/son, master/slave, teacher/student, and mentor/mentee. Jack Horner and Dirk Diggler of *Boogie Nights* also represent a form of this opposition and, if finding an equivalent in *Magnolia* is difficult, we just have to think of Frank T. J. Mackey (Tom Cruise) who, despite being a mentor of the cult of penis-worshipers,

also has a father dying in bed whose existence he barely acknowledges. *There Will be Blood* represents a complex, awful and harsh form of such masculine dichotomies, and if *Punch-Drunk Love* seems to lack these dichotomies, one should point out that it is Anderson's most personal film. In fact, being raised in a family of many children, the lone male hero of *Punch-Drunk Love* is fundamentally inspired by his own life. The absence of the father/master or teacher/mentor pole finds a meta-textual meaning and, therefore, agitates the son/slave or student/mentee pole to a certain extent. This opposition between father/mentor and son/mentee expands and evolves throughout a dramatic process that takes place at the heart of Anderson's films. For example, we see this in Sydney's relationship with John (John C. Reilly) in *Hard Eight*. Although in the film's beginning we see the training of a novice/apprentice with some degree of pity and compassion, when we gain more narrative information, this relationship assumes a two-sided form. The central drama between Daniel (Daniel Day-Lewis) and Eli (Paul Dano) in *There Will Be Blood* reveals a strange complexity of mutual need, profit-seeking, and competition. We enter both the narrative and the Master's ship with Freddie (Joaquin Phoenix) in *The Master*. The idea here is that the conflict between Freddie and the Master, which sets in motion the film's central drama and shapes our perception and understanding of the two, will become more profound at every step.

But the important point about these dichotomous relationships is the fact that they produce psychoanalytical manifestations, which increasingly grow horrifying with

each new film. For example, in *Hard Eight*, Sydney elevates his teacher-student relationship with John to the level of a father-son relationship and, by placing John near Clementine, creates a symbolic family. At the end of *Boogie Nights*, Dirk is forgiven by Jack who is now able to transform his mentor-mentee relationship with Dirk into a father-son relationship in order to create a symbolic family which also includes Amber and the Rollergirl (Heather Graham). In *Magnolia*, Frank, who is a stranger to any notion of family, appears at his father's bedside and satisfies his dying wish. On the other hand, although the relationship between H. W (Dillon Freasier/Russell Harvard), who survives certain death in a miraculous way, and Daniel in *There Will Be Blood* functions within the father-son paradigm in the film's beginning, it disintegrates and turns into an irreconcilable hostility in the end. In *The Master*, the nature of this conflict is more complex than in all Anderson's previous works as the dichotomous relationship shifts from teacher-student and master-slave relationships to father-son, mentor-mentee, and even mentee-mentor ones. In general, it seems that the frenzy of the porn business in *Boogie Nights*, cults in *Magnolia* and *The Master*, and emperorship in *There Will Be Blood* are meant to hide or compensate for the deficiency that has shattered the structure of the family, which figures as the locus of polarized oppositions. The more critical this oppositional masculine relationship becomes in Anderson's films, the more insistently the patriarchal ideology is questioned. This aspect has, of course, visual corollaries in Anderson's films.

Just as the drama in *Boogie Nights* takes shape primarily around a particular male sexual organ, Frank in *Magnolia* is a mentor to the cult of penis-worshipers. However, this aspect in *There Will be Blood* is more muted compared to the transparent masculinity in the other two films. Daniel's will and power are basically depicted by phallic symbols that have been the mainstays of the patriarchal history of American capitalism. Think of the oil well drilling scenes at the moment when oil shoots out of the rig; such scenes obviously replicate the moment of masculine ejaculation. However, *The Master* penetrates into the unconscious of males, which Anderson had explored before.

Apart from the relationship between two males as a thematic axis, several other points of gravity exist in the narrative of *The Master*. As an example, Peggy (Amy Adams) disrupts the dominance of the paradigm of male polarized relations in the scene where she stimulates her husband's penis with her hand. Here Peggy presents herself as dominant rather than subservient by assuming complete agency. The same is more or less true of Doris (Madisen Beaty), a woman whose presence haunts Freddie like an image out of the past. By subverting the dominance of masculinity, Anderson's films can be seen as cinematic expressions of the moral and emotional bankruptcy of patriarchal capitalism. Symbolic fathers, who once appeared as potent figures of capitalism, reveal their fundamental emptiness, loneliness, and ineffectuality in Anderson's films. These films stage continual attacks on the patriarchal family and demonstrate the impossibility of realizing its desires and fantasies while depicting its

frustrations and the violence that its structures produce. These attacks are directed at the institution of family as the pillar of American society, an institution that also forms the basis of the narratives of the Old Testament.

The Hero/Protagonist

Like many heroes of independent cinema, Anderson's protagonists are problematic characters that, unlike Hollywood heroes, are not entitled to the superior values and virtues of American life, such as career, family, and social status. Instead, they seek some form of liberated individualism, which compels them to abandon many of the established norms. John in *Hard Eight* is a good-for-nothing loafer who has none of the relevant virtues, such as a home, family, career or an income associated with American heroes. Moreover, Clementine is a low-level waitress who does not shy away from prostituting herself to earn extra income. Although Dirk Diggler in *Boogie Nights* is defined within the structures of home and family, which are aspects of the virtues and values of American middle-class heroes, his quest for liberated individualism and his existential malaise and frustration about peripheral contacts and relationships prompt him to abandon all higher values of American life, including career and family. His individualism initially lands him in a dishwashing job at a nightclub and then affords him the opportunity to appear in pornographic movies. Barry Egan (Adam Sandler), the hero of *Punch-Drunk Love*, differs from all other Anderson's characters as he is placed in the most formulaic cinematic pattern in Anderson's

oeuvre: romantic comedy. Nevertheless, Barry suffers the same existential frustration which afflicts Anderson's problematic protagonists. Of course, the best example of this type of character is Freddie Quell in *The Master*. With his hung shoulders, scruffy poker face, staring eyes, inverted lip on the left side of mouth, and frightening hysterical laughter, Freddy has returned from the war, seemingly as one of the 30,000 American soldiers suffering from post-war trauma in 1946. However, within the structured pattern of absorption and desorption, which characterizes the polarized male relations in Anderson's films, Freddie escapes by motorcycle and fades into a desert's horizon to realize a liberated individualism at the end of *The Master*. By his departure, Freddie rejects the paradigm of the teacher/student, master/slave, father/son, and mentor/ mentee relationship in which he has been trapped.

A common feature of all characters in Anderson's films is their deficient family ties. This finds its most striking expression in *Hard Eight*. Undoubtedly, what brings Sydney closer to John is not just the guilt of murdering John's father, but also the fact that Sydney's children have rejected him. In this sense, John becomes a substitute for Sydney's absent children in the same way that Jack Horner and Amber, the middle-aged characters in *Boogie Nights*, practically adopt Dirk as their child in order to forget their loneliness and deficiencies. Of course, it is also crucial that the significance of this relationship is felt by both sides. Thus, while John accepts Sydney as his father, Dirk acknowledges Jack and Amber as his parent figures. The despair resulting from loneliness and sense of deficiency

can also be seen in *Magnolia* and *The Master*. For example, as the eponymous character in *The Master*, Lancaster Dodd (Phillip Seymour Hoffman) feels frustration because he knows that his son does not believe in his doctrine. That is why Lancaster seeks a surrogate son who would follow him blindly. Although in *Hard Eight* and *Boogie Nights* the characters suffer from loneliness and absence of family, they make up for this deficiency by forming symbolic families. In the same vein, although *Magnolia* is about broken families, its characters are strangely healed by their own penitent spirits and actions in the end. However, this sense of relative peace and resolution does not exist in *There Will Be Blood* and *The Master*, and while male polarized relations emerge in these two films in a more complex and horrifying way, major differences characterize the personality traits of their protagonists. In fact, unlike Anderson's previous films, the protagonists of *There Will Be Blood* and *The Master* are traumatic characters whose wounds and sufferings would not heal in any way in the end. However, apart from these personality traits, part of the trauma is related to differences between male polarized relations that appear in Anderson's films. In *There Will Be Blood*, unlike Anderson's previous films, the father/son relationship is shaped from the beginning, but is destroyed in the end. In *The Master*, this opposition is reversed from mentor/mentee to mentee/mentor. At the end of *The Master*, when we enter Lancaster Dodd's secluded place in his workroom, Freddie rejects Lancaster as his master. In *There Will Be Blood*, when Daniel becomes aware of his godson's decision to travel to Mexico, he swears at him, but this fury is actually due to deeply buried

emotions. Later in these scenes, the filmmaker uses two visual signs to indicate that this father/son relationship is the only thing that Daniel regrets. Continuing the scene, we see Daniel slowly descends the stairs to reach the lower floor of his home, a movement which conveys his downfall and painful loneliness and the beginning of his path to eventual madness. At the same time, Anderson employs a flashback in which Daniel recalls his good days with his godson. Many have compared Daniel in *There Will Be Blood* with Charles Foster Kane in *Citizen Kane* (1941). In this case, this shattered and lost relationship is like the Rosebud in Welles's film.

Besides the individual attributes and loneliness caused by castration and broken families, Anderson's protagonists are involved with the idea of drama and role-playing in a complex way. In some cases, such as those of Sydney in *Hard Eight* and Frank in *Magnolia*, this situation has its roots in a dark and bitter past for which drama and role-playing is supposed to provide a cover. *Hard Eight* ends with a view of Sydney's hands covering the dried blood on his shirt sleeves, which implies his crime before he pulls the edges of his coat down. This concise image is the objectification of his secrecy throughout the film and a reminder of the figurative veil that he always wears when encountering John. In *Magnolia*, the same concept leads to the formation of a penis-worshipping sect of which Frank is the guru. However, for Frank, playing this role has precisely the same function that it has had for Sydney in the previous film. It is Frank's bitter past that has produced repressed complexes which find expression

in a dramatic form throughout the film, especially when the interviewer confronts Frank about his past while he remains unable to talk about it and becomes emotionally and mentally paralyzed. The other ironic point of the film occurs when Frank, far from the uproar of his devotees, appears at his father's bedside and awaits his death without the slightest trace of the confidence that has characterized his overwhelming persona as the guru of the penis-worshipers cult. This dramatic dimension is also present in *Magnolia*'s other important character, the famous host of a TV quiz show. His past is far more horrifying than the other characters of the film, and when his wife confronts him about molesting their daughters, instead of denying it, he simply and without delay answers: "I don't know." The point is that even the drama and role-playing in which he engages as the host of a long-running quiz show cannot offer him an effective veil to conceal his dark and tainted past, even though suffering from cancer ultimately prompts him to commit suicide. This dramatic aspect also exists in *Boogie Nights* in the relationships behind the scenes of pornographic industry, which lead to the formation of a large semi-family. Drama and role-playing are also present in *There Will Be Blood*, where they appear as part of the dialectical structure which exists throughout the film. In *There Will Be Blood*, Daniel establishes a presence based on the power of speech and rhetoric, such as when he introduces himself as the "Man of Oil" and announces the beginning of better days for his listeners as though he were pronouncing the word of God. However, Daniel later confesses to be a misanthrope who hates everyone. On the other hand, Eli as a pastor

dramatizes another show in the church where his oratory powerfully moves his audience, thus presenting him as a serious rival to the Oil Man until the end of the film. The concepts of drama and role-playing are even denser and more threatening in *The Master*, the entirety of which is based on a show in which Lancaster Dodd plays his role as a new prophet.

Theological themes

In general, theological themes have a complicated presence and function in Anderson's films. On the one hand, the presence of home and family in Anderson's films has a negative relationship with the theological elements; on the other hand, in some cases, the punishment of characters in his films is portrayed in the form of divine retribution and torment. Here we should point out that family is one of the sacred pillars of Catholic teachings and the Bible promises that home of a family will provide the ultimate settlement, security, and peacefulness for the faithful. However, both family and theological themes are portrayed by Anderson in a fully critical manner. As we have mentioned previously, the deficiency and dysfunction of family as a whole is the most important theme in Anderson's oeuvre, where home is not a place of settlement and peace as Catholicism suggests, but rather a place of struggle full of tension and stress. With respect to Anderson's treatment of theological elements, the concept of penalty or punishment is one of the most important themes in his films. For example, the frog rain at the end of *Magnolia*, which is a heavenly response to

the sinful and remorseful conscience of the characters, has been directly borrowed from the Book of Exodus and the vast catastrophes which plague Egypt in the Bible. However, even as the frog rain signifies divine retribution, it is transformed into a miracle which offers relative peace and serenity to the film's characters. In this respect, it can be compared with the miraculous escape of Jules (Samuel L. Jackson) and Vincent (John Travolta) from a barrage of bullets at close range in Quentin Tarantino's *Pulp Fiction* (1994), after which Jules, believing that divine forces have intervened to save him, decides to take the path of salvation. In any case, standing outside the causal structure of the film's narrative, the frog rain in *Magnolia* takes an ironic form.

Undoubtedly, *There Will Be Blood* includes the most theological themes within Anderson's work. The film begins in absolute darkness and the first scenes are accompanied by a music that suggests tension and chaos. We first see a large, uninhabited area which appears undiscovered and untouched by human hands. Then we see Daniel digging in a well and a little later he is outside of it with nothing around except for dust and dirt blowing in a strong wind. Daniel makes a fire, drinks some water and freshens his breath. Explicit presence of the four elements in the beginning of *There Will Be Blood* leads us to a mythological reading by suggesting the myth of genesis. Daniel belongs to the realm of darkness and a linkage of signs makes the well an archetypal biblical location, which specifically refers to the Book of Psalms and Yahweh's struggle with Leviathan, after whose defeat

the creation of day and night takes place. At the same time, the film's theme of brother-killing has an archetypal dimension. Daniel kills two people in the film; the first is Henry who claims to be his brother, and the second is Eli the preacher who at the moment of his death tells Daniel that they are like brothers. In both cases, Daniel is portrayed as a Cain figure that kills his own brother, but the important point in this situation is that Anderson does not portray Abel as an innocent victim. Both Henry, who before death confesses that he has pretended to be Daniel's brother only to steal money from him, and Eli, who is merely a greedy preacher, are guilty of deception, betrayal and avarice and deserve punishment just as much as Daniel does. This is why, through a journey to the depth of archetypes, Anderson tunnels into the dark and horrifying aspects of mankind's psyche by linking these themes to myths and archetypes. Just like the frog rain at the end of *Magnolia*, Daniel's madness at the end of *There Will Be Blood* is a deserving retribution as his endless greed is punished by insanity and loneliness, especially because punishment is one of the recurring themes of the film.

At different stages of digging the earth, whatever is found is immediately negated by something being lost. During the first digging, Daniel's leg is broken; next, digging leads to the death of H.W.'s father; during another digging, a worker dies and H.W. loses his hearing. These recurring structures prepare us for the confrontation with the most gruesome incident in the film during Daniel and Eli's scuffle in the bowling alley, in which Anderson reworks the elements of the baptism scene. But this time, the roles

of the priest and follower are reversed as though familiar mythical patterns were telling us that rebellion does not end happily. In addition, the film's title, which is derived from the Book of Exodus and its transfiguration of the Nile's water into blood, provides a framework for looking at the world of the film and expecting the ill fate of its characters as they literally create a situation in which "there will be blood." However, when it comes to *The Master*, the use of theological themes and references becomes more complex. In *The Master*, theological elements are still present, but they are now concealed under a pseudo-science that Lancaster preaches. Anderson even gives the appearance of a prophet to his protagonist in *The Master*. In fact, we can claim that in this film, confrontation is essentially transformed into the cohabitation of religion and science as Anderson depicts a prophet who builds his ideological system by presenting himself with the face of a scientist.

Prologue

Finally, considering the recurring themes in Anderson's films, we conclude that they should be taken as a whole in what constitutes the "cinema of Paul Thomas Anderson," even though this presents the problem that analyzing each segment of each of his films would be a betrayal of the essence of his cinema as a totality. In Anderson, we encounter a filmmaker whose films reveal a coherency that very much resembles that of classical artists. This does not mean that the term "classic," when applied to Anderson, corresponds with the concept of classic

On the Cinema of Paul Thomas Anderson

228

Hollywood directors; rather, it means that we can find an aesthetic coherency between the narrative, visual and even musical aspects of his films (especially as Anderson refers to the history of cinema throughout his work). Therefore, we can claim that Anderson utilizes a classicist approach to his materials for the sake of giving coherency to them, and this is what we wish to call the "cinema of Paul Thomas Anderson."

All of Anderson's films are battlegrounds between two men, a man against himself, and finally Anderson against himself. All these battles happen within specific mise-en-scènes. To acquire a better understanding of Anderson's films, we should analyze these three types of battle next to each other to reach the point where, whatever meaning these films generate, their true meaning still stands somewhere outside the film itself, facing outward, facing the future, facing his next films. Perhaps, if we return to his films many years from now, we will think about today and remember that Anderson's films, with all their colorfulness and contradictions, all their beauties and deficiencies, were painful moments of giving birth to an extraordinary filmmaker out of the panoply of his previous films.

Contributors

Ramin Alaei holds an MA in cinema studies from Tehran Art University. He works as translator and researcher in the field of cinema and has already co-authored a couple of articles on cinema and philosophy for Cinema & Literature, Culture Today and Chapter of Thought.

Adam Bagatavicius received a BFA in Film Studies from Concordia University, and is currently finishing an MA in Film Studies at the University of British Columbia. He has been published in *Offscreen*, co-edited Issue 10.1 of *Cinephile* ("Music in Documentary"), and his overarching cinematic interests lie in sound design, cross-modal perception, excess, horror, gender and sexuality, and non-narrative filmmaking. He is currently completing a thesis on the sublime and embodied spectatorship in Godfrey Reggio's *Qatsi* trilogy.

Ben Dooley has a PhD in Film from the University of Essex and an MA in Film and Media from Birkbeck College, University of London. He has taught film, literature and media, including running modules, at the University of Chichester, Brunel University, the University for the Creative Arts and the University of Essex. His

PhD research focused on mobility and modernity in the films of Rene Clair, Fritz Lang and Alfred Hitchcock, from the silent era to the 1940s. He has had writing on film published by Offscreen and Electric Sheep. He also writes short stories and has recently made the short documentary film Fixed Odds.

Amir Ganjavie, a Phd student in communication and culture, York university, is a Toronto-based writer and cultural critic. He writes for Filmint, Mubi, Senses of Cinema, Offscreen and Brightlight. He has recently co-edited a special volume on alternative Iranian cinema for Film International and edited Humanism of the Other, an essay collection on the Dardenne brothers (in Persian).

Borna Hadighi, holds an MA in cinema studies from Tehran Art University. He works as translator and researcher in the field of cinema and has contributed to the journal of Cinema & Literature.

Nojang Khatami is a PhD student in political science at the University of British Columbia with interests in cosmopolitanism, identity politics and social psychology. His past work has focused largely on democratization in Iran, including co-authored articles in *Constellations*, *openDemocracy* and *The Progressive*. In 2014, he was awarded the Vanier Canada Graduate Scholarship, which supports his research. Since then, he has been exploring the possibilities for cosmopolitan understanding across cultures through empathy and perspective-taking through sharing narratives. For this project, he is looking to social and cross-cultural psychology to guide experiments in the practice of empathy in different social settings, including

research at UBC and fieldwork in South America. Having completed his undergraduate degree in English and world literature, his central focus remains on the power of fictional representation to build understanding among diverse peoples. He is particularly interested in literature and cinema as media through which viewers empathize with and take the perspectives of others, with an eye toward guiding socially advantageous policies and institutional designs in multiethnic societies. He is an avid reader and writer of fiction, and firmly believes that through sharing distinct experiences, people in those societies can go beyond merely coexisting and find ways to thrive together.

Mahmood Khoshchereh holds a PhD degree in English and Cultural studies from McMaster university. He has worked as a critic in the field of cinema in past few years. He has also taught courses on Persian literature and film and world literature at McMaster University.

Zorianna Zurba has recently completed her PhD in the jointly held program in Communication and Culture at Ryerson and York Universities.